Art in the Social Order

Art in the Social Order

The Making of the Modern Conception of Art

Preben Mortensen

STATE UNIVERSITY OF NEW YORK PRESS

Published by
State University of New York Press, Albany

© 1997 State University of New York

All rights reserved

Printed in the United States of America

For information, address State University of New York Press,
State University Plaza, Albany, NY 12246

Production by David Ford
Marketing by Hannah Hazen and Theresa A. Swierzowski

Library of Congress Cataloging-in-Publication Data

Mortensen, Preben, 1957–
 Art in the social order : the making of the modern conception of
art / Preben Mortensen.
 p. cm.
 Includes bibliographical references and index.
 ISBN 0-7914-3277-7 (HC : alk. paper). — ISBN 0-7914-3278-5 (PB :
alk. paper)
 1. Aesthetics. 2. Aesthetics, Modern—18th century. I. Title.
BH39.M6227 1997
701—dc20 96-15473
 CIP

10 9 8 7 6 5 4 3 2 1

For Laura

CONTENTS

ACKNOWLEDGMENTS

I wish to thank Barry Allen for his continuous help and support and for believing that I could pull it off. His always insightful and penetrating criticism of the earlier versions of this manuscript helped me greatly in sharpening the focus of the work. I am also grateful to Evan Simpson for helpful comments and criticism. I thank David Novitz and especially Richard Shusterman for encouragement and assistance along the way. Had I been able to carry through on all the suggestions they made, this would have been a better book. Laura Robertson read and commented on earlier versions of the entire manuscript and did much to turn my writing into passable English. I am also happy to thank Ann Robertson for giving so freely of her time to look after Torben, who did nothing to help me write this book, but thought my time would be better spent playing with him. I'm sure he is right.

Earlier versions of various parts of the book have been published elsewhere. I would like to thank the editor of *Eidos* for permission to reprint material from my essay "A New Historicism for the Philosophy of Art," published in vol. 9 (1990) of that journal. "Shaftesbury and the Morality of Art Appreciation," *Journal of the History of Ideas* 55.4: 631–50, is reprinted by permission of the Johns Hopkins University Press. I also thank Philip Alperson, editor of *The Journal of Aesthetics and Art Criticism*, for permission to reprint from "Francis Hutcheson and the Problem of Conspicuous Consumption," which appeared there in vol. 53, pp. 155–65.

The Modern Conception of Art

Our conception of the fine arts seems to most of us in the Western world obvious, perhaps even the natural one. With a minimum of probing, most will agree that something like the following four points characterize what we mean by 'art' quite well:

1. The most important forms of art are sculpture, painting, music, literature (including drama and poetry), and architecture.
2. Art has a value in and of itself, just in virtue of being art, and not just as (for example) an instrument for moral or religious instruction or as a source of knowledge.
3. The creation of works of art is essentially, as it ought to be, a free creation by individuals endowed with special talents, and cannot, or only to a limited degree, be learned and taught. Indeed, works of art partly gain their significance and value because they are the personal expressions of unique individuals.
4. Works of art express a subjective truth, and therefore differ fundamentally from science or other forms of systematic inquiry, which deal with objective facts of nature or society. We can only get at what a work of art expresses if we actually experience it. It is not possible to repeat or replicate, or perhaps even translate, a work of art in the same way as it is, at least in principle, possible to substitute one account of the Russian Revolution with another, equally good, account.

Though this idea, or this collection of ideas, about the nature of art seems commonplace to us, historians and anthropologists tell us that it is neither obvious nor particularly natural. If we ignore the fact that there are cultures which have vastly different conceptions of art (if they have any at all), we still have to contend with the fact that even in the Western world this conception of art is of a comparatively recent origin.

In this book I seek to persuade the reader that there are important philosophical lesson to be derived from this history. Philosophers in particular must take this historical message seriously and examine carefully what more specifically it entails. This, of course, implies that so far philosophers have not given sufficient consideration to the historian's message, a point I argue in part 1.

Seduced by the singular form of the question "What is Art?," many philosophers have sought a single answer to it. My aim, or one of them, with the following work is to argue that there is not and cannot be a single answer to the question. I propose instead to redirect the search on the principle that many specific answers must be sought rather than one general answer. General philosophical answers must be replaced by localized cultural history. In part 1, I argue for this reorientation in a discussion of contemporary philosophy of art. I predominantly discuss the possibilities of generating certain *types* of answers to questions in aesthetics (more so than actual answers), and this part can, therefore, be considered an essay in meta-aesthetics rather than in aesthetics as such.

I use the four ideas listed above as a preliminary empirical characterization of our conception of art, and do not, so far, make any claims as to whether this conception is correct or desirable. My only claim is that these are ideas Westerners now typically associate with the terms 'art' or 'work of art' or 'artist'. I call this conception of art "the modern conception of art."

The modern conception of art has not, of course, met with universal assent. It can be disputed exactly which forms of art are among the "most important," and some sociologists of art (as well as some historians of art) point out that central parts of the modern conception of art are simply wrong. In a recent book Vera Zolberg says that sociologists usually question traditional assumptions about art. She mentions three such assumptions: "that a work of art is a unique object; that it is conceived and made by a single creator; and that it is in these works that the artist spontaneously expresses his genius." Though this conception is "at odds with facts well known not only to sociologists (Becker 1982) but to other scholars as well" (Zolberg 1990, 43), it nevertheless still forms the basis for, for example, most history of art, and is shared by many aestheticians (Zolberg 1990, 55, 81). Marxists, feminists, and many others have particularly criticized the idea that art is supposed to be autonomous, beyond politics, money, and morality. Some philosophers (for example John Dewey and more recently Richard Shusterman and David Novitz) and many twentieth-century artists deplore this conception of art, because, they claim, it isolates art from the broader concerns of people, makes it elitist, or outright irrelevant. But the attention given to the autonomy of art,

even by those who disapprove of it, serves to underscore its place as one of the most important components of a widely held conception of art.

The fact that the modern conception of art is the object of criticism and has become visible as a part of an historical development, is perhaps evidence that it is one of those forms of life which has aged. As Hegel so poetically expressed it: "When philosophy paints its grey in grey, then a shape of life has grown old, and it cannot be rejuvenated with grey in grey, only understood; Minerva's owl begins its flight only with the falling of the dusk" (Hegel [1820] 1942, 13—I have changed Knox's translation slightly). Though it may have lost some of its youthful vigor, the modern conception of art is still sufficiently common to warrant the label "typical." It is embodied in the institutions of the art world (museums, concerts, literary criticism, the art sections of newspapers and magazines), as well as in the way the educational system is organized, textbooks are written and so on.

A reorientation in the philosophy of art (and here I refer mostly to mainstream Anglo-American philosophy of art, the descendant of the analytic movement in philosophy of art) is necessary because this discipline has come to an impasse, particularly as this concerns the discussion of the concept 'art'.

The impasse in contemporary philosophy of art currently consists in an inability to move beyond the two main alternatives: An essentialist and a descriptivist approach (discussed in part 1). As a result of "the linguistic turn" in the philosophy of art in the middle of the twentieth century, traditional aesthetics of the essentialist type came to be widely seen as mistaken. But no satisfactory alternative emerged, thus leaving the road open to renewed attempts of the traditional type. We are, therefore, still in a situation where two major alternatives compete for attention from the philosophical audience (though there are of course exceptions). To move beyond this impasse I suggest an historicist alternative.

I am not the first in recent philosophy of art to propose an historicist theory of art. Jerrold Levinson and Arthur Danto are just two among contemporary philosophers who have advanced historicist theories of art (I discuss their theories in chapter 5). The type of historicism I propose is, however, much more far reaching than theirs, and it can in part be expressed in the terminology created by Nelson Goodman (Goodman 1968, 1978, 1984). Goodman urges us to not consider forms of classification as enumerations of the constituent parts of a preexisting order, but as based on the categories we choose for the classification. Classification is, at least in part, based on the standards we choose for the job. We should consider our way of dividing up the world (for example into art and nonart) as a result of our own activities. Divisions are made, not found. Something is art when a world is made wherein it is possible for it to be art. In Goodman's conception of worldmaking, worlds can be very small and in principle made by a single individual. A painter painting an imaginative picture would be an example of a world created.

Goodman's conception of worldmaking has been disputed. I do not wish to enter into this debate, but only to use the idea of worldmaking as a suggestive metaphor which can lead us in new directions. It is possible (though Goodman

probably does not) to conceive of the larger worlds created by science or philosophy as the results of the creative efforts of many people, often over an extended period of time. I wish to suggest that we consider our conception of art as the result of such protracted and collective efforts.

With the formation of the modern conception of art certain forms of discourse become possible, and the conception expresses a certain way of classifying and evaluating things in the world. It is a shared view of the world, or such it has become. The discourses made possible by this world must be understood not just as an exchange of statements, but as a practice regulated by rules. The rules determine or limit, in a very broad sense, the activities carried out within the practice and the linguistic utterances made about them. The rules are explicit or tacit rules regulating, for example, agreement, truth, membership (whether or not something is art, philosophy, science, etc.), and what is a legitimate move. The making of a world establishes rules, procedures, and standards.

When I say that classification is based on standards we choose, it should not be taken to mean that these are totally arbitrary. Initially we could choose other categories. Painting was once called a science. But when a practice has been established there are specific rules and procedures which must be followed. That standards are based on practices (and thus conventional) does not mean that they are groundless, or that the views we hold are worthless.

I advocate a view of philosophy as worldmaking and, in particular, as an examination of the ways in which worlds are made. To elucidate this view of philosophy, I examine a crucial period in the formation of a discourse about art. This type of philosophy does not offer any general, abstract answers applicable to any situation; in fact, it rejects the view that this is the task of philosophy, and it wishes, similarly to what has been suggested by Richard Rorty, to ask specific questions, rather than general questions, and to provide answers to these by examination of the historically contingent development of discourses (Rorty 1989, xiii). 'Contingency' refers to the view that there is not anything "deep" in the world that makes one way of talking about it better or more true than another. No preexisting order of the universe grants or withholds validity to our statements. Only other statements can do that. We are without philosophical foundations in the traditional sense. Historical, social, or psychological explanations go all the way down.

No philosopher will deny that a history of varying conceptions of art can be told, and that this story may be illuminating and interesting; but many insist that this does not solve the philosophical question about the nature of art. When the story is told, there is still a question left (a "purely philosophical question"). I wish to deny this. A reinstatement of the modern conception of art into its historical and social web is as much answer as we can reasonably hope to provide to the traditional philosophical question about the nature of art.

The statement that this "is as much answer as we can reasonably hope to provide" has an aura of unfulfilled aspirations—as if this is, after all, a second rate answer, not quite as good as the traditional, philosophical answer which

regrettably eludes us. This is not at all what is intended. On the contrary, this type of philosophy brings philosophy much closer to the everyday concerns of most people. It brings philosophy and philosophers down from the clouds, by situating the philosopher and the philosophical problems in the world of everyday practical concerns.

A philosophical inquiry which seeks to examine the historical contingencies of worldmaking must articulate what initially is, or through the course of history has become, inarticulate. This articulation can only be achieved by exploration of origins and developments of discourses, ideas, and institutions. In the course of their development, ideas and institutions pass from a phase wherein their *raison d'être* requires articulation in the face of other competing ideas and institutions, to a point where this is no longer needed. When ideas are originally formulated they are advanced in opposition to other ideas. A set of initially controversial ideas can become the received opinion of the matter in question, they come to be taken for granted. To use a metaphor of Wittgenstein's, the ideas become part of the "*scaffolding* of our thoughts" (Wittgenstein 1969, sec. 211). The ideas against which they at first had to be defended drop out of the historical narrative, or come to be seen as naive or mistaken, as was the case with Hobbes' opposition to Boyle's advocacy of experimentation or with Galileo's Aristotelian opponents (Shapin and Schaffer 1985; Feyerabend 1988). Important assumptions on which the victorious ideas rested sink to the level of tacit knowledge. Some categories of thought and action have been with us for so long that they have become part of our collective unconscious. They become a matter of, for example, mastering techniques necessary for participation in practices (to be considered a competent practitioner of science or medicine), or for membership in a culture.

Such a process of forgetting has, I suggest, taken place in the philosophy of art. At the core of recent philosophy of art is a conception of art which contains unacknowledged philosophical, political, cultural, and social presuppositions. These presuppositions were shaped by the specific circumstances surrounding the genesis and development of the modern conception of art. Historically, philosophy of art comes into being in tandem with the modern conception of art. As a branch of intellectual activity, philosophy of art is about this conception of art. The modern conception of art is part of a tightly woven social and historical fabric which is largely ignored in contemporary philosphical analysis of the concept; but to understand the nature of art we need to recognize the historical contingencies which shaped our ideas of art.

The final formation of the modern conception of art happened in a period stretching from the end of the seventeenth century to around the mid-eighteenth century. Though elements of each of the four components with which I characterized this conception above can be found prior to circa 1700, for example in the ancient conception of poetic creation, they did not exist together before about 1700. (For literature documenting this point, see for example Barasch 1985, 1990; Gombrich 1980; Hauser 1951; Kristeller 1951–52; Pollitt 1974; Ritter 1971; Tatarkiewicz 1970–74, 1980.)

Why call the conception of art under discussion 'modern'? What does the concept 'modern' yield? Historically, three meanings have been associated with 'modern':

1. It can simply mean that which is contemporary, as opposed to that which belongs in the past.
2. It can mean that which is new, as opposed to the old, and reveal an awareness of living in an epoch which is separated from, and different from past epochs. In this sense it is not just chronological, as in the first sense, but also oppositional: those who call themselves 'modern' in this sense see themselves as already living in the future (Habermas 1987, 5).
3. It can refer to something passing, of only temporary duration, as opposed to the eternal. We find this meaning of 'modern' in the late Middle Ages and in some places in Hegel and Schlegel (Gumbrecht 1978).

The second sense of 'modern' becomes prevalent from around 1700, and it emerges out of the "Querelle des Anciens et des Modernes." To call something 'modern' in this way, as for example Shaftesbury did, introduces a number of differentiations. It expresses a consciousness of living in a period which is historically distinct from another period. To Shaftesbury, it would be a difference partly in relation to "the ancients" in classical Greece and Rome, partly in relation to England before 1688. The term 'modern' implies that something constitutes a difference between the present and the past (for example "politeness," liberty, or knowledge), something which serves to give the modern period its special character. The term 'modern' expresses therefore partly a periodization (which may or may not express what is actually the case), and partly an attitude or a self-consciousness.

The conception of art under discussion has both these characteristics: it belongs to and is characteristic of a given historical period, and it expresses a quest for legitimacy and self-consciousness; those who think of themselves as "we moderns" bring to awareness their own standpoint within history (cf. Habermas 1987, 6).

To call the conception of art under discussion in the present work 'modern' serves, then, to bring out contrasts to other, earlier and contemporary, conceptions of art: those held in ancient Greece, a medieval conception of art, a Leninist conception of art, perhaps a postmodern conception of art, and so on. Some of these may differ so much, that they have nothing but the term 'art' in common (either occurring "naturally," or because 'art' is the word chosen to translate a term from another language into current English).

The conception of art under discussion is modern because it belongs to a certain period, beginning in the late seventeenth, early eighteenth centuries (though historical processes strictly speaking have neither end nor beginning), and because it demarcates an attitude *characteristic and typical* of this period, the period in which we still live. To be of any interest, or, indeed, of any use, history

cannot be written without assuming that *some* things in a given period are more important than others, that *some* things warrant labels such as "characteristic" or "typical."

To preempt a possible misunderstanding: I do not wish to deny that in most cultures (probably all) throughout most of human history people have been dancing, singing, making music, telling each other stories, and so on. But these activities have been carried out under vastly different circumstances, which have lent them many different functions, and have provided the participants with different frameworks in which they have understood their own activity: as reinforcing social rank, as a way of communicating with the gods, as an attempt to control the forces of nature, as an activity which has no purpose beyond itself, and much else. It is exactly such diversity which is the starting point for this examination.

When we now peruse geographical, cultural, and historical horizons, we may be tempted to see universal patterns of behavior. But we should not insist that all these activities be placed under one general concept of art, similar to our own. This is generalization for the sake of generalizing. It does nothing, except perhaps satisfy that philosophical craving for generality Wittgenstein deplored. Superficial commonalities should not lead us to ignore the profound differences in cultural forms.

In chapters 1, 2, and 3, I examine some of the main contentions in contemporary British and North American philosophy of art. It has generally been assumed that one of the most important tasks for the philosophy of art is to provide an answer to the question "What is Art?"

Chapter 1 discusses the approach to that question which has come to be known as "traditional aesthetics." The most characteristic feature of traditional aesthetics is its essentialism. Its proponents search for an essence of art, and seek to capture it in a definition. Usually, though not always, the definition gives the necessary and sufficient conditions that make something art. The traditional approach is unsatisfactory, and in chapter 2 I consider Wittgenstein-inspired approaches, which are generally thought to provide the main alternative. The Wittgensteinian alternative typically amounts to a descriptive and synchronic approach to, for example, the concept of art: at time t the concept 'art' is used in these ways, it has these different meanings, and so on. Instead of finding essences we must describe a certain state of affairs, or a specific type of practice, in a manner not unlike the one in which an anthropologist would describe a culture foreign to her own. This approach is more promising, but equally unable to provide us with a theoretical framework able to shed light on the historicity of the concept of art. The historical diversity of the conceptions of art is implicitly or explicitly recognized by both traditional and Wittgensteinian philosophers, but they have not been able to develop a satisfactory alternative based on this fact.

Some recent work in the philosophy of art—notably the writings of Arthur Danto—exhibits a growing emphasis on the connection between theoretical

reflections in the philosophy of art and developments in the art world, or in society in general. George Dickie's institutional theory of art—though intended as a revival of traditional aesthetics—emphasizes the many conventional aspects involved in the production and reception of works of art. The conclusion of recent philosophical investigations such as Danto's and Dickie's has been that art must be seen in a social or even an historical or art-historical context. While this is true, this insight should not be considered a conclusion, but made a point of departure for further investigation.

Chapters 4 and 5 probe deeper into the historical nature of philosophical problems and develop a historicist approach to them. In addition to the general arguments I advance in part 1, I seek (in part 2) to substantiate the historicist approach by applying it to write a partial account of the emergence of the modern conception of art. As Henry Fielding observed: "It is a trite but true observation, that examples work more forcibly on the mind than precepts" (Fielding [1742] 1985, 39).

In chapters 6 and 7, I provide some of the background to the emergence of the modern conception of art. The conception forms a central part of new ideas of the presentation of the self in an era where old, feudal or aristocratic, values and codes of behavior have been displaced.

Chapter 8 is an exploration of the place of the arts within this larger transformative process in Britain in the latter part of the seventeenth century and the early part of the eighteenth century. Changing interpersonal relations, resulting from the final collapse of the old order following the revolution in 1688, is an important cause of the explosive growth of interest in the arts in this period. The writings of Shaftesbury, Addison, Hume, Hutcheson, and others, must be seen as steps in the development of a theoretical framework, wherein the changing role of the types of activity, which came to be included in the modern conception of art, could be understood and made legitimate. Chapters 9 through 13 examine their work and situate it within the broader transformative process.

The historical account is far from a complete history, but focusses on selected aspects of the development, particularly in Britain, and to a lesser extent in Germany. This is not an indication that I believe the theoretical discussions in France to be insignificant. The connections between the Continent and Britain were complex and reciprocal. The impetus for some of the early theoretical work in Britain came from France, and British contributions (for example Shaftesbury's and Hume's) were influential on the continent.

The modern conception of art and the philosophy of art were not created out of nothing in the eighteenth century, merely as a response to changed social and political conditions. Those who thought and wrote about these questions in the seventeenth and eighteenth centuries naturally appropriated the tradition preceding them. They read Plato, Aristotle, Horace, Plotinus, and many others, and in the process they transformed and adapted what they found useful. I say little about this aspect in the following, and am acutely aware that in this respect too my historical account is incomplete.

When, for example, Shaftesbury's and Hutcheson's work is interpreted in its social and historical context, it becomes apparent that their contributions to the formation of the modern conception of art and the philosophy of art are deeply influenced by these historical circumstances. It is perhaps less apparent that contemporary philosophy of art contains unacknowledged political, social, cultural, and philosophical assumptions, and that these where shaped through the genesis and development of the modern conception of art. The final chapters (14 and 15) seek to connect the historical narrative to the present, in an effort to substantiate this part of my hypothesis.

Recently some philosophers (Paul Ricoeur, David Carr, and David Novitz among others) have emphasized the role narratives play in shaping our self-understanding. We weave, as it were, stories based on the way we understand our lives. The modern conception of art is an important part of the way many people view their lives, an integral part of their personal narratives. If the origin of the modern conception of art is, as claimed in this book, deeply embedded in history, traditions, and practices, and is an important part of the way many people think of themselves, it becomes clearer why many discussions of a seeming academic nature get so entrenched, why the modern conception of art is fought for so dearly, and why discussions about it are often highly animated.

Philosophical theories should make a difference in the way we view and explore the world; they should be relevant in relation to other areas of culture. To achieve this I try to focus on broader patterns of thought and explore the question why these, and not other patterns, became the accepted or prevailing ways of thinking and writings about, in this case, the arts.

The modern conception of art did not suddenly "capture the Western imagination." It grew out of specific historical processes; it became institutionalized, and gained, in this way, material expression. One of the most important of these institutionalizations is to be found in the way in which intellectual spheres of interests have been divided: the separation of the good (morality), the true (which became monopolized by science), and the beautiful (the arts, the aesthetic, that which is worthy of attention for its own sake). It is, above all, in this context that the modern conception of art has become a "cultural universal," a tacit assumption characteristic and typical of "we Moderns."

PART ONE

The Quest for the Essence of Art

One day in January 1990 outside the Public Library on Vancouver's Burrard Street a local artist, Rick Gibson, found himself surrounded by people angered by his publicized intention to crush a rat, Sniffy, between two canvasses with the help of a concrete block. The block would be dropped on top of Sniffy, who was presumably trapped between the two canvasses. On impact, the flattened Sniffy would leave its imprint on the canvasses (see *Globe and Mail*, 13 January 1990, D1–2).

In that same winter 1989–1990 Andres Serrano's *Piss Christ*, a photograph of a plastic crucifix submerged in a yellow liquid, allegedly the artist's own urine, enraged segments of the American public, including some politicians (see Bolton 1992, 27–37). The waves from the upheaval in the United States were felt as far as Winnipeg, Manitoba. Serrano's appearance at the Winnipeg Art Gallery in March 1990 resulted in a demand from some Winnipeg city counsellors to stop the city's financial support for the gallery (Noble 1990).

Gibson's and Serrano's are but two cases out of many in which would-be-artists present, to an increasingly unmoved world, strange new phenomena for which they claim the status of works of art. Much of the explanation for the outrage occasioned by these "works of art" must be sought, no doubt, in their violation of moral, political, and religious conventions. The offense caused by works such as Serrano's and Mapplethorpe's in the United States, though no doubt genuine, was probably not entirely spontaneous, but orchestrated by the religious right. The works have subsequently become vehicles for extensive debates about "freedom

of expression." Sniffy's life was saved by incensed animal lovers chasing Gibson down the street, rather than by philosophical arguments convincing Gibson that his work was not really art after all.

In the long run, Gibson's, Serrano's and Mapplethorpe's works may turn out to merit no more than a footnote in the history of art. If such works do gain a place in future accounts of the history of art, this will probably be due more to the attention Senator Jesse Helms and his fellow moral reformers drew to them, in itself an instructive example of the influence of extraneous forces on the creation of art-historical discourse.

In any case, during visits to art galleries, or while gazing at a new civic sculpture, most of us have had occasion to reflect on the question of why this particular object is a work of art, and how, if at all, it differs from other, more mundane, objects. Our apprehension is fueled by the belief that the history of Western art is fraught with instances of Van Goghs who, initially the objects of scorn, ridicule, and suspicions of madness, become universally recognized as artists of genius. We do not want to be among those who could not find the courage or innocence to point out that the emperor is parading about stark-naked—nor do we want to be condemned by history as ignorant and insensitive to contemporary works of art which may turn out to pass "the test of time" and obtain canonical status.

Some modern artists see it as the purpose of art to raise the question about art's nature:

> The "value" of particular artists after Duchamp can be weighed
> according to how much they questioned the nature of art,
> which is another way of saying "what they *added* to the con-
> ception of art" or what wasn't there before they started. Artists
> question the nature of art by presenting new propositions as to
> art's nature. (Kosuth 1969, 135c)

Artists, if Kosuth is right, have become theoreticians. Through their artworks they pose theoretical questions. A. C. Danto, perhaps the most eminent of contemporary American aestheticians and art critics, has made this theoretical nature of art the centerpiece of his philosophy of art. Art, particularly in the twentieth century, increasingly presupposes theory and sees its task as accounting for its own nature (see, e.g., Danto 1986, 125). It is no doubt correct that the question about the nature of art arises from the actual historical development of artistic practices, from the variety of art production and reception. As observed by Noël Carroll (1994, 5, 14–16), this is particularly true in the age of the avant-garde. The first requirement of any general theory of art must therefore be to say something about this diversity, its unity (if any), and its historical development. And this is exactly one of the core problems of philosophy of art in our century.

In this chapter, I briefly review traditional attempts to deal with this problem. The philosophy of art (or aesthetics—I use the two terms interchangeably) to

be discussed in the following is mainly of what can broadly be characterized as of the analytic variety, and is the type dominating aesthetic discussions in for example *The Journal of Aesthetics and Art Criticism* and *The British Journal of Aesthetics* (for an overview, see Shusterman 1989). The expression "traditional aesthetics" gained prominence with Kennick's essay "Does Traditional Aesthetics Rest on a Mistake?" (1958), but is now widely used in discussions in the philosophy of art. Starting from the observation of the great variation in art production and reception and its historical developments, traditional aesthetics wants, so to speak, to cut through the diversity to the unchanging essence of art. This is also the intent of George Dickie's celebrated institutional theory of art, which is actually a form of traditional, essentialist aesthetics. For this reason (I will argue) it has nothing to say about why and how art and conceptions of art develop historically.

Essentialism and Traditional Aesthetics

Clive Bell (1881–1964) and Roger Fry (1866–1934) are probably the most famous proponents of the essentialist type of traditional aesthetics (see, for example, Bell 1927 and Fry 1926, and below, chapter 2). The main content of essentialism can be formulated in the following manner: though we seem to perceive an endless variety of things and phenomena in the world, there is, for each group of things to which we apply one name, something unchangeable behind the perceived variety that makes it possible to use one name. This is of course thought to be part of the reason why we *have* one name for one kind of thing. Distinctions in the natural or real world are reflected in our language, a fact that makes it possible to define art by giving the necessary and sufficient conditions (or *genus proximum* and *differentia specifica*) that make something art. This is exactly what Bell does. According to Bell, all works of art provoke, at least in sensitive people, a certain kind of emotion, an "aesthetic emotion." This sensation, Bell presumes, is generated by a common quality in works of art. "[E]ither," Bell said in an often quoted passage,

> all works of visual art have some common quality, or when we speak of "works of art" we gibber. Everyone speaks of "art," making a mental classification by which he distinguishes the class "works of art" from all other classes. . . . There must be some one quality without which a work of art cannot exist; possessing which, in the least degree, no work is altogether worthless. . . . What quality is common to Sta. Sophia and the windows at Chartres, Mexican sculpture, a Persian Bowl, Chinese carpets, Giotto's frescoes at Padua, and the masterpieces of Poussin, Piero della Francesca, and Cézanne? Only one answer seems possible—significant form. (Bell 1927, 7–8)

In the philosophy of art few consciously advance essentialist definitions of art or directly defend essentialism, but theories of an essentialist nature are still with us. George Dickie's famous—and continuously influential—institutional theory of art is, as I show below, one of the most elaborate attempts to revive traditional aesthetics, a fact which is frequently not made clear.

The Institutional Theory of Art

The institutional theory of art, Dickie says, "concentrates attention on the *nonexhibited* characteristics that works of art have in virtue of being embedded in an institutional matrix which may be called 'the artworld' and argues that *these characteristics are essential and defining*" (Dickie 1974, 12 [last italics mine]). It does so by defining art as an artifact some aspect of which has had "conferred upon it the status of candidate for appreciation by some person or persons acting on behalf of a certain social institution (the artworld)" (Dickie 1974, 34)

The institutional definition of art has been true at all times, but it has not always been apparent that the institutional character of art is indeed the essence of art. Only with the emergence of modern works of art in the early parts of the twentieth century, particularly Dadaism, was it revealed that none of the other features of works of art (such as their representational or expressive features) could define art.

The artworld is a social institution, not in the sense in which a formalized organization, such as a corporation, club, or political party, is an institution, but in the sense of an "established practice" (31), or a "customary practice" (35). The artworld is composed of a very large group of people: artists, producers, museum directors, museum-goers, theater-goers, reporters for newspapers, critics, art historians, art theorists, philosophers of art, and others (35–36). They are what Dickie calls the core of the artworld. "In addition, every person who sees himself as a member of the artworld is thereby a member" (36).

Many of the elements of the artworld mentioned by Dickie change through history. In the not too distant past (prior to about 1750) there were no public art museums as we know them today, and therefore no museum directors or museum-goers, no critics, and no reporters for newspapers. The actual contents of the artworld undergoes dramatic changes. One of the features of Dickie's definition of art is supposed to be that it, as opposed to other definitions, is able to take developments and changes into account (33, 48).

Though the ability to take change and development in the artistic institutions into account is an important aspect of Dickie's definition of art, it is difficult to see how defining art in the way Dickie does actually contributes to understanding and explaining change and development in the institutional setting of art. In one passage Dickie minimizes the role it would have for his theory if, for exam-

ple, the ancient Egyptians had a conception of art radically different from ours (1974, 28). It would be enough, he says, to specify the present conception of art. But if this is the case, why formulate a theory of art in the form of a definition giving the necessary and sufficient conditions that make something art? If a central concern in defining art is to understand change and development, an investigation of the particular circumstances under which a certain conception of art emerged and developed would be preferable to an essentialist definition of art.

As an essentialist definition of art, the focus of Dickie's institutional theory of art is on the eternal and unchanging nature of art, but the cost is extreme generality. In his explanation of, for example, who the artworld is composed of, Dickie clearly has in mind limited aspects of more recent developments in artistic practice.

The institutionalization of art is a feature of art specific to an historical period where what we consider the fine arts become identifiable as an institution (Bürger and Bürger 1992, chap. 1). Of particular significance in this institutionalization of the arts is the development of the art museum. It is only when the work of art is isolated in the museum, and robbed of that context in which it originally existed that it appears autonomous and the contemplation of it disinterested. Art can then become an aesthetic object, high art, or fine art, in our understanding of this concept (Saisselin 1992, 134–38).

Dickie takes the existence of the entire framework of artistic institutions for granted. Things can enter the institutional framework and thus obtain the status of works of art. But clearly the relationship between works of art and the institutions of art is more complicated than that, and the institutions of the artworld are partly defined by works of art. In some way all the aspects of the institutions must, from a historical point of view, come into being at once and so to speak create each other, or create the entire artistic field.

Dickie elevates an aspect of the development of art to its eternal essence, at the cost of the really interesting questions: to the extent that art is institutionalized and governed by conventions, where did these institutions come from, and how did they develop? Have they changed through history, and if so, what is the nature of this development? Because other parts of Dickie's theoretical efforts are directed to the examination of the historical origin of the aesthetic and of the conventional nature of the presentation of aesthetic objects, the lack of historical specificity seems particularly regrettable.

A similar uncertainty attaches to the question of the composition of the artworld. Though looser in its organization than that of a more formalized organization, it is certainly not true, as Dickie's theory implies, that anyone considering themselves part of the artworld has it in their power to turn something into a work of art. This question—of the composition of the artworld—is one where Dickie's theory would point in the direction of specific, for example sociological, examinations of questions such as, What constitutes membership in the artworld? and Why can some people can get away with exhibiting urinals and others not?

Reduced to its simplest form, Dickie's theory makes the point that it is in the web of human activities we must look for the answer to the question of how some things become art, others not. Rather than following the treads in the web, however, Dickie is satisfied with a formal expression of this relationship between certain forms of human activity and certain objects. The institutional theory of art is a house divided against itself: it emphasizes the collective and social nature of art and could serve as a guide in the examination of what actually constitutes the different forms of "established social practice," and of how they develop and change, but Dickie presents it as the ultimate answer to the question about the essence of art. His theory, therefore, rests on a philosophical assumption which excludes or at least renders uninteresting historical or sociological examinations of those forms of collective human activity which make art.

Definitions and the Real World

As other concepts, 'art' is not a mysterious entity. It is an expression of the way people think about an activity they or others are or were involved in. It sums up aspects of this activity the participants find important. It classifies and evaluates.

Bell's definition of art illustrates that definitions of art can have this function. It was no coincidence that Bell mentioned Cézanne along with Giotto, Piero della Francesca, and Poussin. The three latter painters were clearly accepted as a part of the art-historical canon by Bell's British contemporaries, but Cézanne was not. Until around 1910 Post-Impressionist painters such as Cézanne were relatively unknown in England, and an exhibition of the works of the Post-Impressionists organized in 1910 by Roger Fry had caused quite a stir in the British art-establishment. Bell argues, in effect, that Cézanne, and, by implication, the other Post-Impressionists, are part of the art-historical tradition, because they by definition exhibit the art-making quality: significant form. Bell's definition draws attention to features which have been overlooked in the prevailing mode of reception, where pictures were seen as mainly representational in some straightforward sense of that term, and the definition recommends another way of looking at pictures. (The events surrounding Bell's definition of art as "significant form" are discussed in greater detail below, chapter 2.)

The American sociologist Howard S. Becker (and more recently Noël Carroll) points out that Dickie's institutional theory has a function similar to the one here suggested for Bell's. It provides a theoretical justification for, for example, Dadaist art; in particular, it offers an explanation of how such objects as Duchamp's Readymades can come to be considered art. When artistic phenomena which cannot be accounted for within the prevailing theoretical framework occur, it is the typical task of aesthetics to develop a new theory or definition of art which is able to accommodate these phenomena (Becker 1982, 164; Carroll 1994).

Dickie's theory, then, is not an alternative to traditional aesthetics, and cannot provide us with the framework for an historically oriented understanding of the concept of art. In Wittgenstein's philosophy we do, however, have a sustained and influential criticism of essentialism, and it has been one of the most significant sources in the efforts to develop a new approach to aesthetics. I will therefore take a closer look at some attempts to develop Wittgenstein's philosophy in this area.

Wittgensteinian Philosophies of Art

Wittgenstein's *Philosophical Investigations* has been a particularly important source for criticism of essentialism in the philosophy of art. Wittgensteinians point to the conventional nature of our concept of art, to the fact that our concepts are shaped by the manner in which our lives and our worlds are organized. After a brief survey of some early Wittgenstein-inspired attempts in the philosophy of art, I examine one of the most sophisticated recent applications of Wittgenstein's philosophy to aesthetics, Benjamin Tilghman's *But is it art?* I argue that if we ask why we have the practices we actually do, we will be lead into an examination of the historical development of these practices and of our way of thinking and doing. To suggest an historical examination of the origin and development of our conception of art is to suggest a move beyond Wittgenstein, whose conceptual apparatus, though compatible with, perhaps even indicating the necessity of such a move, does not provide us with much guidance when we take it. My discussion of Tilghman is, therefore, also a general examination of the possibilities and limitations of a Wittgensteinian approach to the philosophy of art. This examination reveals that the Wittgenstein-inspired criticism of essentialism suffers from some of the same shortcomings as essentialism, most importantly an inability to explain why the concept of art has a history at all.

Traditional Aesthetics
and the Uses of Languages

Weitz's "The Role of Theory in Aesthetics" is one of the first attempts to directly apply principles and ideas from Wittgenstein's *Philosophical Investigations* to questions in the philosophy of art. The frequent discussion of Weitz's essay (for good discussions, see Tilghman 1984 and Davies 1991) justifies a very brief treatment here.

Weitz rejects the project of traditional aesthetics, because the concept 'art' has no necessary and sufficient properties. A theory of art (in the sense of a definition) is therefore not merely factually difficult, but logically impossible (Weitz 1959, 147). Weitz suggests instead a synchronic description of the different uses and meanings of 'art'. Rather than finding essences, we must describe a certain use of a word or concept, or a specific type of practice. We must give "a logical description of the actual functioning of the concept, including a description of the conditions under which we correctly use it or its correlates" (147).

Descriptions of "the actual functioning" of a concept can, however, be deceptive. A brief look at Frank Sibley's celebrated attempt to do so in his 1959 essay "Aesthetic Concepts" is instructive (Sibley 1987). Sibley distinguishes between two types of statements that can be made about works of art. The first type can be called descriptive. Their use articulate some aspect of the work of art which can be seen by anyone and which will not give rise to disagreement. But in addition there is a more complicated type of statement:

> [W]e . . . say that a poem is tightly knit or deeply moving;
> that a picture lacks balance, or has a certain serenity and repose,
> or that the grouping of the figures sets up an exciting tension;
> that the characters in a novel never really come to life, or that a
> certain episode strikes a false note. (29)

Such statements require an ability to make discriminations of a nature different from the descriptive type. They require the exercise of taste, and the concepts used belong to the type that Sibley calls aesthetic concepts or taste concepts. Sibley wants to examine how we "actually employ these [aesthetic] concepts" (43). Aesthetic concepts are not governed by rules or conditions in the way descriptive terms are, and cannot be justified by appeal to "nonaesthetic conditions" (39–40). In the absence of rules, Sibley's finds confirmation for his idea that we need special sensibilities to make aesthetic judgments.

It is important to notice the character of the aesthetic concepts Sibley's description picks out. He has in mind concepts such as the following: unified, balanced, integrated, lifeless, serene, sombre, dynamic, powerful, vivid, delicate, moving, trite, sentimental, tragic, handsome, comely, garish, lovely, pretty, beautiful,

dainty, graceful, and elegant. Though this vocabulary is presented as if it is the natural vocabulary to use when encountering a work of art, it is in fact exclusive of other legitimate discourses on art. None of the concepts listed above deal with, for example, the possible moral, religious, or political content of a work of art, or with the various ways in which it may affect different recipients. The concepts listed are derived from formalist art criticism. They are based on the dual ideas that art should be appreciated for its own sake, and that this appreciation requires a certain sensitivity not everyone can acquire.

Weitz and Sibley suggest describing an existing conceptual practice. Any discourse, however, excludes or creates an other, that which is outside the discourse and against which the object of the discourse tacitly or explicitly must define itself. This cannot be avoided. What should be avoided as far as possible is to present this exclusion as grounded in the order of Nature. When this happens, description easily become prescription, and the result of the description is an acceptance and reinforcement of prevailing prejudices.

"Prejudice" should here be taken in the sense that Gadamer gives the term (*Vorurteil*): it does not mean that the judgment is false or groundless, but that it is made without awareness of its own embeddedness within a particular historical tradition or practice (Gadamer 1987, 137). As Richard Shusterman points out, analytic aesthetics was considered a "second-order discipline" meant to bring clarification and conceptual rigor to existing discourses about art, particularly art criticism. This seemed appropriate at a time when art criticism was dominated by similar aspirations, and New Criticism was relatively undisputed in literary theory. But it has become clear that criticism is actually characterized by a plurality of contested practices (Shusterman 1989, 7, 14; 1992, chap. 1). Rather than describe, the philosopher must examine the basis for existing practices.

The search characteristic of traditional aesthetics was primarily motivated by a desire to discover or create some uniformity in variety. It was prompted by the manifold forms of contemporary art and the historical development of art, by a desire to bring to light the conception of art "implicit in the behaviour and conventions of the artworld" (Osborne 1981, 5). But it is clear that essentialism is unable to provide us with such an understanding. My discussion of Weitz and Sibley shows that early attempts to replace traditional aesthetics also lead to a simplified view of artistic practices. We must, it would seem, try to develop a theory which confronts the complex practical contexts of art more directly.

Art and Practice

The emphasis on practice redirects the investigation of the nature of art away from the focus on certain types of objects towards the forms of human activity wherein something becomes art. Art can then be seen as a form of cultural practice

as for example Noël Carroll (1988, 1994) does. The cultural practices of art, though based on custom and tradition, evolve historically.

We can (and typically do) have a conception of art through participation in the activities characteristic of this form of practice, but without being able to articulate the concept or concepts of art which sustains this practice. We can master procedures, acquire skills, participate in activities, and so on, simply by imitating what other people do. Imitation is an important form of human learning through which we acquire much of our "know how." Knowledge, as Gilbert Ryle insisted, is not just "knowing that," but also "knowing how" (Ryle 1960, chap. 2). A given practice can be described as possessing regularities, as being in accordance with rules. One such example is our linguistic practices which can be described as conforming to grammatical principles. But this does not mean that the child who learns to speak actually has any knowledge of these rules. The child learns by repetition and by extension of standard cases and gradually come to perform in accordance with the established practice. Describing a state of affairs as in accordance with specifiable rules or as possessing specifiable regularities should not be confused with giving an explanation of the causal mechanisms that creates the activity (Erneling 1993, 60; Dreyfus and Dreyfus 1987; Allen 1994). A rule may *fit* a certain set of observed phenomena, but it need not serve as a *guide* for the phenomena observed (Bourdieu 1990, 39–40). The ability to imitate, to perform actions, to learn *how* to do things without resorting to the application of a rule is also an important point in Wittgenstein's discussion of rule-following. Rules have to be accompanied by practices since there cannot be rules for following all rules. Justification and explanation come to an end, and I just do something.

Alaisdair MacIntyre points out that it is impossible to become a participant in a practice without obeying the rules regulating the existing practice, and thus, at least for a time, suspend one's own judgment. "A practice involves standards of excellence and obedience to rules as well as the achievement of goods. To enter into a practice is to accept the authority of those standards and the inadequacy of my own performance as judged by them. It is to subject my own attitudes, choices, preferences and tastes to the standards which currently and partially define the practice" (MacIntyre 1984, 190).

We can call the knowledge which finds expression in the ability to competently participate in artistic practices a *concrete conception of art*, while the articulated theoretical conception of art is an *abstract conception of art*. To understand abstract conceptions of art expressed in, for example, philosophies of art it is therefore necessary to understand the concrete conception of art they are meant to articulate.

Recently Shusterman has criticized attempts to understand art as a cultural practice. The problems with the approach, according to Shusterman, is much the same as the problem I pointed to in discussing Sibley and Weitz. The practice-approach usually relies on the reasons and standards given within an artistic practice for granting something the status of art (Shusterman 1992, 43). It typically gives a

sociohistorical account of a given practice based on these internal principles. Shusterman agrees with substantial parts of it, but justifiably thinks the approach runs the danger of becoming mere description. "[A]ll substantive decisions as to what counts *as* art or *in* art are left to the internal decisions of the practice as recorded by art history. Philosophy of art simply collapses into art history" (1992, 44). The practice approach thus, according to Shusterman, severely limits the possibility of critical interventions into received opinions about the nature and purpose of art. The philosopher cannot have "an activist role in rethinking and reshaping art" (45).

It is true that the practice-philosopher cannot avoid or solve the philosophical problem of the nature of art simply by looking over the art-historian's or critic's shoulder and taking notes. Historians of art have not reached universal agreement among themselves about how to construct art-historical narratives, and they may be blind to forces external to their discipline which influence what will eventually be included in a historical narrative of art. Since not everything can or should be told in such narratives, the historian consciously or unconsciously makes philosophically motivated choices in constructing a given narrative. The philosopher is bound to do the same, and, as little as the art historian, cannot simply account for the historical development of the practice of art by enumerating the historical facts. The philosopher should examine the conscious and unconscious factors motivating the inclusion of some works and the exclusion of others. The historical examination of the practice of art (if it goes beyond the history recorded in the historiography of art) might show (for example) how this practice has excluded or marginalized activities that were initially seen as closely allied with fine arts. The philosopher would then go further than a mere description of an existing practice, to a critical evaluation of it. Shusterman's own account of the fate of popular art seems to me to be of such a nature (Shusterman 1992, chaps. 7–8). This is no doubt a much less smooth account of the development of artistic practices than the one for example Carroll (one of the targets of Shusterman's criticism) or, as I argue below, Tilghman has in mind. Carroll and Tilghman seem to envision the history of art as a fairly harmonious, unified, and coherent tradition, while the account I allude to sees the history of art (and the associated philosophical discussions about the nature of the concept of art) as an arena of conflict.

Wittgenstein, Cézanne, and Fry

The emphasis on practice is a central feature of Tilghman's understanding of Wittgenstein, and of his approach to the philosophy of art. Tilghman views art as a form of practice, or a set of practices, and strives for a close connection between the analytical endeavor and these practices (Tilghman 1984; future references are to this work unless otherwise indicated). We learn, Tilghman says, to master the concept 'art' not by description and explanation, but by being placed in situations

where we *do* certain things: listen to music, have poems read to us, watch movies or plays, and the like. Because we think of activities such as reading poetry, looking at pictures and listening to music as connected in our social practices, we can talk about a family resemblance, and group the different arts under the general name of art. Wittgenstein, according to Tilghman, "does not use the family resemblance model as a criterion for identifying individuals as members of a class, or as a rule for 'extending' a concept to cover new cases; it plays no kind of a justificatory role in his thinking. It belongs, rather, to *a description of language as it is; it belongs to an account of what may be called the natural history of language*" (45; my italics). There is, therefore, no point in expecting one general answer to the question "What is the meaning of 'art'?" The meaning of a concept or a statement must always be investigated in the specific context in which it is used and within which alone it has meaning.

Tilghman's emphasis on practice in conjunction with his interpretation of "family resemblance" enables him to add a historical or developmental dimension to his theory. I will focus on this aspect in the following discussion.

An alternative theory of how the concept of art develops emerges through Tilghman's discussion (in chap. 4) of the following example: In 1910 an exhibition entitled "Manet and the Post-Impressionists" was held at the Grafton Gallery in London. For the first time, an English audience was exposed to a large collection of the works of those painters who were to be known as the Post-Impressionists. Besides Manet, pictures by Van Gogh, Cézanne, Matisse, Picasso, and many others were shown. Cézanne, Van Gogh, and Gauguin were particularly well represented. The far-reaching consequences of this exhibit are perhaps difficult to fully understand today. It became a focus for a clash of fundamentally different views of art and culture. Virginia Woolf alluded to this event when she said that "in or about 1910 human nature changed" (Scott 1992, 97). To her and to Fry (and their fellow Bloomsburians) the work of these painters were a revelation. But the critical establishment, as well as a great number of the audience, were appalled. Since the Post-Impressionists did not use the traditional representational techniques in any immediately recognizable fashion, their work could not be considered art at all.

Roger Fry—the organizer of the exhibition—defended the Post-Impressionists by making a comparison with developments in the Italian Renaissance. We will still be able to appreciate Giotto's paintings and see them as having an independent value in their form and expression, Fry argued, if we do not regard them as crude forerunners of Leonardo's and Michelangelo's masterpieces. It is, similarly, impossible to understand or appreciate Cézanne's pictures if they are considered as attempts to do the same as nineteenth-century academic paintings. Rather, we should look at them as we would look at Giotto's pictures, that is, by focussing on their formal features. We will then realize that Cézanne's pictures too have an independent value. Fry, according to Tilghman, shows us "how to look at Cézanne so that we will see his value for ourselves. He helps us to do this by pointing out likenesses between his work and aspects of the artistic tradition with which we are

already familiar despite those aspects having been neglected in the then prevalent view of art history" (75). Fry himself said that "the group of painters whose work is on view at the Grafton Gallery are in reality the most traditional of any recent group of artists" (Fry 1910a, 331). Fry, in other words, defended the Post-Impressionists by arguing that their work is part and parcel of the art-historical tradition, though it might not initially appear that way.

Tilghman has apparently opened the door to an understanding of what we could call "conceptual change" in art-historical, as well as in more ordinary, discourse about art. But in fact he does not fully exploit the potential in his criticism of traditional aesthetics. Because his approach is descriptive, Tilghman remains, so to speak, at the level of appearances. As a consequence, he tacitly accepts a formalist approach to art works, which enters with his acceptance of Fry's theories, and which in turn blocks the understanding of conceptual change.

Tilghman's reliance on Fry creates two problems:

1. There is an incompatibility between an essentialism drawn from Fry's formalist theories of art and an approach which is otherwise anti-essentialist.
2. When Tilghman takes his theory a step further, this essentialism leads to problems connected with the conception of art-historical development, to which I will turn shortly.

In his theoretical essays about aesthetics Fry advances the view that our experiences in confronting works of art are of a nature sufficiently different from all other kinds of experience to warrant talk about a special "aesthetic experience." We find this experience in relation to all types of art—not just paintings, but also architecture, drama, poetry and music. If we compare our reactions to a number of artworks, we find, according to Fry, "that *in all cases* our reaction to works of art is a reaction to a relation and not to sensations or objects or persons or events. This, if I am right, affords *a distinguishing mark* of what I call esthetic experiences, esthetic reactions, or esthetic states of mind" (Fry 1926, 3 [my italics]).

There exists "a special orientation of the consciousness," "a special focusing of the attention" (1926, 5; see also 1929, 242), which Fry calls "disinterested contemplation" (for example, 1929, 29). He assumes that the possibility of the aesthetic experience rests on the existence of a certain quality found in all works of art. In "Retrospect," Fry uses Clive Bell's term "significant form" for the quality (1929, 284–302), while for example in "Transformations—Some Questions in Esthetics" he talks about "plastic qualities" as opposed to psychological and literary. The plastic qualities are the distinctive aesthetic qualities, the essence of art. For the present purposes, we do not have to worry about what, more specifically, these plastic qualities may be.

The remarks made so far are only meant to establish that Fry's method and approach to aesthetics—as well as Clive Bell's—is that of traditional aesthetics and essentialism. I now turn to the consequences this has for Tilghman's understanding

of art-historical development. How one views art in its historical development naturally influences one's view of the development of the concept of art.

Tilghman interprets Fry's arguments in defence of Cézanne and the Post-Impressionists as "in essence a rejection of the view of art history associated with Vasari that understands Giotto as doing in a crude and clumsy beginner's way what Leonardo, Michelangelo, and Titian did superbly well" (75). Instead, as we saw, Fry pointed to *formal values* common to Giotto and Cézanne. An alternative view of the history of art must therefore emerge from Tilghman's analysis of Fry's approach.

According to Tilghman, changes in art history, as in the case with the Post-Impressionists, are only apparent novelties. Actually, a new form of painting is only accentuating hitherto neglected aspects of the already existing tradition, though this may not be immediately obvious. The tradition can be "modified and enlarged," but there is no real break (77–78). Such modifications also create new patterns of reception and new ways of looking at the history of art leading up to them. By comparing Cézanne with Giotto we get a new way of looking at Cézanne, but it also makes it possible to take a fresh look at Giotto (76–77).

If all concepts must be understood on the basis of their place and function within human practices—a view any Wittgensteinian philosopher must be committed to—this was as true in fourteenth-century Italy as it is today. But in the world of Giotto and his contemporaries the concept of art was significantly different from ours, if we consider both in their context of artistic and other practices (see, for example, Baxandall 1972; Warnke 1993). How, then, can Giotto be said to be part of the same artistic tradition as Cézanne? For the essentialist the answer is easy: what Giotto made was art, as was what Cézanne made, because their work share that essential quality which makes something art. But for those who, like Tilghman, do not want to subscribe to essentialism, there is no simple answer to the question.

Much art history does not reach more than a basis for a reconstruction of the historical development of art—it explains developments to the extent that changes in fashion are seen as expressing changing tastes. Past events are interpreted in the light of contemporary concepts. (For a fuller discussion of what I mean by "reconstruction of the historical development," and what the alternative to it is, see below, chapter 5.) Tilghman's interpretation of the events surrounding the exhibition in England in 1910 is to some extent based on Ian Dunlop's work, and Dunlop does in fact see conflicting tastes as a major reason for the events surrounding the exhibition (Dunlop 1972, 127, 146). But if we consider the events in a wider historical context it becomes clear that more than conflicting pictorial tastes were at stake.

Art in Context

The years leading up to the First World War were times of intense political conflicts in Britain, which had lost its position as the world's leading industrial

power and was facing severe economic and political problems. The labor movement was growing, and in 1906 the Labour party was for the first time represented in Parliament. The election in 1906 was also the first the Conservatives had lost in twenty years, and it led to the formation of a Liberal government. In retrospect, the death of Queen Victoria in 1901 assumes symbolic proportions. In the words of Leonard Woolf:

> When in the grim, grey, rainy January days of 1901 Queen Victoria lay dying, we [Woolf's generation at Cambridge] already felt that we were living in an era of incipient revolt and that we ourselves were mortally involved in this revolt against a social system and code of conduct and morality which, for convenience sake, may be referred to as bourgeois Victorianism. (Woolf 1975, 106)

Roger Fry was older than Leonard Woolf (born in 1866 and 1880, respectively), but both were associated with the Bloomsbury Group, which "grew up in London during the years 1907 to 1914. . . . Bloomsbury grew directly out of Cambridge; it consisted of a number of intimate friends who had been at Trinity and King's and were now working in London, most of them living in Bloomsbury" (Woolf 1975, 108).

When we know of the political and economic decline of the established powers in Britain, and combine it with the knowledge that Fry was, at the time of the first Post-Impressionist exhibition, a well known scholar of early Renaissance art, the outcry the exhibition created and the hostility towards Fry assumes another dimension: Fry was seen as taking sides for the forces of moral decadence undermining society.

Those who attacked the Post-Impressionists, as well as those who defended them, saw in the discussion more than aesthetic issues: it was a moral, political and ideological question. A letter from Robert Morley in *The Nation* (3 December 1910, p. 406) attacking the Post-Impressionists illustrates the moral and ideological component in the discussion:

> If English art is not to be dragged through the mud, if we are to uphold the great traditions of the past—not blindly, but accepting all that is good, all that is true, all that has behind it a high ideal wrought with the infinite labour of love, such exhibitions as these must cease, for disease and pestilence are apt to spread.

Fry realized that the work of the art historian and the critic had far ranging political implications, and that these surfaced in particular in connection with the introduction of Post-Impressionism into England. In "Retrospect" from 1920 Fry said about the events:

I found among the cultured who had hitherto been my most eager listeners the most inveterate and exasperated enemies of the new movement. The accusation of anarchism was constantly made. . . . I now see that my crime had been to strike at the vested emotional interests. These people felt instinctively that their special culture was one of their special assets. That to be able to speak glibly of Tang and Ming, of Amico di Sandro and Baldovinetti, gave them a social standing and a distinctive cachet. . . . It was felt that one could only appreciate Amico di Sandro when one had acquired a certain considerable mass of erudition and given a great deal of time and attention, but to admire a Matisse required only a certain sensibility. One could feel fairly sure that one's maid could not rival one in the former case, but might by a mere haphazard gift of Providence surpass one in the second. So that the accusation of revolutionary anarchism was due to a social rather than an aesthetic prejudice. (Fry 1929, 290–91)

For some, the Post-Impressionists were "the uncorrupted idealists, searching after reality, uninfluenced by their contemporary (mechanistic) world," according to one historian of the period (Falkenheim 1980, 17). Where the defenders of Post-Impressionism saw sincerity and idealism, its opponents saw childishness and ineptitude—if not downright madness. Fry thought it regrettable that art, instead of being appreciated for its *own sake*, had become a form of social adornment and he found the art which had the approval of the Royal Academy inferior and commercial. The producers of this official art were often living in comfort, while artists who were, in Fry's view, far superior had difficulties making ends meet (see, for example, Fry 1929, 55–78; 1926, 44–55; 1910b, 536–37).

These events illustrate how the question about the nature of art arises from the actual development of artistic practices. Questions about what art is and what it should and could be, about art for art's sake and significant form, arose under specific circumstances, and they were more than purely theoretical questions about (for example) ways of analyzing works of art. In the historical context the defense of the Post-Impressionists was an attack on bourgeois Victorianism, on the established order of society and on the cultural elite in that society, which, according to Fry, had seen a particular form of art as their special property. One's attitude to Post-Impressionism became an ideological and political question. The debate about the Post-Impressionists can only be fully understood if we take into account the entire complex of events.

Today the works of the Post-Impressionists are considered masterpieces. But this acceptance did not come about merely because everyone gradually conceded the strength of Fry's arguments. This played a role too, but of greater importance is the fact that those segments of society who saw in the Post-Impressionists

a threat to the established order lost ground for other reasons. They became socially and historically obsolete and thus lost their voices. Social experiences changed, and along with it ideas of what acceptable art is. Whatever the case may be, the story is not confined to the development of critical and theoretical arguments.

Let me draw out some conclusions from this part of our examination. In spite of his attempt to do so, Tilghman does not really bring art back from philosophical theory to our actual dealings with art in galleries and elsewhere. His reliance on Fry's conception of the history of art leads to a reconstructive view of the history of art, and consequently to essentialism on the conceptual level. In spite of appearances to the contrary, Tilghman's approach is basically ahistorical.

My account of the events in 1910, however brief, is meant to suggests how an alternative to the reconstructive view of the development of the concept 'art' would look. This difference will become clearer in the following two chapters. The guiding ideas for this alternative is that changes in the concept 'art' represent renewed attempts to come to grips with the development of artistic practices within a web of other practices. Our present ideas of art, as well as earlier conceptions of art, develop as part of artistic and other practices; they grew out of the historical diversity of conflicting practices and ideas. To understand these changing conceptions of art in a historical perspective they must be "reinstated" in the historical processes they were a part of; that is, they must be understood against the background of that larger historical context to which they belonged.

Philosophers make, in Nelson Goodman's phrase, new worlds no less dispensable (though often less conspicuous) than the worlds created in science. These new worlds are not created by an individual fiat, but worked out within a complicated network of old and new beliefs, theories, and practices. Art is made when a world of discourse is present to make it possible. The task of philosophy must then be to examine the establishment and development of forms of discourse, the creation of worlds which make, in this case, art possible. The question to be answered is then how worlds are made. And the answer must take the form of an account of the conditions under which worlds are made, and of the means whereby they are made. Rather than general, philosophical theories (with their emphasis on definitions and universality), we must develop a form of historical narratives. The nature of these narratives will be the subject of the following chapters.

Art as
History and Theory

Traditional aesthetics is widely recognized as unsatisfactory, but the main contender for an alternative, some form of Wittgensteinian philosophy, has not been able to overcome the difficulties confronting traditional aesthetics. I suggested a historical approach to a philosophical problem as an alternative to both.

Before this alternative can be developed in more detail, it is necessary to consider a few recent, historically oriented contributions to the philosophy of art: Jerrold Levinson's and A. C. Danto's.

Danto's philosophy of art is widely considered a promising candidate for an historicist approach to aesthetics. Danto emphasizes the close connection between artistic practice and philosophical conceptions of the nature of art, but assumes that art prior to about 1900 can be understood in terms of a progressing ability to correctly represent reality. For this and other reasons Danto's approach is also unable to provide us with the alternative sought for.

Refining and Defining Art Historically

Jerrold Levinson's definition of art is briefly the following: "an artwork is a thing (item, object, entity) that has been seriously intended for regard-as-work-of-art, i.e., regard in any *way preexisting artworks were correctly regarded*" (Levinson 1989, 21).

A number of aspects of this definition are problematic, and might be a potential target for criticism, for example the implied idea that there is one way of regarding works of art which is the correct one. Anita Silvers has provided a penetrating criticism of this point in Levinson's definition (Silvers 1993). Noël Carroll has argued that there are cases where regarding something as art was once regarded, for example as magic or as part of religious activities, does not turn it into a work of art. Some past ways of regarding works of art have become obsolete (Carroll 1994, 34–35). The criticism I advance suggests that Levinson's theory of art is actually ahistorical.

Levinson explicitly considers his definition of art a historical definition. It is historical because it connects present art with what has been correctly considered art in the past. In the past, some things have been established as works of art along with corresponding ways of correctly regarding them. For a thing to be considered art at the present, it must be possible to consider it in a way similar to the way in which past objects of art have been considered, and someone must intend the object for such regard.

It is probably clear that Levinson's theory is much less far ranging than the one I propose. Levinson wants to find "a minimal thread of continuity" between what once was and what now is art, but without appeal to "the social, political and economic structures that surround the making of art at different times" (1993, 411). Rather than focussing on broad patterns of social activity (as for example institutional theories of art do), he concentrates exclusively on "the *intention* of an *independent individual*" to make a work of art. The individual does this by referring (overtly or covertly) to the historical tradition of art, but art can in principle be private and isolated (1979, 232–33). The artist's intention is the connecting fibre in the historical tread of artistic activities, and it is at the same time what ensures that art is art. The essence or core of art is that intention which connects present with past art (see, e.g., 1993, 411–12).

Levinson's historicism is, in other words, a purely internal historicism, and he believes the intentional act can be executed and individuated without reference to the larger institutional and social fabric within which the concept of art exists. But intentions themselves are shaped within a historical and social room. Intentions to create works of art or to consider things in a manner normally deemed appropriate for something called works of art evolve as part of social, political, and cultural developments. Only when a vast array of other practices are in place does something obtain the status of work of art. The idea of the isolated individual forming intentions to create works of art is therefore an illusion. 'Art' does not belong to a private language but is part of a communal language and tied into the social conventions regulating this language.

While Levinson thinks that "the common thing going on [when someone makes a work of art] is the right sort of intentional connection to preceding art," Levinson also acknowledges that the conception of art has changed throughout history. In some cases there may not even be a general concept of art at all (1993, 411). If calling something art in 400 B.C.E. is radically different from calling something

art in 1994 C.E., how can intending to make a work of art be the same thing in the two cases? Did or could Homer, for example, really intend to make a work of art, and, if he did, how do we know?

Levinson's answer to this is that "there is no real question whether they [works such as the Iliad] were created and projected with at least a good number of intentions that *we now view as paradigmatically artmaking*" (1993, 414; my italics). In other words, it does not necessarily have to be the creator of the work who intends the work as art, but we who at the present, quite anachronistically it seems, say that (1) Homer intended to make an oral narrative. (2) *We* (at the present) would consider oral narratives art. (3) Therefore, Homer, in intending to make an oral narrative, indirectly intended to make a work of art. This reasoning makes it clear that Levinson's historical definition of art is not really able to tell us anything about the various conceptions of art prevailing at different times, but merely about the possibilities of subsuming activities at different times and in different cultures under the currently prevailing notion of art. Levinson does say that his "analysis is aimed just at capturing what the concept of art is at present— that is, what it *now* means for an object created *at any time* (past, present, or future) to count as art at that time, rather than what it meant at the time of the object's creation" (1979, 246).

But if the theory does not tell us anything about past conceptions of art, where is then the historical dimension of Levinson's theory? His historical definition of art amounts to a claim that it is possible to give an historical account of certain types of activities by creating links between these activities from the point of view of the present. At the time these activities took place they may not have been connected. It is possible retrospectively to link, for example, the kind of thing Homer did with what James Joyce did, or what Rembrandt did with what Andy Warhol did. Most likely, Joyce and Warhol saw their activities as part of a tradition which included Homer and Rembrandt respectively. This is in fact the way many general accounts of the history of literature and art are written. Rather than shedding light on the particular context in which works of art or literature were created, distributed, and consumed, they tell the story of a loosely connected series of object we now see as forming part of an historical development. Since we already have an abundance of histories of literature and art that do just that, histories of literature and art, that is, written with little regard for the actual social and theoretical contexts within which these activities took place, a philosophical theory which only shows us that this is a possibility seems of little use.

Real and Unreal Things

Danto has arguably become one of the most influential contemporary philosophers of art, and, since the publication of *The Transfiguration of the Commonplace* in

1981, also an influential art critic. Danto's philosophy of art is of particular interest to the discussion in this work because of his emphasis on an historical dimension in the understanding of art.

The major problem in contemporary philosophy of art is, according to Danto, posed by works of art such as Duchamp's and Warhol's. The troublesome nature of these objects is, Danto thinks, that they are in all respects like ordinary objects which we might find in hardware stores or supermarkets: urinals, bottle racks, Brillo boxes, and whatever else. While, on the one hand, these objects are in all respects mundane, and purposely so, they are, on the other hand, very different from ordinary things because they are works of art. The nature of this difference is the most important problem for the philosophy of art:

> In view of the fact that any work of art you choose can be imagined matched by a perceptually congruent counterpart which, though not a work of art, cannot be told apart from the artwork by perceptual differentia, *the major problem in the philosophy of art consists in identifying what the difference then consists in between works of art and mere things.* (Danto 1986, 63–64; my italics)

The major purpose of *The Transfiguration of the Commonplace* (1981) was to resolve this problem. The explanation of the apparent paradox is not, as Dickie would suggest, to be found in the institutional setting of art, but in an ontological difference: "We are dealing with an altogether different order of things" (Danto 1981, 99). The world consists of different "ontological spaces" (Danto 1981, 17) or planes (21, see also 42, 43, 83, 99). In one of those spaces, that of real things, the world just is as it appears to our senses, or as it is described by science. Objects are projected onto our retina, and can be described. With the assistance of our five senses we can enumerate whatever qualities objects have, without recourse to theory and interpretation. When scientific theories have changed this only implies a new interpretation of the preexisting facts. The believer in the Ptolemaic model of the universe has a picture on the retina identical to that found on the retina of a follower of the Copernican model of the universe. In the world of artworks the interpretation *constitutes* something as a work of art. Interpretation lifts "an object out of the real world and into the artworld" (1986, 39). But "no knowledge of an object can make it look different, . . . an object retains its sensory qualities unchanged however it is classed and whatever it may be called. . . . [O]ne's sensory experiences would not be expected to undergo alteration with changes in the description of the object (Danto 1981, 98–99).

Danto introduces a particular "is" of artistic identification, similar to magical or mythical identification (Danto 1981, 126), and he emphasizes theory and history, rather than the existence of an artworld, as that which makes art possible:

> To see something as art demands nothing less than this, an
> atmosphere of artistic theory, a knowledge of the history of
> art. Art is the kind of thing that depends for its existence upon
> theories; without theories of art, black paint *is* just black paint
> and nothing more. (Danto 1981, 135)

It is a characteristic feature of works of art that they cannot be understood without some knowledge of "where in the historical order [they] originated" (1986, xi; cf. p. 51). When Danto talks about history he primarily means the history of art, but he is aware that factors external to the history of art are important, though he has little to say about them.

From time to time, Danto appears to allow for the possibility that science, too, depends on theories and interpretations, but his general presupposition is that the world of real objects, the one dealt with by scientists, differs from the world of art: "One may be a realist about objects and an idealist about artworks; this is the germ of truth in saying without the artworld there is no art" (Danto 1981, 125). Danto's divided world can be schematized in the following manner (page references to Danto 1981):

The World of the Realist	The World of the Idealist
Real things, objects (passim)	Works of art (passim)
Movements (4, 48, 100)	Actions (ibid.)
Reality (83)	Language (83)
The five senses—sensory qualities (98–99)	The aesthetic sense (98–99)
Body Nervous system	Mind (104) Personality, character (160)

Danto's understanding of science is, then, based on a relatively straightforward scientific realism and much of his understanding of art and aesthetics is developed in contrast to this realism in the sciences. The aesthetic puzzles emerge because in the area of art we have a realm that does not confirm to the realistic picture of the world science supposedly provides us with.

Danto's entire theoretical construction runs contrary to a large, and growing, body of literature in the philosophy of science which has shown that it is, in fact, not possible to separate theory from fact in scientific explanations. What counts as a fact (or an objective quality) is partly determined by a concomitant piece of theory. Furthermore, many of the entities dealt with by scientists are only understandable

within a large body of theory which scientists internalize through years of training: genes, cells, quarks, electrons, fields, and forces are not the kinds of things normally and straightforwardly open to sensory inspection. If works of art possess qualities which are "logically hidden from the senses" (1986, 26), the same can certainly be said for many qualities of "mere real things." Danto correctly points out that if Duchamp's bottle rack was placed alongside other such bottle racks in a warehouse or in a wine cellar, it would be indistinguishable from the "mere real things." But to conclude from this that there must be a separate ontological realm is unwarranted and unnecessary. What it shows is that we classify things on the basis of the context in which they appear, and based on our previous experience. (It is beyond the scope of this work to go into a discussion of perception and representation. Serious doubt is, in my view, thrown on Danto's position by the evidence and arguments presented in, for example, Bourdieu 1993, chapter 8; Bryson 1983; Goodman 1968, 1978, 1984; Toulmin 1972, 1983; Wartofsky 1979.)

Philosophy, Representation and the History of Art

Danto views the history of pictorial representation as, in part, a history of how inference has been replaced by direct perception. The history of art until the beginning of this century can be seen as an attempt to create increasingly convincing representations of the world, or "equivalences to perceptual experiences" (Danto 1986, 99—future references are to this work unless otherwise indicated). In the early twentieth century, cinematography developed techniques of representation with which artists could no longer compete. Whereas a painter or a sculptor can produce a representation from which we can *infer* that, say, someone is moving, it is now possible to actually *show* movement, or create a perceptual equivalent to the perception of actual movement. The function of art changes. Painters and sculptors no longer see it as their task to produce "equivalences to perceptual experiences":

> [P]ainters and sculptors could only justify their activities by redefining art in ways which had to be shocking indeed to those who continued to judge painting and sculpture by the criteria of the progressive paradigm, not realizing that a transformation in technology now made practices appropriate to those criteria more and more archaic. (99–100)

From the late nineteenth and early twentieth centuries the representational view of the arts consequently disappears. The increasingly short-lived art movements char-

acteristic of the twentieth century all asked the question "What is Art?" and tried to provide an answer to it: "it began to seem as though the whole main point of art in our century was to pursue the question of its own identity while rejecting all available answers as insufficiently general" (110).

Through this process art becomes increasingly dependent on theory—it requires theory to be understood. Simultaneously the art object approaches zero. Art has in effect become philosophy, and can now be taken over by philosophers, or the artists in effect become philosophers. Art has come to the stage where it is known what art is (111): "art sought to merge with its own philosophy, seeing its task to be primarily that of providing an account of its essence which it began to think was defined by providing just such an account" (125).

The essence of art, at least in the twentieth century, has been to account for its own essence! Now that we know this, there is no reason to continue the search for the nature of art, and the search can no longer serve as an organizing principle for artistic activity and the history of art. Rather than a particular historical development we get a proliferation of different forms of art. The age of postmodern pluralism is upon us, and this pluralism means the end of art, though not in the sense that people will stop making works of art (114–15, 208). Undoubtedly, they will continue to do so, but their activity no longer has any real historical significance: "whatever comes next will not matter because the concept of art is internally exhausted" (84).

To summarize: until around 1900 art was oriented towards the goal of creating perceptual equivalences. From the beginning of the twentieth century this task can be carried out much better by moving pictures. Art becomes philosophical. It begins to ask questions concerning its own nature. In due course it turns out that the nature of art, at least in this particular stage of its development, is to ask the question about the nature of art. Art then comes to an end *as an ordered development in stages*. Art has achieved self-consciousness and becomes philosophy.

Danto's account makes sense of part of the history of art in the twentieth century, but there are also significant parts of it which, it seems to me, cannot be understood only in terms of posing the question about the nature of art, for example the work of Diego Rivera, the Group of Seven, Judy Chicago, Hans Haacke, and most of Picasso's work. Danto, like Dickie, actually has in mind a limited aspect of the history of art: the trajectory leading from Duchamp to Abstract Expressionism, Minimalism, Conceptual Art, Pop Art, and beyond. Danto reproduces the conception of the history of art as exclusively regulated by factors internal to the history of art. The artist reacts to previous styles and conventions in the world of art, not influenced by political, economical or moral considerations. Similarly, we must understand the works only in these terms. When we look at a painting by Pollock or other works of the twentieth-century avant-garde, we must understand them as making a point narrowly confined to the artistic tradition and to their own existence as works of art. But, as Guilbaut's work indicates, this is not sufficient as an historical explanation of the rise of, say, abstract expressionism

(Guilbaut 1983). Danto's account underestimates the radical intentions which fuelled much avant-garde art in our century. Duchamp (for instance) was not just motivated by a desire for philosophical clarity, but sought to *undermine* prevailing notions of what art was supposed to be (Bürger 1984, 49). Barnett Newman saw his paintings as revolutionary acts (see Anderson-Reece 1993). The artists thought they already knew at least in part what art was—and they didn't much like it.

The revolutionary success of modern art has been minimal. On the contrary, as Novitz points out, art in the twentieth century has become more and more esoteric, and has thus retained its function as being the property of an elite (Novitz 1992, 183). At least part of the explanation for this is that much art is so difficult to understand. In Danto's words, it does indeed to a high degree presuppose "an atmosphere of artistic theory, a knowledge of the history of art." But the general failure of attempts to undermine the dominant conception of art is also testimony to the ingenuity of philosophers such as Dickie and Danto in incorporating new forms of art into the existing conception of art.

Danto's conception of the history of art up to 1900 relies on the assumption that the history can be organized as a history of progression in the representation of reality. Danto bases part of his case on Gombrich. It is correct, as Danto points out, that Gombrich considers linear perspective an objectively better representation of space on a two dimensional surface. But the entire purpose of Gombrich's *Art and Illusion*, which Danto repeatedly refers to, is to reject the idea that the history of art can be construed in terms of the creation of better and better "likenesses." It is, furthermore, difficult to imagine anyone more opposed to the kind of teleological history that Danto outlines than Gombrich. In his anti-historicism, as in much else, Gombrich is a declared disciple of Karl Popper (see, for example, Gombrich 1979a, 1979b). Even if we granted that the history of art could be constructed in terms of progressing abilities to represent reality, this would be an extremely impoverished version of the history of art. The function, meaning, and significance of art cannot be reduced to or derived from its quality as a representation.

Fry, Sibley, Danto, Levinson, and other philosophers who claim that we require special sensibilities or special perceptive abilities to see art, point, no doubt, to actual experiences. Some change in point of view, an ability to sees something *as* something, is needed to suddenly see a Brillo box as a work of art rather than as an ordinary piece of merchandise in a store. To the philosophers, this ability appears as a faculty which some people for reasons unknown have, and others do not, as something which requires us, if only momentarily, to become idealists, or to assume that art has a special ontological nature. Danto is close to something important when he ascribes it to history, theory, and the existence of an artworld. His work points to the shifting historical nature of conceptions of art, and to how these conceptions of art are related to the development of artistic activity. The reasons *are* historical and depend on the existence of an artworld, and are, I believe, to be found in the existence of a historically shaped *habitus*, in the sense Pierre Bourdieu uses this term. If we approach it from this angle there is no need to become idealists.

The concept of *habitus* is similar to the practical conception of art discussed above (chapter 2). Bourdieu defines *habitus* as a system "of durable, transposable dispositions, structured structures predisposed to function as structuring structures, that is, as principles which generate and organize practices and representations that can be objectively adapted to their outcomes without presupposing a conscious aiming at ends or an express mastery of the operations necessary in order to attain them" (1990, 53). *Habitus* is defining of entire cultures, but also of more limited practices within a culture, for example scientific and artistic practice. *Habitus* in effect represents the principles within which an individual is conditioned or socialized to perform according to the principles acceptable to a given culture or a class. The principles are developed through the history of the culture and *habitus* therefore "ensures the active presence of past experience" (Bourdieu 1990, 54). We expect members of our culture to act according to specific principles, and because we all follow them the *habitus* also makes behavior predictable. The principles or rules defining a *habitus* are unconscious and unstated and appear as mere nature, they represent how a given culture simply does certain things. *Habitus* is an immanent law "inscribed in bodies by identical histories" (59). "The *habitus*—embodied history, internalized as a second nature and so forgotten as history—is the active presence of the whole past of which it is the product" (56).

Habitus also establishes patterns of representation and perception, it lends patterns of behavior and evaluation unity and consistency and makes them predictable and intelligible within a class or a group. The *habitus* makes aesthetic judgments conform to standards and make them appear as if they have a ground beyond time and space. The educational system plays a particularly important role in this area as creator of competent consumers for the aesthetic products and by establishing a set of classificatory schema (Lash 1993, 196). It seems, then, that in order to solve Danto's aesthetic puzzles, we must examine the history which shaped an artistic *habitus* which today seems so obvious that it appears as an ontological divide.

The Histories of
Philosophy

M any philosophers now believe that it is an inherent feature of most philosophical problems that they require a historical or genetic approach. It would however be a self-destructive course to think that, by becoming historians rather than philosophers, we could avoid philosophy altogether. The historicist alternative cannot simply replace philosophical argumentation by history. Philosophy without history is blind, but history without philosophy is empty. The historicist alternative can however point to the historically shifting framework, the contingencies of history, within which philosophical argumentation—in the absence of any universal canon of rationality—always takes place.

In most contemporary philosophy in the British and North American tradition (analytic philosophy) history and philosophy are seen as sharply separated. The uneasy relationship between history and philosophy is analogous to the controversy between science and history, which, as Putnam has pointed out, has been a central feature of philosophy throughout the nineteenth and twentieth centuries (Putnam 1983b, 288). The result of post-positivist conceptions of science is the view that there is, we might say, an inescapable element of interpretation in all science.

The analytic philosopher has typically taken the side of science in the controversy. To distinguish the view of the analytic philosopher from the historicist view, I will call the former the 'scientistic' view or conception of philosophy. The problems with the scientistic view are, by now, well known. I defend a historicist view by reviewing the criticism of the scientistic view, and then (in chapter 5) explain in more detail what a historicist account must amount to.

Rationality and the Scientistic
Conception of Philosophy

A major reason for rejecting an historical or genetic approach to philosophical problems is that it is thought to be unnecessary. Why should it not be possible to approach philosophical problems in a manner similar to the way in which scientists approach their problems, that is, without worrying about their history? (For the sake of argument, I assume that scientists do not have to worry about the history of their disciplines.)

In a recent essay, Roy Mash has rejected the historicist approach, under appeal to, among others, the authority of Quine. Mash quotes from Quine's autobiography, *The Time of My Life*:

> Science and the history of science appeal to very different tempers. An advance in science resolves an obscurity, a tangle, a complexity, an inelegance, that the scientist then gratefully dismisses and forgets. The historian of science tries to recapture the very tangles, confusions, obscurities from which the scientist is so eager to free himself. (Mash 1987, 287)

According to the scientistic conception of philosophy, methodological principles and practical results of natural science, particularly mathematics and physics, should form the basis for philosophy. If the scientific method was adopted, a new foundation for philosophy would be created. In particular, Frege's and Russell's development of mathematics and logic were thought to make this possible.

The most overt form of scientism was positivism. With an optimism difficult to comprehend today, Russell could conclude his survey of the history of philosophy with the promise that modern analytical philosophy had finally brought us in a position to "achieve definite answers, which have the quality of science rather than of philosophy." This type of scientific philosophy would finally render the ancient problems of philosophy "completely soluble" (Russell 1946, 862; see also Russell 1952, 245–46). Philosophy had, said Reichenbach, finally "proceeded from speculation to science" (Reichenbach 1951, vii).

Science, conceived along positivist lines, became a canon of rationality that should be extended to other areas of inquiry. This philosophical development coincided with a tremendous growth in higher education in the years after World War II, and its attendant institutionalization and professionalization of intellectual disciplines (see Jacoby 1984, 1994). In colleges and universities, it became important to justify one's existence by arguing that one was not reading Milton or Locke or Kant just for one's own pleasure and edification, but because one was involved in a project no less serious or scientific than those producing more tangible results in the departments of physics or bio-chemistry. It is within the complex of events here

alluded to the scientific program for philosophy became scientism. Positivism probably has no defenders left, but some of the positivists' aspirations have been retained in later analytic philosophy (Rorty 1979, 315–16; 1982, 211–30; Putnam 1981, chap. 8; 1983a, chaps. 10–13). Analytic philosophers now characteristically see themselves as possessing special skills in analyzing the rigor and conceptual clarity of arguments, regardless of the area in which they have been advanced (Rorty 1982, 219; Putnam 1983a, 180). Philosophers should, if they followed this conception of analytic philosophy, proceed by piecemeal analysis and argumentation.

In the philosophy of art, historical and contextual approaches became discredited through wide acceptance of the so-called "intentional fallacy," and, more generally, the "genetic fallacy" (Shusterman 1992, 21–22). According to Arnold Isenberg, the analytic philosopher could contribute conceptual clarity and methodological rigor to the humanities. Philosophers of the analytic persuasion are in a much better position to do this than are those who actually practice the respective disciplines (Isenberg 1950).

As long as the philosopher knows the problem, she can, in principle, solve it without resorting to the history of philosophy. The development of analytical skills and tools in philosophy in this century has placed contemporary philosophers in a better position to do this than their predecessors. This point of view was expressed by W. K. Frankena in a critical review of Alasdair MacIntyre's *After Virtue*. About MacIntyre's historical analysis of emotivism Frankena says:

> Of course, I can know *that* an emotivist held a certain view
> only by a kind of historical (biographical) inquiry, and I can
> understand *how* he came to hold that view only by a kind of
> historical investigation (biographical or otherwise). But I can, *if*
> *I have the right conceptual equipment* [my italics], understand
> *what* the view is without seeing it as the result of a historical
> development; and, so far as I can see, I can also assess its status
> as true or false or rational to believe without seeing it as such an
> outcome. (Frankena 1983, 580; MacIntyre responds to the crit-
> icism in "Postscript to the Second Edition" [1984, 265])

The more modest form of scientism found in contemporary philosophy assumes that it is possible to evaluate the validity of arguments independently of any knowledge of their purpose and of the context in which they were advanced (see Hacking 1990, 346–47 regarding different forms of this attitude). All we need is "the right conceptual equipment," which is seen as a transhistorical standard of rationality. But this response begs the question since the existence of such standards is exactly what the historicist disputes: we do not have the right conceptual apparatus, and we cannot know what a position is without knowing of its historical context. Frankena, and those of a similar persuasion, still have to show us that there is such a thing as a conceptual apparatus applicable and valid regardless of time and space.

In the philosophy of science, criticism of positivism emerged in no small measure as a result of close scrutiny of the historical circumstances under which scientific theories and concepts changed. Historical evidence plays an important role in the criticism of positivism advanced by, for example, Kuhn, Toulmin, and Feyerabend. The changing nature of questions and answers is the core of Kuhn's concept of paradigm and the later developments of this concept. The prevailing paradigm or disciplinary matrix determines what constitutes a scientific problem, the orientation of the scientists' search, and what they and their scientific colleagues will accept as a solution to the problem. These disciplinary matrixes develop through history (see Kuhn 1970, 1974; Toulmin 1983, 101).

In periods of normal science, that is, when a particular view of science (a paradigm) is prevailing, testing and research have the character of puzzle solving. In this situation the underlying theory is not questioned, but phenomena are sought subsumed inside a range of explanations acceptable within the theory. When something seemingly inexplicable appears, this is not a cause for rejection of the theory. Newton's theory of gravitation was not rejected because the movements of the planets did not follow the course that this theory predicted. Instead, other areas are examined. Error may have crept in, some auxiliary phenomenon (for example the existence of an unknown planet) may not have been observed, and so on. Additional hypotheses are added or subtracted, to avoid rejection of the paradigmatic theory as a whole. The effort is to preserve the paradigm (*see* Putnam 1975). Paradigms also determine the kinds of questions that can legitimately be asked, that is, it concentrates efforts in areas that are likely to find their explanation within the framework of the paradigm. It is because of the changing nature of the questions which men and women throughout history have sought to answer, that it is necessary to look at the historical background and context in which a particular theory was advanced.

As indicated by Kuhn's early work and by much historical work since, science takes place inside a framework where political, social, religious, and philosophical beliefs cannot be separated from the scientific enterprise. The emergence of modern science in the seventeenth century was, for example, closely connected to religious developments (Protestantism and Puritanism) as well as to the profound economic and social changes taking place in England at the time.

From the disintegration of the positivist view of science and the scientific enterprise many have drawn the lesson that there is no way to distinguish false statements from true, that there is no such thing as a statement which does not rely on an idiosyncratic understanding of the world and that all statements are a matter of political, moral, or aesthetic preferences. This is, however, not the conclusion I wish to draw. This view is incapable of accounting for the instrumental success of science: science and technology have in fact allowed us to manipulate our natural environment, build machines, cure diseases, and so on. Any serious theory must account for this fact. But it is clear that the explanation of this success is much more complicated than had been assumed, and, in particular, it cannot be explained on the comfortable assumption that we are approaching the Truth about Nature.

The point, then, is not that we must choose between a God's eye point of view or a hopeless relativism, but that we must try to navigate a way between objectivism and relativism as it has been expressed by philosophers such as Hilary Putnam and Richard Bernstein (Bernstein 1985). We do not have to choose between an untenable scientific objectivism on the one hand, and an equally unpalatable subjectivist relativism on the other.

A conclusion which emerges from Putnam's work is that science does not constitute a canon of human rationality, and there is little reason to think that any can be constructed. But scientific practice does embody an evolving notion of what Putnam calls "cognitive virtues": "Rationality may not be defined by a 'canon' or set of principles, *but* we do have an evolving conception of the cognitive virtues to guide us" (Putnam 1981, 163). According to Putnam, an examination of what scientists and ordinary people actually consider rationally acceptable will reveal that the goal of science is to construct a representation of the world which is instrumentally efficacious, coherent, comprehensive, and functionally simple (Putnam 1981, 134).

We rely on these criteria because, Putnam suggests, they can provide us with representations which are "*part of our idea of human cognitive flourishing*, and hence part of our total human flourishing" (ibid.). It is important to understand that this does not mean that the process is "really irrational." This is what rationality is. It is not rationality in a transcendent sense of the term, but this is what human beings mean with rationality. Putnam also makes the point that the values are not subjective in the sense of being the preferences of individuals who cannot justify them. The values are as objective as we can reasonably expect them (or anything else) to be, which again does not mean "conforming to a transcendental measure," but that they are in accordance with our criteria of reasonableness.

With the rejection of the idea that it is possible to develop a canon of rationality (with science as the most promising candidate), an important objection to historical approaches in science and philosophy has been cleared away. Post-positivist developments in philosophy of science have shown that scientific theories must be understood against the background of specific forms of scientific practices. Theories are answers to questions posed for a particular reason. This is why it is not possible to understand *what* a view is without recovering which questions it was meant to answer. Or, to put it in other terms, the context of justification cannot be separated from the context of discovery. In later theoretical developments the specific background against which a problem or a set of problems was posed is often forgotten. A particular view obtains the status of a common assumption, or tacit knowledge which is no longer articulated. The task of the historical approach is to recover the background against which questions were asked and answered.

Implied, therefore, is an historical approach different from the still common view of the history of philosophy as a succession of differing answers to basically *the same* questions. We must see history as "a repository for more than anecdote or

chronology" (Kuhn 1970, 1). In addition to the disagreement about rationality we have, in other words, a disagreement about the proper approach to the history of philosophy.

It has, so far, been established that philosophy without history is blind, but, as mentioned in the introduction to this chapter, there is another side to the dialectical equation: history without philosophy is empty. I do not, in other words, wish what I have said so far to be understood to imply that history must take the place of philosophy, but rather I wish to point to a complex relationship between history and philosophy.

The historical examination of philosophical positions cannot take the form of description of "events as they really were." Historical narratives are informed by philosophical standpoints, prejudices (in Gadamer's sense), and theories, as fully as scientific enquiries. Otherwise, something like positivism *would* be true—and if positivism is the truth, any philosophy of it is false. Our understanding of history is as inescapably philosophical as our philosophy is historical. We can, however, as far as possible try to become aware of our prejudices and try to articulate the philosophical basis on which our historical account rests, to make what may be implicit as explicit as possible. In the next chapter, I try to make explicit the principles on which the historical part of this book rests.

Conceptions of History

The disagreement between the historicist and the adherent of the scientistic view is complicated by a submerged difference of opinion about the appropriate way to write the history of philosophy. This disagreement makes it necessary to specify the principles guiding a history of philosophy which can fulfil the promises of the historicist programme. I do this, in part, by elaborating on a distinction mentioned in chapter 2. There I introduced a distinction between a reconstruction of the history of philosophy and a theory of development, and illustrated it in relation to an episode in the history of the concept of art. The principles outlined in the present chapter will make the alternative to the traditional view of the history of philosophy more specific and sketch the approach which in the following chapters will be applied to outline the genesis of the modern conception of art. What I offer is not a model or a paradigm for the understanding of history or of historical texts. To do so would be of little use. History is interpretation of events and texts of the past, and, as all interpreters, historians must in the end rely on their imagination. Interpretation is an informal activity which involves "our imagination, our feelings—in short, our full sensibility" (Putnam 1990, 129). But the careful historian tries to narrow the gap that must be filled exclusively by the imagination.

Historical Reconstructions

A reconstruction of a historical process bases itself on present standards of and ideas about (for example) pictorial representation, scientific procedures, political institutions, and so on, and looks back through history to find likenesses and differences in relation to these standards. The historical account is written by including those theories that correspond to or which can be said to "anticipate" the current conception of what, for example, philosophy or philosophy of art is. As a result, the present standards appear as the inevitable end-product of a long chain of development, and historical predecessors are understood as immature or incomplete forms of the present. Historical reconstructions are therefore also typically teleological (for the distinction between 'reconstruction' and 'theory of development,' see Jensen 1981, 1983). Auguste Comte's (1798–1857) view of scientific development, according to which knowledge passes from a religious to a metaphysical and finally to a positive phase, would be an example of this understanding of history, as would Locke's view of Amerindian societies as less developed forms of European political formations (Tully 1993, 139, 141). The view of art history associated with Vasari, where earlier painters are seen as preparations for Leonardo and Michelangelo, would be another. Reconstructions are, as is perhaps evident, similar to what is sometimes called "Whig history," but the term "Whig history" is, as Ernst Mayr has pointed out, used in so many different connections, that its exact meaning has become uncertain (Mayr 1990).

A reconstructive history of aesthetic theory views the object of the discipline as something relatively unchanging, usually beauty (or the idea of beauty) or the fine arts. It is, consequently, not necessary to deal with the actual circumstances that gave rise to certain problems, such as the question about the nature of 'art'. This leads to anachronistic classifications of theories, and consequently to distortions.

On the basis of a reconstruction the history of aesthetics appears as a continuous chain of differing answers to the same question. Often theories of fine arts or beauty are attributed to, for example, Plato or Aristotle. This ignores the considerable difference in content and meaning between the Greek words *technē* and *kallos* and the modern English terms 'art' and 'beauty' usually chosen to translate them. That there is this difference is of course often acknowledged, but rather than give up the idea that there are perennial questions, the views of the predecessors of the current view are seen as suffering from "elusiveness" (Barasch 1985, 5), as "relatively ill defined" (Stolnitz 1961b, 189), or one finds that the development in the Middle Ages "obscur[es] the concept of the fine arts" (Barasch 1985, 46). When in due course the modern conception of art appears on the scene, this is taken as a long sought realization of something which has always been the case, though an adequate theoretical expression for it has never been found. In this spirit, Wladyslaw Tatarkiewicz, the author of one of the most extensive recent histories of aesthetics, says that

[t]he concept of the fine arts and their system seem to us simple
and natural, but the historian knows how late and with what
effort they were established. . . . From the mid-18th century on
there was no doubt left but that the handicrafts were handi-
crafts and not arts, and that the sciences were sciences and not
arts; thus only the fine arts were really arts. . . . Looking back at
the evolution of the concept of art, we will say that such an evo-
lution was natural, indeed inevitable. One may only wonder
that so many centuries were needed to bring the concept to its
present-day form. (Tatarkiewicz 1980, 21–22)

The division of the fine arts which became the commonly accepted one from
some time in the eighteenth century has, though no one realized it, actually always
been the correct one.

The organization of contemporary museums embodies this understanding
of art and aesthetics, as Paul Mattick, Jr. points out. Objects from widely dif-
ferent cultures and historical periods are displayed in the same museum and
categorized as art, regardless of the actual context in which they were produced
and the purposes for which they were initially intended (Mattick, Jr. 1993c,
7–9). But this conception of history only makes sense if it is assumed that the
essence of art has not changed, and therefore relies on an essentialist notion of
the concept 'art'.

George Dickie's discussion of the origin of the aesthetic in *Art and the Aes-
thetic* is another example of a reconstructive approach to the history of the phi-
losophy of art (Dickie 1974, chap. 2). Dickie considers, in particular, the
development of theories of taste in Britain in the eighteenth century. Shaftesbury
is generally recognized as one of the most influential early theoreticians of the
arts, and he greatly influenced, for example, Hutcheson. Though Dickie discusses
Hutcheson at some length, he does not want to examine Shaftesbury's philosophy.
Shaftesbury does not "fit in with the British philosophers he influenced" (1974, 59).
The problem, however, is actually that Shaftesbury does not fit into the category
("taste") chosen by Dickie to classify the British philosophers whom Shaftesbury
influenced. Dickie's choice of classificatory units forces him to disregard aspects of
the actual historical development.

The historical development does not follow the neat conceptual divisions we
(retrospectively) devise, but is a field of competing and clashing ideas and practices.
History, including intellectual history, is an arena of conflict. A reconstruction
does not distinguish between the units chosen for classification and the actual
units of historical development. In fact there may be considerable difference
between units of classification and units of development. To show that this dis-
tinction is possible and necessary, I wish to draw attention to how biologists con-
ceive of a similar distinction of great importance for their field.

Forms of Classification and Forms of Change

Evolutionary biologists distinguish between two different forms of species concepts: species taxon and species category (Mayr 1982, 253–54; 1988, pt. 6). Species taxon refers to the actually living groups of animals or plants, existing at a particular place at a particular time. Species categories are theoretical products, made by biologists, and are a matter of definition. This does not mean that the categories are arbitrary, but because there is no one defining trait (an essence or a substance) that determines inclusion or exclusion in a species, the taxonomist does choose to draw the line somewhere. There will always be actually living entities that do not fit into the categories chosen.

Species categories are units of classification, while species taxa are (or can be) units of development. When a taxonomist encounters a living organism he or she examines whether or not the organism "fits" into the species category. It is necessary to distinguish between species taxon and species category because it is not the possession of an essence or one common trait which defines the species. Within an actual species there is considerable variation among the individuals. This variation must be recognized by the biologists, since evolution presupposes variation. An essentialist definition of a species would be based on the assumption that something remains unchanged, and that every species has a distinct essence. It can, therefore, not take gradual development into account, and essentialism cannot account for evolution.

This may seem a cumbersome way to make the point that it is necessary and possible to make a distinction between classificatory units which are a product of our intellectual efforts and the actually existing diversity. At the same time, the distinction between two types of units acknowledges that our understanding of the natural variety develops through the creation and application of standards or prototypes.

Similarly with classification of the different aspects of human culture: concepts of art always exists within a field of other concepts, from which they are more or less sharply differentiated. When we classify something as art we make an effort to come to terms with this diversity of practices, and express, among other things, how we see art in relation to other phenomena within a given culture or in a given historical period. In the seventeenth and eighteenth centuries "art" and "science" were, for example, often used almost synonymously to refer to any activity requiring the exercise of skill, whereas to most people in the late twentieth century the difference between art and science is considerable.

When we wish to understand the historical development of conceptions of art we do so on the basis of the creation of standards. George Dickie, for example, discusses theories of taste and theories of aesthetic attitude in Britain in the early eighteenth century, whereas Jerome Stolnitz insists that the development of early

philosophy of art must be understood in terms of theories of "aesthetic disinterestedness" (for references, see the discussion in chapter 10). Both are attempts to develop the equivalent of what the biologist would call a species concept: they are products of acts of classification, but both are by their proponents presented as if they were the units of development, that is, to continue the analogy to biology, they are presented as if they are species taxa. This identification of the classificatory units with the units of development does not, however, hold up to even a relatively cursory examination of the historical diversity and complexity of the development of theories of art in Britain in the early eighteenth century. If the actual variety is considered, we can ask the question why particular ideas and particular forms of practice (artistic and other) developed and rose to prominence and others not.

Developmental Theories

When a philosopher advances an argument or refutes a view it is always an argument with someone, for or against a point or view or a particular way of acting. To understand an argument, it is necessary to understand what it was an argument for or against, which question it was meant to answer, and so on. These questions will rarely find their answer in the text alone, but must be derived from historical knowledge about important issues at the time in question, knowledge about other philosophers, about scientific and religious controversies at the time, and so on. We cannot look at a text in isolation from that larger world in which it came to be.

In his discussion of Hutcheson's moral philosophy, Mautner points out that it is impossible to understand Hutcheson's view of human nature and morality exclusively by examining the great philosophical texts. Hutcheson was rejecting a view of human nature as depraved and of people as unable by themselves to distinguish between good and evil. At the time, this was a commonly accepted religious doctrine and a frequent target of philosophical criticism, but it is difficult to find a major philosopher who defended or expressed the view. This central aspect of Hutcheson's moral philosophy (and consequently of his aesthetic) can therefore only be understood by examining broader patters of thought (Mautner 1994, 27–28).

Similarly, to understand, for example, what Shaftesbury meant by 'taste', 'genius', 'science', or 'art', we must look beyond the text. Understanding the internal structure of a text necessarily involves us in external considerations. When someone presents an argument, we need, in the words of Quentin Skinner,

> to be able to give an account of what he was *doing* in presenting
> his argument: what set of conclusions, what course of action, he

was supporting or defending, attacking or repudiating, ridi-
culing with irony, scorning with polemical silence, and so on
and on through the entire gamut of speech-acts embodied in
the vastly complex act of intended communication that any
work of discursive reasoning may be said to comprise. (Skinner
1984, 201)

The modern conception of art is not the exclusive property of philosophers,
and not solely an intellectual product, but also a practical reality. We don't just hold
it in our heads but also act it out. In fact, as implied by the idea of a practical con-
cept and by Bourdieu's concept of *habitus*, we do not even need to have the ideas
available in our heads to act them out (see Bourdieu 1990, 68). But even sug-
gested solutions to philosophical problems (in a narrower sense) represent, as for
example Mandelbaum has argued, an attempt to come to grips with some aspect of
the world in which the philosopher lives (Mandelbaum 1976, 728).

For most philosophers, the most important source for philosophizing or
for philosophical problems was their contemporary world. Locke, among others,
did not arrive at his theories of knowledge, government and education because he
wanted to enter into a conversation with his philosophical predecessors, but
because he was a child of his times. He was deeply involved in and deeply touched
by the conflicts and struggles affecting England in the seventeenth century. The
civil and religious wars of England in the seventeenth century shook established
belief in authorities and received truths. It was from these events that the necessity
of making a fresh start emerged for Locke.

The philosophy of history assumed in the following therefore conceives of
men's and women's intellectual efforts as inseparable from their practical lives.
This is opposed to the reconstructive view, where, as mentioned, the present stan-
dards are seen as the inevitable end product of the historical development. The
developmental strategy will therefore emphasize diversity and contingency, and it
seeks to answer the questions why something develops and what, more specifically,
develops, whereas the reconstructive approach will have a tendency to emphasize
necessity and teleology.

The theory of development differs, then, from the reconstruction mainly in
emphasizing the contingent nature of the concepts, ideas and beliefs we hold.
They have no basis "beyond the reach of time and chance" (Rorty 1989, xv). 'Con-
tingent' does not mean subjective or a matter of arbitrary, individual choice. Con-
tingency allows empirical examination of patterns of development and variation,
and of how different factors influence, play into, and limit each other. There may
be degrees of constancy within the patterns discovered. Contingency primarily
means that a system is to be thought of as "an effect of multiple, continuously
changing, and continuously interacting variables" (Smith 1988, 30).

For the essentialist it is possible to explain theoretical development (for
example, in aesthetic theory) as progress towards the realization of the true nature

of things. Change is correction of mistakes, approaching the one correct picture. This is the sense expressed by Tatarkiewicz in the citation above. By viewing the present standards as the necessary outcome of the historical development, reconstructions give the appearance of neutrality, while in fact any standpoint simultaneously excludes and differentiates. This became apparent in the discussion in chapter 2, and in part 2 it will become apparent as an inherent feature of aesthetic thought from its inception in the eighteenth century.

It should now be clear that the scope of the history to be written must be significantly broader than the scope of most traditional history of philosophy. The specific consequences this broader conception of the history of philosophy has for the concept of art will be the subject of the following chapters. The modern conception of art has passed from a stage in which it had to be defended against competing conceptions, to a stage in which its acceptance is a matter of being a competent member of the artworld. Many of the assumptions—among them cultural, social, and political assumptions—that went into the formulation of the modern conception of art are no longer explicitly formulated assumptions, but they have obtained the status of tacit assumptions shaping philosophical and other discourses about art. Because our own practices and convictions are a product of this development, we may, by retracing the historical course through which the modern conception gained the status of self-evident truth, obtain important new insights into our present forms of behavior and thinking.

Point of View in History: Past or Present

Though I have emphasized the difference between a historiography which proceeds from the standpoint of the present, and one which proceeds form the standpoint of those who participate in the historical events, this distinction should not, and in practice cannot, be taken as mutually exclusive. It is a difference in emphasis. Peter Bürger observes that it is necessary to strike a balance between what he calls "presentism" and "historicism." Presentism is the treatment of texts from the past without sufficient concern for their historical context, while historicism is interpretation solely in terms of the past, thus divorcing historical texts completely from the present. Both blur the distinction between the past and the present, and rely on the assumption that "the work is accessible 'as such'" (Bürger and Bürger 1992, 31–32).

Understanding requires some translation into the spectator's own culture. As long as a participant in a practice or a member of a culture considers the practice or culture unproblematic it calls for no reflection. The native participant simply masters and accepts customary forms of practice. Interpretation requires and is

motivated by distance to the observed, by a degree of strangeness or otherness. The one fully submerged in a practice or a culture rarely *understands* it in a manner satisfactory to the outside observer. The understanding or interpretation required by the outside observer must be a form of translation or interpretation relevant to the outsider. We need to understand, explain and describe phenomena because they are foreign to us, and because we need to relate them to our own world. Understanding and explanation cannot be provided in general, but must always be generated for a specific group of people for a specific purpose. It is from our point of view that Shaftesbury contributed to a discipline called philosophy of art. His contemporaries devoted more attention to his religious and moral ideas, and Shaftesbury did not know that his writings about the arts came to be seen as the starting point of a discipline called the philosophy of art. When we look to Shaftesbury in the hope that we may discover something about problems in contemporary philosophy of art, we obviously do so from the point of view of the present.

Any historical account must then to a degree be written from the standpoint of the present and will be guided by the interests of the narrator. We do not delve into the historical material in a completely arbitrary manner. We search into the past to shed light on the questions of the present, how our culture, society, political institutions, or philosophical concepts came to be what they presently are. It is precisely because we construe the historical narrative around our interests, hopes, and desires that it can illuminate our present darkness.

Objectivity, Interpretation, Relativism

Many philosophers and literary theoreticians now doubt that it is meaningful to assume that it is possible to get to the "true meaning" of a text by, for example, analyzing it in its historical context. Truth, it is now widely agreed, is a quality of statements we make, and therefore a linguistic matter. Since we no longer believe in the myth of the given or that texts or events have one true meaning embedded in them, they conclude that all we ever have are interpretations, texts pointing to other texts, interpretations pointing to other interpretations. There is thus no end to interpretation. The question this gives rise to is, naturally, if it is possible—and if so, how—to say that one explanation or interpretation is better or more true than another.

Those who reject the traditional philosophical attempts to demarcate true from false statements do so for a number of reasons. One significant reason is that actual cases of sorting true from false statements, for example, in the sciences, do not as a matter of fact apply philosophical criteria. As for example Stanley Fish points out, disagreements are not settled with reference to an algorithm or transcendental method, but through the mixture of procedures available within a given practice and within the institutional settings of a discipline. In everyday

circumstances as well we do not normally appeal to philosophical principles of truth when we seek to persuade someone of the truth of a view that they do not currently hold. No method or philosophy is required or actually invoked. In addition, these philosophers believe that having a philosophy of truth, even if it were possible, would hinder rather than help in the search for true statements about the world. Even if we imagined we had such a measuring rod, it would not be self-explanatory, but would have to be applied and interpreted in different situations, and would thus be open to divergent interpretations (Fish 1989, chap. 4).

When we read or interpret *Hamlet* or a novel by Agatha Christie (to use Fish's examples), it is not possible in advance to trace the boundaries between possible and impossible interpretations. The history of divergent interpretations should instill in us the utmost caution. This does not mean, however, that everyone is free to do what they please with the text. There are constraints, but these are not determined by some mysterious extra-linguistic given, but by the whole complex of customary practices within which reading of *Hamlet* or Christie novels take place. The constraints do not set a priori specifiable limits to what can and cannot be done; "it is neither the case that interpretation is constrained by what is obviously and unproblematically 'there,' nor the case that interpreters, in the absence of such constraints, are free to read into a text whatever they like" (Fish 1989, 97).

Understanding of any utterance requires, according to Fish, interpretation. We are always interpreting, no matter what we do. Interpretation is not restricted to texts, and they are not in all cases provided by the interpreting individual, but are interpretations we find through participating in already existing practices (Fish 1989, 127–28).

This form of interpretation ("without reflection") amounts to simple participation in a practice. Fish is no doubt right in saying that through becoming a participant in practices (let's say by training as a literary critic or a philosopher), we come to share certain basic ideas, through something similar to what Kuhn calls a paradigm or a disciplinary matrix, or what one with Bourdieu could call a *habitus*. Problems arise if we call this an interpretation (and I am not entirely certain that Fish does). It makes little sense in situations where no reflection takes place to say that we interpret. In such instances I do share an understanding with my fellow participants that we are engaged in soccer or literary criticism or philosophy or other activities regulated by rules, standards, and principles, though we are hardly ever aware of all of them. I participate in a game where rules, examples, and practical activity mutually support each other. Or, earlier, I watch others play a game and try to do the same. An existing practice is already structured by rules and values and "by an understanding of what it is a practice *of* (the law, basketball), an understanding that can always be put into the form of rules—rules that will be opaque to the outsider—but is not produced by rules" (Fish 1989, 125).

It stretches the boundaries of the notion of "interpretation" unreasonably to say that I *interpret* my activities as playing soccer or basketball or practicing law or literary criticism. Interpretation is only an issue when something is not understandable

as business as usual. Interpretations allow for the existence of other, competing, and mutually exclusive interpretations, but in normal circumstances it seems impossible that someone could justifiably claim that a competent user of the English language who believes him or herself to be playing soccer was actually wrong. My understanding of my own activity could be incomplete, since I might be doing something in addition to playing soccer. Someone might for example claim that I am a participant in a macho ritual. But from the fact that "I'm playing soccer" is not an exhaustive description of everything I am doing at the time it does not follow that it is false. It just isn't all that can be said.

Interpretation, as it is normally understood, involves some conscious mental activity. But there are many instances where I simply do things. Sometimes I think about available options and deliberate, but, as Ryle pointed out, this is only one form of knowledge—there is also *knowing how* to do certain things. Conceiving of all knowledge as of the deliberative, reflective kind is, Ryle claimed, an "intellectualist legend" (Ryle 1960, 29). The deliberation, the formulated rules and principles, the interpretation comes after the doing of something, as I argued earlier in connection with the distinction between concrete and abstract conceptions. And it is perfectly possible to have a sophisticated practice without formulated rules or principles. Here we should follow Wittgenstein in rejecting the idea that we always interpret. Understanding is not, as Wittgenstein labored to show us, a process. Only in special circumstances do we interpret or do we need to go through a process to be able to understand, for example when the utterance is in a language we do not master completely, or when we substitute one way of expressing a rule with another (Wittgenstein 1953, secs. 154, 198, 201). Repetition, endlessly doing the same (reacting to utterances, calculating, judging the curve of a ball passed to me) results in a situation where I just do certain things. Many of our basic skills are acquired in this way. As Brubaker points out, specialized practices "are regulated by incorporated dispositions." This is the case both for activities requiring manual dexterity (playing a musical instrument, sport, typing) and those requiring manipulation of symbols, for example, proofreading, writing, or appreciating a painting (Brubaker 1993, 214–15). This is expressed in terms such as having a "feel for the game," an ear for something (rhythm, a good sentence), or a flair for writing a good tune or selecting a good painting.

Another serious problem with the claim that we always interpret is the status of interpretations. Interpretations themselves have to be interpreted too, and we are thus in a process of infinitely regressing. To make sense of the notion of interpretation, it is necessary to insist that they come to an end. The idea of an end to interpretation should not lead to a reappearance of the notion of a foundation for our knowledge. The noninterpreted ground for our interpretation is itself based on customary practices, which are open to correction and change. It is not a foundation in the traditional sense of that term. But from the correct view that no understanding is foundational, it does not follow that all understanding is interpretive. Knowledge and understanding which is (as all knowledge and understanding must be) subject to change or correction is none the less knowledge and understanding.

The assumption that knowledge without foundations cannot be considered knowledge at all, and therefore must be interpretation, only makes sense if one shares a foundationalist conception of knowledge and understanding.

The weak form of relativism that may be said to flow from the historical approach I have suggested presupposes that some historical accounts are better, more true to historical events, than others. Strong relativism, the type of relativism which would deny this ("anything goes"), in fact shares important presuppositions with essentialism. The strong relativist actually agrees with the essentialist, that we need a transhistorical essence or substance to secure the foundations of art history or science or philosophy, but does not believe that we actually have or could develop such a foundation, and concludes that without foundations one explanation can be as good as another. But the validity of historical accounts does not depend on the existence of foundations. We should not think in terms of the presence or absence of foundations.

The words and concepts we use are not the arbitrary choice of individuals, but a part of the communal activities of a given culture. We apply concepts ('art', 'philosophy', 'science', 'law') to stand for different aspects of human activity. When something enters our horizon of social experience it becomes designated with a concept which can, for theoretical purposes, draw distinctions between activities and phenomena which are part of the complex web of human life. Our concepts, as Volosinov pointed out, do not just register facts, but at the same time they evaluate (Volosinov 1973, 22). We do not have words for everything at every given time. When something in our world becomes designated with a sign it is because it has entered the limited circle of objects which gain social attention. Any word or sign or concept is always a product of social intercourse. It acquires a value in social life. The word is a crystallization of collective human experience (Volosinov 1973, 23; see also Allen 1994).

When the nature of a deeply held conviction is explained as a result of historical and social developments, it seems to lose its aura of the sacred and valuable. We may feel that our intense personal experience of Beethoven or Jane Austen is diminished if it is not ours alone, and not based on anything deeper and more substantial than what human beings in a particular social order, at a particular time in history happen to do. If in fact the story to be told reveals that, had we lived in other times at other places, we might not have had the values we happen to have, it seems we might as well not have them at all. Despair and nihilism sets in, and the relativist messenger is blamed.

But this is premature. I personally recognize, for example, that many of my convictions and values are, from a historical point of view, the result of the influence of that pietistic form of Protestantism which has played such a crucial role in much of Northern Europe and North America; that whole complex of notions of what it is worthwhile to strive for in this world, of how one should conduct oneself and so on, that we refer to as the "Protestant ethic." Kant's moral philosophy best exemplifies this ethic.

Although I acknowledge the historical and social contingency of my ideas and values I cannot discard them, or choose another set of values at random; the acknowledgment does not turn them into a hat I can choose to wear or not to wear. They are, after all, *my* values, and, as Bourdieu points out, beliefs are not just of the head, but also of the body. The understanding of the historical genesis of the Protestant ethic and of my own place within it does however make it possible for me to recognize the ideas and values associated with this ethic more clearly as mine, while, at the same time, it makes me acutely aware of their limitations and of the fact that they are not universally shared. Relativists or historicists point to the social and historical contingencies of the beliefs and values we hold not because they are mean-spirited, but because this seems to them an inescapable conclusion.

There is in this historicist approach perhaps an analogy to psychoanalysis: Through the process of historical analysis I become aware of hitherto unrecognized forces and events that has played a crucial role in shaping the kind of person I am. I cannot change the past events, but perhaps I can know the ties that bind me. This realization liberates and makes it possible for me to take charge of my life.

Conclusion

In the Introduction we started with the observation that the question "What is Art?" arises as a response to the development of artistic practices, particularly when new works of art challenge the prevailing idea of what art is and should be. Historically shifting ideas of art are the basis for philosophical attempts to answer this question. Different philosophical approaches can be seen as attempts to deal with the historical diversity of art.

Essentialism, or traditional aesthetics, can be understood as a claim that changes in the concept of art are only apparent or superficial changes. The essence of art has actually remained unchanged. This answer is generally considered unsatisfactory, and I therefore reviewed different attempts to replace it.

Danto, Tilghman, Carroll, Levinson, and others all point to the historical basis of our conceptions of art. They pinpoint procedures through which something may be or actually is included in an art-historical narrative, but the procedures they specify are seriously incomplete. In particular, they do not question or examine what sustains or legitimizes historical or critical discourses of art. They therefore fail to fully appreciate the historically shifting nature of conceptions of art. I suggested a number of principles which could serve as guidelines for an historical exploration of this kind. It is now time to apply these principles in an investigation of aspects of the emergence of the modern conception of art.

PART TWO

Art and Science

Throughout most of the nineteenth and twentieth centuries, philosophy of art has been deliberations on the modern conception of art as I described this concept in the Introduction. The modern conception of art had its origin in the eighteenth century, but the philosophical analyses are not usually identified as analyses of a concept of art typical of a given epoch.

Many of the ideas formative for later philosophy of art and for the modern conception of art are found in the works of Shaftesbury (Anthony Ashley Cooper [1671–1713]), Joseph Addison (1672–1719), Francis Hutcheson (1694–1746), David Hume (1711–76), and Edmund Burke (1727–97).

Seventeenth-century England saw the demise of many well-tried authorities and the emergence of what was to amount to a revolutionary transformation in philosophy and science identified with names such as Bacon (1561–1626), Harvey (1578–1657), Boyle (1627–91), Hobbes (1588–1679), Newton (1642–1727), Sydenham (1624–89), and Locke (1632–1704).

Philosophers have sometimes suggested that the increased interest in the arts must be seen as a reaction to the growing prestige of what we would now consider a scientific approach. According to this line of thought, when empirical and scientific forms of explanation of natural phenomena become predominant, nature, including human nature, becomes objectified, which leads to a break or a form of loss in relation to earlier, more holistic approaches. The new sciences do not concern themselves with the truth of human existence (*Seinswahrheit* [Klein 1967, 143]). Those who feel this loss find in the arts a sphere where it can be overcome or

compensated. I will call this theory the "compensation thesis." The task of the arts is, so to speak, to compensate for whatever is lost in the scientific "objectification."

While there is some truth in the compensation thesis, it captures only one limited aspect of a more complex process. In this and the following chapters, I argue that the growing interest in the arts, and the emergent conception of art (the modern conception of art) must be seen against the background of much deeper and more comprehensive changes, not just on the political and economical level, but in the very conception of what it is to be an honorable human being, of the place of men and women in society and in the universe.

Science and the Emergence of Aesthetics

An inseparable part of our conception of the arts is its opposition to science. It may well be impossible to have a full understanding of the modern conception of art without knowing something about conceptions of science. Since the modern conception of art develops simultaneously with modern science, it is perhaps natural to see in the development of scientific forms of knowledge part of the explanation of the genesis of the modern conception of art and, along with it, of aesthetics as a philosophical discipline. This explanation has been suggested by P. O. Kristeller and the German philosophers Joachim Ritter and Hannelore Klein.

Though the following discussion is focused on Ritter's account, the compensation thesis has wider significance. I will not argue the point, but I think some form of the compensation thesis underlies the understanding of the arts expressed by, for example, the Frankfurt School (Adorno, Marcuse, and, to some degree, Habermas) and by Heidegger. Ritter's formulation in his—unfortunately little known—*Landschaft: Zur Funktion des Ästhetischen in der Modernen Gesellschaft* (Landscape: On the Function of the Aesthetic in Modern Society [Ritter 1978]) is however one of the most elaborate. I will briefly summarize the major points Ritter makes in this essay.

In the philosophical tradition of antiquity and the Middle Ages philosophy provided human beings with a view of nature and the universe as a whole, free of any particular purpose or intent. There was, thus, no place for a specifically aesthetic attitude to nature. The emergence of modern science changes all this. *Naturwissenschaft* objectifies nature, and has nothing to say about the place of human beings in the cosmos or about the way we subjectively experience nature.

> At the historical time when nature, its powers and materials, become the "object" for the natural sciences [Naturwissenschaften] and that technical use and exploitation which is based on the sciences, poetry and the visual arts take over—no less universally—the task of grasping and making "aestheti-

cally" present the same nature in its relation to the sensing
human being. . . . What must remain unsaid in science is the
presence of nature "as a whole," as the heavens and the earth,
which belong to human beings' life on earth as their sensu-
ously present natural world. (Ritter 1978, 21, 25)

An opposition between *Naturwissenschaft* and the arts becomes, as Ritter amply
demonstrates, a central feature in the view of the arts characteristic of the later part
of the eighteenth century and of the nineteenth century, as can be seen in the
writings of Kant, Schiller, Alexander von Humboldt (1767–1835) and Goethe
(1749–1832). But the basis for aesthetics has already been created in the earlier
parts of the eighteenth century.

Religion, Morality, and Science

Formulations found in, for example, Shaftesbury do, however, seem to lend
plausibility to the compensation thesis. Shaftesbury objected strongly to Descartes'
mechanistic explanations of human behavior (as did the followers of Newton), on
the grounds that they do not give us any understanding of man "as real man, and
as human agent, but as a watch or common machine" (Shaftesbury [1711] 1963,
1:191; see also 2:274f.). But Shaftesbury's criticism is directed against the form of
speculative natural philosophy developed by Descartes and his followers, rather
than against the type of experimental science which developed in England, and
which quickly won the day over the Cartesian type. It is, further, only with the
utmost caution one can transfer considerations on 'art' and 'science' from the sev-
enteenth and eighteenth centuries to a contemporary distinction between art and
science. At the time, the two concepts were frequently used synonymously for
any type of activity requiring practical, intellectual or technical dexterity.

At least in its earlier stages, the proponents of the new experimental sciences did
not venture any general claims about the possibilities of a universal theory of nature.
Boyle, for one, made it very explicit that the experimental practices he advocated
did not, as opposed to the Scholastic philosophers and natural philosophers such as
Hobbes, suggest any general theories of nature. Rather, the advocates of experimen-
tation as a way of obtaining knowledge emphasized the fallible and probable charac-
ter of their findings (Shapin and Schaffer 1985, 23–24; Walmsley 1993). Locke was very
pessimistic about the possibilities of a science of nature: "The works of nature are con-
trived by a wisdom, and operate by ways, too far surpassing our faculties to discover,
or capacities to conceive, for us ever to be able to reduce them into a science" (Locke
[1693] 1963, 182). In fact, a much higher degree of certainty could, according to Locke,
be obtained in matters of morality and religion (see *Essay*, 4.3.18.). As Tully has put it,
Locke's *Essay* is a celebration of probabilistic knowledge (Tully 1993, 195).

The advocates of experimental practices hoped to achieve at least two things: by concentrating on areas which could be examined experimentally they intended to eliminate areas such as politics and religion in which endless, unresolvable disputes (which might ultimately lead to civil war) were likely to occur. Experimental practices were supposed to rule out of court those problems that bred discord and divisiveness among philosophers. This required the creation of new forms of discursive and social practices (Shapin and Schaffer 1985, 46, 298). In *The Spectator* (262 [31 December 1711]) Addison commented that one advantage of his paper was that it would provide men (Addison's term)[1] "with Subjects of Discourse that may be treated without Warmth of Passion." He compared this to the purpose of the founders of the Royal Society. Successfully, they had "turned many of the greatest Genius's of that Age to the Disquisitions of natural knowledge, who, if they had engaged in Politics with the same Parts and Application, might have set their Country in Flame. The Air-Pump, the Barometer, the Quadrant, and the like Inventions, were thrown out to those busy Spirits, as Tubs and Barrels are to a Whale, that he may let the Ship sail on without Disturbance, while he diverts himself with those innocent Amusements" (Bond 1965, 2:519). Secondly, the experimental practices were meant to provide criteria for agreement, which, as implied by Addison, was an important question in England after the civil wars in the seventeenth century. Sprat pointed out that experiment gives room for differences without leading to civil war (Shapin and Schaffer 1985, 306). In his *History of the Royal Society* Sprat is careful to emphasize that the activities of the Royal Society do not pose a threat to the established social order, nor does the society in any way (or at least only very minimally) interfere with the teachings of the Church. Some of these assurances can perhaps be ascribed to political expediency. Though the Royal Society had its own *imprimatur* and printing privileges it could still be dangerous to publish books that might be considered subversive. Many of the founding members of the Royal Society were on the side of the Parliament prior to 1660, and therefore politically suspicious (Hill 1974, chap. 12).

The fact remains, that the activities of the Royal Society were only one part of a general interest in critical examination of areas that had hitherto been left to the Church or the court. Much of the impetus for this more naturalistic attitude to natural phenomena was grounded in religion and had been created by the decline in and criticism of belief in magic and supernatural phenomena brought about by the Protestant Reformation (see Thomas 1991). The Reformation generally leads to a more questioning attitude to received opinion and established authorities.

The probabilistic conception of knowledge had itself religious roots. It was, Tully has argued, based on the voluntaristic understanding of god and nature which did not acknowledge the existence of any immutable laws of nature. We can only hope to discover regularities that may be of some use in our earthly undertakings. Our knowledge is hypothetical or probabilistic because god is omnipotent and man is mediocre. God may do as he pleases. The idea that the

mind initially is a blank sheet is an expression of man's inferiority. We have no innate insights into God's plan, but must rely on observation. We are in the dark (Tully 1993, 202–5). It is in part against this rather bleak view of man's place and of a potentially capricious god that Shaftesbury and Hutcheson found it necessary to raise their objections.

The advocates of the new science were therefore champions of much more than a different manner in which nature could be explored: they were, as Shapin and Schaffer put it with a phrase of Wittgenstein's, advocates of a new form of life, the experimental form of life. By performing experiments witnessed by a number of trustworthy people it was hoped that agreement could be obtained through public discourse. Experimental activities were themselves meant to create spaces for this type of public discourse (Shapin and Schaffer 1985, 152, chap. 8).

In many historical accounts it appears as if the new sciences immediately won the day, but in fact the experimental practices were initially not particularly popular (Shapin and Schaffer 1985, 70). Throughout much of the eighteenth century the scientifically inclined virtuoso collecting shells and rocks, or performing pointless experiments, remained a subject of ridicule. A too specific and detailed knowledge of an area was thought to be incompatible with proper manners and politeness. According to Defoe, a "meer schollar," as opposed to a man of polite learning, is "all learning and no manners" (Defoe [1729] 1972, 203; see also Shaftesbury [1711] 1963, 2:253; Heltzel 1925, 107.)

The experimental practices and new scientific theories coexisted with many older, more traditional convictions. Boyle and Newton were reluctant to give up belief in miracles and the role of providence (Thomas 1991, 93). Belief in witches and spirits were not seen as contradictory to the embrace of the new science. Glanville (1652–80) is probably the one most famously associated with the defense of the existence of witches and spirits, but Boyle agreed with him (Shapin and Schaffer 1985, 314–316). Hobbes, on the other hand, rejected the new science, but did not believe in witches. In the late seventeenth century Antoine LeGrand (1629–99) developed a Cartesian philosophy which also contains accounts of witches and spirits (LeGrand 1694). Witches were still persecuted in England through much of the eighteenth century, though after 1737 without the sanction of the law. Pneumatology covered the area of spiritual beings—including God, angels, demons, and the human soul—and was, particularly in Scotland, taught well into the middle of the eighteenth century. In spite of Harvey's discovery of the circulation of the blood and the development of more empirically oriented forms of medicine, individual behavior and personal characteristics were still widely understood within the Galenic theory of the humors. In his *Reflections upon Ancient and Modern Learning*, Wotton considers Harvey's discovery of the circulation of the blood as a corrective, but not a refutation, of Galen's theory of the humors. Harvey's theory sheds, according to Wotton, light on how the humors of the body communicate (Wotton 1705, 211. See also the postscript and chaps. 18, 19. About medical practice, see also Earle 1989, 69).

Locke's and Boyle's modest pretensions can, of course, not be taken as evidence that the views they advocated did not, as a matter of historical fact, eventually result in the emergence of views with the function Ritter ascribes to the natural sciences. If so, it is nonetheless still necessary to explain why the compensation was sought in art and the aesthetic, rather than in, for example, morality or religion. Even if the new science was perceived as being in need of something to compensate it, as suggested by the compensation thesis, it is not clear why those to whom this need appeared should have turned to the arts, rather than to, say, moral philosophy or religion. These were actually the areas which were still perceived to contain the truth about human existence.

Bacon's, Boyle's, and Locke's views were to a high degree shaped by basically Puritan religious convictions. In his preface to *The Great Instauration*, Bacon emphasized that the knowledge he seeks creates no conflict with matters of faith, but that knowledge is obtained through humility and grace; only through "true and legitimate humiliation of the human spirit" can true knowledge be gained. Bacon did however reject "pleadings of antiquity, or assumption of authority" (Bacon [1620] 1939, 11).

Locke's political theory in *Two Treatises* depends, as Dunn points out, on a view of "man's place in nature as one in which each man is fully instructed by the Deity on how he ought to live" (Dunn 1984, 30), and his probabilistic view of human understanding has its roots in his latitudinarianism (Walmsley 1993, 384). The disagreement between Hobbes and Boyle about experimentation was also a religious disagreement. Boyle rejected Hobbes' views because he considered them a danger to "good religion and to the conception of nature that was required by proper Christianity" (Shapin and Schaffer 1985, 201). Moral philosophy, particularly in Scotland, was a somewhat less abstract discipline in the eighteenth century than it often is today. In the Scottish universities it was taught with the teaching of actual rules of behavior in mind, and closely tied to the teachings of the Church (R. B. Sher 1990. See also MacIntyre 1988; Scott 1900).

Charles Taylor has stressed that it is erroneous to see intellectual developments in the eighteenth century as a secularization rooted in the development of the sciences in the period. Such a view is tantamount to a conception of religious conviction as, in Taylor's metaphor, blinkers, and the Enlightenment as a removal of blinkers obtained mainly through scientific insights (Taylor 1989, 312f.). When we come across expressions of religious belief in Locke or Shaftesbury or Voltaire we retrospectively assume that these are mere rhetorical decorations, or perhaps a display of prudence intended to keep the writer out of trouble with the authorities. But the sole reason for this assumption is a conviction that our own state of disbelief is the only natural one. In fact, religious belief was prevailing throughout the eighteenth century, and declared atheists an absolute minority. As Taylor points out, deism presented a clear picture of the order of the universe and of the place of human beings in that order (Taylor 1989, 272, 277). In Alexander Pope's *An Essay on Man* (1733–34) we have a clear expression of this order:

Vast chain of Being! which from God began,
Natures ethereal, human, angel, man,
Beast, bird, fish, insect, what no eye can see,
No glass can reach; from infinite to thee,
From thee to Nothing. . . .

. . . .

From Nature's chain whatever link you strike,
Tenth or ten thousandth, breaks the chain alike.

. . . .

All are but parts of one stupendous whole,
Whose body Nature is, and God the soul.
(Pope [1733] 1951, 136–37)

The idea of the great chain of being, or the Scale of Beings, was commonplace in the eighteenth century (see Lovejoy 1964, chap. 6). It is, therefore, difficult to see why the presence of "nature as a whole," even if it, in Ritter's words, should fall outside the language of science, would necessitate a turn to art and to nature as landscape, and thus to the development of the aesthetic: "nature as a whole" was still conceived of in traditional, religious concepts. Religion and morality held the truth of human existence and of the place of humans in the order of nature.

To the extent, therefore, that the compensation theory relies on an understanding of the emergence of aesthetics as a reaction to a secularization of nature it contains an element which is false or at least greatly simplified. The compensation thesis relies on a notion of science and of the division between the arts and the sciences which is a later product of the very historical period whose origin it is meant to explain. The compensation thesis ignores the difference between what science was and what it now is. Scientific or experimental activities were to a high degree directed more to the solution of urgent practical problems than with general theory (see below). In addition, the different spheres of culture were not specialized. Hooke was for some time a pupil of the painter Lely, and Wren was a professor of astronomy at Oxford (Foss 1972, 31).

This is not to deny that science in the longer run achieved an "objectifying" character, perhaps particularly with the emergence of positivism in the nineteenth century. The understanding of the arts contained in the compensation theory is a reaction to an aspect of modernity which, in Berman's appropriation of Marx's word, melts all that is solid into air (Berman 1988). But in the seventeenth and eighteenth centuries science emerged as only one element in an immensely complicated process. It is as part of this process that the significance of science for the development of the conception of art, and ultimately for aesthetics, must be seen.

New Discursive Practices

Theoretical developments in the understanding of the arts in Britain cannot be separated from attempts to create a new ideological, political, and economical order after the settlement of 1688. An important aspect of this transformation is the de facto disappearance of any one central authority in moral, political, and religious questions. New institutions, new forms of authority and discourse must be found. Locke's philosophy (one of the most influential expressions of these developments) and the emergence of experimental practices testify to new ways of understanding the construction of knowledge, belief, and opinion: they no longer emanate from a center, but are formed collectively in a new social space, the sphere of public opinion.

The arts play a critical role in this development. The development of the modern conception of art is part of this development of new discursive practices and ultimately also of the attempt to find new principles governing conduct. In the process, conceptions of what it is to be a respectable person (the presentation of the self) also change. (Questions relating to the presentation of the self will be dealt with in the following chapter.)

This chapter provides a background to a more comprehensive understanding of the changing theoretical and practical role of the arts, and of how the growing theoretical interest in the arts connects to what I call the presentation of the self. The considerations to follow are naturally not intended as a detailed historical account of economic, political, and other changes taking place in Britain in the late seventeenth, early eighteenth century, but only as an indication of important elements in the transformative process.

The Transformation of England

The world of the educated European in the late seventeenth century was, in many respects, much larger than that known to previous generations. People no longer thought of themselves as inhabiting a finite universe, but as a small part of one stretching infinitely, and probably containing other worlds similar to ours (Lovejoy 1964, 133). Microscopes, though still rather primitive, had opened new universes, no less amazing than the larger one in the starry skies above.

The civil wars in England and the religious wars in Europe had made it clear that conflicts could no longer be solved by appeal to old authorities, such as the church or the divine rights of kings. Furthermore, no longer did anyone seem to have the power necessary to enforce their particular version of the authorities. The dispersing of authority is reflected in the emergence of the new discursive practices advocated by the Royal Society (discussed above) and in new philosophies (Descartes', Bacon's, and Locke's) where new grounds for assent were laid. The philosophers criticized the factors that actually determined assent (authority, revealed truth, tradition, the desire to conform) and sought to develop new ways that ought to guide assent (Tully 1993, 183). Tully suggests that the religious wars and the effect they had "in the realm of knowledge" is the major reason for the transformation in epistemology, "from clear and distinct ideas to innateism" (1993, 184).

The political revolutions in England in the seventeenth century changed more than its political and economical organization. The revolutionary changes resulted in, and were partly fuelled by, theoretical and ideological changes; together they produced a legitimation crisis. Beliefs contradicting each other were held with equal conviction and people were expected to kill and die for them. On the Continent and in Britain the result had been endless religious wars (Tully 1993, 191). As MacIntyre has expressed it:

> The criteria that used to return the same answers to the ques-
> tions, What standards ought I to accept and, What ought I to
> do? now provide several answers derived from the new compe-
> tition between rival criteria. What God commands or is alleged
> to command, what has the sanctions of power behind it, what
> is endorsed by legitimate authority, and what appears to lead to
> the satisfaction of contemporary wants and needs are no longer
> the same. (MacIntyre 1966, 147)

In England a new class of wealthy landowners had emerged prior to 1640. They did not possess land in the way a feudal landlord did, but owned it as their private, individual property. In many instances, they had bought property the Crown had confiscated from monasteries (Hill 1969, 64; see also Tawney 1984, 142). The system of feudal tenure was abolished during the revolution (in 1646) and was not reestablished during the Restoration (after 1660) (Hill 1969, 146). Land which

had traditionally been held in common among villagers, was now transformed to private property in the process known as "enclosure." This land could be cultivated on a capitalist basis, that is, with paid labor or by renting it to others to cultivate (Wood 1983, 9; Hill 1980, 38). Besides being profitable, ownership of land was a necessary requisite for political power, since the Parliamentary Qualification Act of 1711 made it a requirement to hold a seat in Parliament (Browning 1966, 224).

Often the land was used for pasture, primarily for sheep, in order to benefit from England's lucrative wool trade. Land put to pasture was more valuable than land with timber, so forests were cleared, which in turn led to a shortage of wood for (for example) fuel, and a growing reliance on coal, which became an increasingly important industry (Hill 1969, 66). The change from wood to coal gave a boost to the development of capitalist industries, and also played an important role in the development of science and the activities of the early Royal Society (Nef 1957, 77). Technical innovations emerged as solutions to many of the new problems posed by coal mining and in many areas of manufacture (such as beer and glass) where it was not possible to immediately substitute coal for wood.

Goldsmith observes that trade requires the presence of financial institutions, such as banks, stocks, and stock markets, all of which were present in early-eighteenth-century England (Goldsmith 1985, 129). Merchants who had made money enough on trade or through speculation on the stock market would frequently invest their commercial profits in country estates, or they would retire to the country and aspire to live the leisurely life of the traditional country gentleman. This stimulated the growth of a new class of gentlemen farmers. Often younger sons of the gentry were provided with education and money enabling them to make it on their own in a profession or in trade. They would often move to London (the centre for commercial activities and the new urban culture characterizing the middle class) thus creating "an almost impenetrable web of relationships" between the London middle class and the country gentlemen (Earle 1989, 7). The growth of trade, of the professions and of industry "rapidly increased the number of those belonging to the urban middle station and made a nonsense of systems of social classification based on a purely rural and agricultural society" (Earle 1989, 4).

The "middle class," or what in the contemporary world was referred to as the "middling sort of people" or the "middle station" primarily included those whose material wealth was associated with trade and the existing manufacturing industry, as well as many professionals (clergy, lawyers, doctors, teachers). According to Earle, the middling sort of people consisted of those who (in the absence of a sufficiently large fortune) had to perform some form of nonmanual work in order to turn over and increase the money they had.

Throughout the eighteenth century, the aristocracy remained a significant cultural and political force, but they were aristocrats mostly in name. Historians disagree about the extent to which merchants and middling people turned country gentlemen, but even if the number was not as high as perhaps sometimes assumed, the movement was enough to impress contemporary observers (see Earle

1989, 152). Earle's examinations show, not surprisingly, that few middle-class people owned large country estates, but that it was relatively common to own small estates just outside London (Earle 1989, 155–56).

Questions of land ownership are not just questions of interest to economic historians, but reveal the nature of English society in the early eighteenth century. It is important for the understanding of the development of aesthetics because this development is connected to emerging social forces.

In the middle class we find the typical audience for Addison's and Steele's *Spectator*, an audience eager to display evidence of taste and culture, "which longed to be modish, to be aware of the fashion yet wary of its excess, to participate in the world of the great, yet be free from its anxieties" (Plumb 1982a, 269). Addison eulogized the Bank of England and the Royal Exchange in the *Spectator*, but he did not suggest that gentlemen should become tradesmen, or at least not exclusively so (nos. 3 [3 March 1711] and 69 [19 May 1711] respectively). To balance the leisure activities of the gentleman with commercial, or other, more practical, activities was a concern Addison shared with many of the contributors to the *London Journal* (predominantly a Whig journal). In the *London Journal*, Hutcheson's *Inquiry*, one of the first real works in aesthetics in the modern period, was reviewed and subsequently became the subject of an exchange, in which Hutcheson himself participated.

After the settlement of 1688–89 England was the undisputed world leader in trade as well as in industrial output. The new order emphasized personal merit and achievement—particularly in the form of acquired wealth—more than birth. In principle this made the higher ranks of society open to all. In *Two Treatises of Government* Locke had made property one of the central concepts of his political philosophy: "The great and chief end of men uniting into a commonwealth and putting themselves under government is the preservation of their property" (bk. 2, sec. 124). The work came, as was Locke's expressed intention (in the preface to *Two Treatises*), to serve as a political justification of the settlement of 1688.

The values conducive to the development of capitalism are often, in deference to Max Weber, called "the Protestant ethic." The central point of the protestant ethic is that earning more and more money is "combined with the strict avoidance of all spontaneous enjoyment of life" (Weber 1958, 53), that, in other words, an increase in wealth must be accompanied by asceticism. In continuation of Weber, Gordon Marshall defines the Protestant ethic as "the pursuit of profit and forever renewed profit by means of continuous, rational, capitalistic enterprise, combined with close restrictions on personal consumption, as a duty and an end in itself" (Marshall 1980, 15).

The significance of the Protestant ethic for social and political changes cannot be denied, but the expression itself can be misleading. Some historians have pointed out that the values embodied in the Protestant ethic, though more predominant among protestants, were not exclusively protestant values. They also existed among Catholics (Burke 1978, 213; Tawney 1984, 93), and they were not shared by all Protestants. Luther in particular, as Weber was well aware, was no

friend of capitalism and commerce. The prime examples of the Protestant ethic, in Weber's sense, are the Puritans in England and New England and the Calvinists in Scotland. In his recent examination of the applicability of Weber's thesis to Scotland in the seventeenth century, Gordon Marshall concludes that "seventeenth-century Scots Calvinism is precisely the type of Calvinism that, according to Weber, fostered the development of the spirit of modern capitalism" (Marshall 1980, 107). This does not mean that this spirit of itself generates capitalism. It can, and does, exist independently of capitalism as an economic system. It was, however, a very important factor for the development of capitalism in the West. The ascetic element in Puritanism and Calvinism (and in German Pietism) is, as we shall see, of importance in understanding the role of the arts in this period, and therefore significant for an understanding of early aesthetics.

Exploring Trade

The growth in knowledge and the development of an empirical attitude to the examination of nature were closely linked to the political and economical changes. The company of Merchant Adventurers, founded in 1553, saw themselves not only as tradesmen but also as a company "for the Discovery of regions, dominions, islands, and places unknown" (cited in Habermas 1989, 254n.37).

The interest in non-European cultures and the connection between, in particular, trade and the expansion of human knowledge is emphasized in Thomas Sprat's *History of the Royal Society* from 1667. An important part of the activity of the Royal Society, it appears from Sprat's account, was to systematically gather knowledge from merchants who had visited distant corners of the world. London, Sprat found, was a particularly suitable place to carry out this type of activity, because it "is the head of a *mighty Empire*, the greatest that ever commanded the *Ocean*: It is composed of *Gentlemen* as well as *Traders*." London is a city "where all the noises of business in the World do meet: and therefore this honour is justly due to it, to be the *constant* place of *residence* for that *Knowledg*, which is to be made up of the Reports, and Intelligence of all Countreys" (Sprat [1667] 1958, 87–88).

The connection between trade and the growth of the new sciences was more than theoretical: Prince Rupert, King Charles the Second's cousin and a founding member of the Royal Society, was also an initiator of the Governor and Company of Adventurers of England Tradeing into Hudsons Bay, what contemporary Canadians know as the Hudson's Bay Company. Also considered a company of adventurers, they were granted a Royal Charter in 1670 and effectively given sovereignty over an area covering 40 percent of present-day Canada as well as parts of Minnesota and North Dakota in the United States (Newman 1985, 87). The company counted among its first share holders and founding members the First Earl of Shaftesbury. Shaftesbury was a member of the Council on Trade and Plantations, and was,

along with Locke, involved in British colonial policies in the Carolinas. Locke may
have written part of the constitution for the Carolinas. Locke also invested in the
Royal Africa Company and the Company of Merchant Adventurers to trade with
the Bahamas (Tully 1993, 140–41). At the time of the charter for the Hudson's Bay
Company Locke was Shaftesbury's secretary and there is therefore, according to
Newman, circumstantial evidence that he had a hand in drafting the charter (New-
man 1985, 333). Along with Sir Christopher Wren and Robert Boyle, Locke was
among the fellows of the Royal Society who initially acquired stocks in the new
company. Sir Paul Neile, a natural philosopher and founding member of the Royal
Society, was also a founding stockholder in The Bay. Shaftesbury and Wren both
took an active role in the operation of the company.

The members of the Royal Society were opposed to extravagant and
metaphorical forms of expression and aimed for a return to a "primitive purity and
shortness" of expression. The members of the Royal Society have

> exacted from all their members, a close, naked, natural way of
> speaking; positive expressions; clear senses; a native easiness:
> bringing all things as near Mathematical plainness, as they
> can: and preferring the language of Artizans, Countrymen,
> and Merchants, before that, of Wits, or Scholars. (Sprat [1667]
> 1958, 113)

The incitement to a "close, naked, natural way of speaking" is partly directed
against the obscurity of scholastic philosophy, and the type of public disputations
carried out at the universities (see Walmsley 1993, 381), but it is also characteristic
of the Puritan condemnation of wasting time and engaging in idle talk. Unneces-
sary words are sinful (see Weber 1958, 260–61n10). One of Locke's declared inten-
tions with his *Essay* was to eliminate the, apparently widespread, use of obscure
language, which is not only bad in itself, but it has also rendered philosophy
"incapable to be brought into well-bred company and polite conversation" (*The
Epistle to the Reader*, p. xxxv).

The bewildering array of different activities Sprat mentions as among the
activities of the Royal Society bears witness to two things: a new-found, almost
childlike curiosity in all kinds of natural phenomena, but above all a pressure from
practical concerns, problems arising from navigation, trade, manufacture, and agri-
culture, and a confidence, characteristic of modernity, in the ability to solve them.
The experimental laboratory promised, but did not always deliver, solutions to
practical problems (Shapin and Schaffer 1985, 340). Among the activities of the
Royal Society was the collecting of a catalog of all "*Trades, Works*, and *Manufactures*,
wherein men are emploi'd." This would include description of all the different
instruments used, "Physical Receipts, or Secrets," engines, manual operations, and
so on (Sprat [1667] 1958, 190), much of which was of course meant to be well kept
secrets within the remnants of the guild system. In Harris's *Lexicon Technicum* from

1704 we find this practical emphasis too. A major purpose of the lexicon is to make information about navigation and ship-building publicly available.

Sprat points out that the Royal Society admits men of different "Religions, Countries, and Professions of Life" and aims, not at founding a philosophy of any particular nation or religion, "but a Philosophy of *Mankind*" (63). Though the society admits men of different professions it is, Sprat emphasizes, composed mostly of gentlemen "free, and unconfin'd" (67). Freedom and independence are necessary to avoid being lead astray in the search for truth, either by personal interest in, for example, profiting from some new discovery, or by reverence for authority, in the way this is practiced in the schools, where "some have *taught*, and all the rest *subscribed*" (68). "Free and unconfin'd" gentlemen are better able to question authorities and received beliefs.

The rise of the new philosophy (most clearly, and most influentially, represented by Locke) and the new science is thus closely connected with the broader social, economical, cultural, and political changes taking place in England in the seventeenth and eighteenth centuries, in particular to the rise of the middle class. Associated with this is the increasing prominence of the social values cherished by these groups. These values are also expressed in Locke's philosophy, with which it is now necessary to deal in more detail.

The Significance of Locke

The influence of Locke's writings in England in the eighteenth century was second only to that of the Bible. Locke's *Essay Concerning Human Understanding* was published in four editions in Locke's own lifetime (Locke died in 1704); a fifth edition appeared in 1706 and a sixth in 1710. An additional twenty editions of the *Essay* were printed before the end of the eighteenth century, either separately or in editions of Locke's collected works. In addition to these there were abbreviated editions, for example for students and young people (Wood 1983, 47–48). In *An Essay upon Study* (1731) John Clarke (master of a grammar school in Hull) recommended Locke's *Essay* as valuable reading for ladies along with, for example, *The Tatler* and *The Spectator* (Mason 1971, 193–94). As Koselleck points out, Locke's *Essay* ranked "among the Holy Scriptures of the modern bourgeoisie" (Koselleck 1988, 54).

Philosophers have frequently seen the *Essay* mainly as a contribution to epistemology and perhaps to psychology, but the fact that it appealed to and was recommended as reading for a very wide audience indicates that it was received as more than a narrowly philosophical treatise in the eighteenth century. Locke no doubt intended his work to be accessible to the educated public in general (see Wood 1983, 41–47). Besides epistemological and psychological problems, Locke's *Essay* deals with questions relating to morality, manners, and the laws of citizens. As

Neal Wood shows, the effect of all this is to create for the emerging bourgeoisie a kind of new anthropology: a picture of a rational, industrious, basically selfish, God-fearing, but not popish or fanatic individual, a kind of "ideal of bourgeois man" (Wood 1983, chapter 6). It was to the industrious and rational that God had given the earth, Locke claimed in *Two Treatises* (book 2, section 34). Those parts of the *Essay* which dealt with this new anthropology became one part of the intellectual equipment of the emergent bourgeoisie, in particular of their conception of themselves. Locke offered a new view of what it is to be a rational, worthy human being.

Trade and colonization brought Europeans into contact with cultures where people conducted their lives in ways vastly different from the ones previously known. In the latter part of the seventeenth century and the beginning of the eighteenth, England was flooded with more or less imaginary accounts of travels to exotic places and encounters with strange people. Locke was greatly impressed by the information about non-European cultures, and he frequently referred to the North American Indians, people in China, Ceylon and elsewhere in his argumentation in *Two Treatises* and in the *Essay*. (See, e.g., *Essay*, 1.4.8, 1.4.13, 1.4.15; 1.3.9, 12. Locke attributed these discoveries to "navigation.") Locke used these examples to reject any ideas of innate moral rules or principles (*Essay*, 1.3, 4). In the *Essay* Locke emphasizes a fundamental equality between human beings, at least as far as their natural abilities are concerned, and, as Bacon had done, he criticizes authority as a source of truth in questions of morality. The absence of innate moral principles does not lead Locke to suggest that there is no distinction between true and false moral principles, but the demonstration of the certainty of their truth requires "reasoning and discourse, and some exercise of the mind" (*Essay*, 1.2.1.). Among the most important and demonstrably true moral principles Locke mentions worship of God (1.2.7), as well as the existence of God. Anyone who will use their reason in the right manner must concede the truth of these propositions (1.4.10). That Christianity was rationally defensible and logically coherent was a central tenet of Calvinism. The truth, Locke thought, was Christianity. Reason would require people to live in accordance with Christianity.

Locke perhaps glimpsed the prospect of moral and epistemological relativism, and this was if fact the most common criticism directed against him by his contemporaries (Tully 1993, 192). But Locke himself tried to escape this conclusion and firmly believed that some moral principles conform to reason, others not.[1] That there are in fact no universal rules or principles according to which people actually govern their conduct is apparent to anyone who knows history and who would look "abroad beyond the smoke of their own chimneys" (*Essay*, 1.3.2). We are entitled, even obligated, to demand a reason why any suggested moral rule should be followed (1.3.4). Morality and knowledge were closely connected for Locke. It is possible for men and women to know their moral duties—but unfortunately, Locke realized, most did not. They succumbed to desires and other distractions from that application of reason which would have lent them insight into

the law of nature (Dunn 1984, 60). For most men it is understandable that they do not engage in this questioning, since most of their lives are taken up by earning a livelihood (1.3.24)—"the greatest part of mankind . . . are given up to labour and enslaved to the necessity of their mean condition" (4.20.2). But for the leisured, reluctance to examine their moral principles can only be attributed to laziness, "especially when one of their principles is that principles ought not to be questioned" (1.3.25).

Locke's recommendations are an extension of the principles guiding the activities of the Royal Society (Locke was a fellow from 1668). Locke wanted to be an "underlabourer" to Boyle, Newton, Sydenham, and Huygens (*Essay*, xxxv). In the Royal Society men were concerned with practical affairs rather than idle speculation. If the principles followed by those who are examining the intellectual world were followed in exploration of the material world nothing would have been achieved.[2] Already Bacon had suggested that philosophers should follow the example of those engaged in practical labor rather than that set by the educated, which he found to be nothing but idle theorizing. The mechanical arts have in them a "breath of life, are continually growing and becoming more perfect" (Bacon [1620] 1939, 7). In a manuscript from 1669 which, Wood presumes, Locke wrote with Sydenham the idea is expressed forcefully:

> Thus the most acute and ingenious part of men being by cus-
> tom and education engaged in empty speculations, the improve-
> ment of useful arts was left to the meaner sort of people, who
> had weaker parts and less opportunities to do it, and were there-
> fore branded with the disgraceful name of mechanics. . . . Of
> this the ploughman, tanner, baker, etc., are witnesses.

Not philosophical speculation but "chance or well-designed experiments" led to insight into nature (Locke [1669] 1876, 225, cited in Wood 1983, 126–27).

Locke's philosophy, with its antiauthoritarian, egalitarian, and practical emphases, is an important indicator of a widespread collapse of old authorities. Though Locke claimed that moral precepts could be deduced with mathematical certainty he in fact never delivered on that promise. Locke's moral philosophy becomes, in effect, an instance of what MacIntyre calls the "Enlightenment Project" of founding morality, and an instance of its inevitable failure (see MacIntyre 1984, chaps. 4, 5).

As mentioned in the discussion about the relationship between art and science, an important substitute for authority, and a way to avoid that difference of opinion which degenerates into civil war, was the generation of knowledge through public opinion, or public discourse on available evidence. Immediately after the restoration (in 1660) the Declaration of Breda suggested "freedom of conversation" as a path to resolving conflicts, or at least obtaining a better understanding of the various positions (Shapin and Schaffer 1985, 285). This freedom was very soon

restricted, but it nevertheless testifies to the emergence of a public sphere. In this emerging public sphere, discussion of the arts (art criticism) was to play an important role.

Criticism and Commercialism

In 1675 King Charles issued a proclamation forbidding the operation of coffeehouses. The reason given for his action was that "many tradesmen and others do therein misspend much of their time." In particular they "misspend" their time by not minding their own business, but instead spreading abroad "divers false, malicious and scandalous reports . . . to the defamation of his Majesty's government and to the disturbance of the peace and quiet of the realm" (Browning 1966, 482–83). In London, the first coffeehouse had been opened in 1652, and they grew into meeting places for people with political, literary, scientific, or artistic interests (Pelzer and Pelzer 1982). Some of the disputes about the new experimental science took place in the coffeehouses, and they were often centers of political dissent (Shapin and Schaffer 1985, 292–93). In the first decade of the eighteenth century there were 3,000 such coffeehouses in London alone (Habermas 1989, 32) (as compared to 6,000 alehouses in metropolitan London in the 1730s [Earle 1989, 55]). What we see here (following Habermas) is the emergence of a bourgeois public sphere.

Newspapers formed an important ingredient in the formation of this public sphere. They had been known in England since the beginning of the seventeenth century, but grew in number when the Licensing Act of 1695 removed most forms of censorship. In the case of *The Tatler* and *The Spectator*, the readership of the newspapers is clearly to a large extent identical with the coffeehouse clientele. Newspapers and other forms of information were chiefly distributed through the coffeehouses, which functioned like a form of reading room (Pelzer and Pelzer 1982, 41).

A striking feature of the coffeehouses was the formal equality that characterized the social relations within them. Ideally, *what* one had to say mattered, not *who* said it. As opposed to the houses of the aristocracy, the coffeehouses were open to anyone, and it was, at least in principle, possible to meet and mingle with wealthy and influential people on an equal footing. Women were generally not allowed entry. Discussions in the coffeehouses dealt with any imaginable area, as is evidenced by the topics dealt with in *The Tatler* and *The Spectator*, but for our purposes the most important are discussions about the role of the different arts. Literary and philosophical works as well as different forms of art—theater, music, engravings of paintings—were becoming more readily available to a broader audience. Music, dancing and theatre increased their popularity with the middle class (Earle 1989, 59), and starting in the 1680s the number of paintings brought to England (mainly from France and Italy) grows dramatically (see below, chapter 8).

In Britain these developments are accompanied by a commodification of artistic production. Works of art become commodities along with other commodities. Production and reception of works of art are increasingly subjected to the laws of the market. Literary works and works of art had earlier been (and many continued to be) produced within a patronage system, and their evaluation was restricted to the circles of the aristocracy. For John Dryden (1631–1700), himself a patron of Will's Coffeehouse, the court remained the "best and surest judge of writing" (Foss 1972, 37). The right to public criticism could not be taken for granted, but had to be defended. Charles Gildon prefaced his play from 1714, *A New Rehearsal*, with a vindication of criticism by Shaftesbury. This vindication consists mostly of passages lifted from Shaftesbury's defense of criticism in the *Characteristics*.

Through the insistence on the right to public criticism and the expansion of the audience for the more readily available artistic creations, the public, as a new social entity, creates, as it were, itself, and changes the conditions for production, distribution and reception of works of art. Habermas points out that this change is particularly clear in relation to music, which had been, and to a large extent throughout the eighteenth century remained, closely tied "to the kind of publicity involved in representation—what today we call occasional music" (Habermas 1989, 39). By "publicity involved in representation" Habermas refers to types of public display characteristic of societies where the court is a central unit. An inherent status or attribute is represented; representation makes "something invisible visible" (Habermas 1989, 7), and is the expression of a shared code of conduct. The function of music within this context was to enhance the established social order. Musicians were appointed and worked on commission, and their work was scarcely heard by anyone outside the courtly circles. With the performance of public concerts this changes. Musical performances now become commodities, and music is no longer tied to a specific function or occasion. This is important to the development of aesthetics, because in this process an audience gathers for the first time

> to listen to music as such—a public of music lovers to which anyone who was propertied and educated was admitted. Released from its function in the service of social representation, art became an object of free choice and of changing preference. The "taste" to which art was oriented from then on became manifest in the assessments of lay people who claimed no prerogative, since within a public everyone was entitled to judge. (Habermas 1989, 39–40)

Thomas Crow points out that the *salon* in France played a similar role: everyone now had access to the viewing of paintings, and by exhibiting the paintings side by side in a room for that particular purpose they are freed from any specific social function. They can be, and for the first time were, viewed as nothing but paintings (Crow 1985). It is in these changed conditions of the production,

consumption and reception of art that we find the germ of significant parts of the modern conception of art. The concept of taste forms an important entry into this emerging conception. Along with the other developments discussed in this chapter, it signals the demise of old authorities and the search for new ones. Politics and religion were no longer able to provide a basis for social harmony. Commonality of taste may be able to create it anew. "Taste," possession of the good taste become, in the absence of clear social differentiations created by birth and rank, an indicator of belonging to the right social group. The commonality of the judgement of taste becomes the sign of belonging (cf. Gadamer 1975, 32–33).

The importance of taste, and what came to be known as politeness, must, then, be understood against the background of the decline of older criteria of nobility and social status. The language game surrounding the arts changes, but this change is only a part of a larger change in the form of life. Forms of social interaction change. The connection between the change in the language game surrounding art and the emergent new form of life is the subject of the following chapter.

Art, Manners, and the Presentation of the Self

The significance of "taste" must be seen against the background of the collapse of the old social order. Discussions of taste are part of the search for new social standards and new forms of regulating behavior. In Britain in the early eighteenth century social position had become less transparent; one no longer wore one's social position on one's sleeve. The possession of "good taste" became a sign of belonging to "good company." That an involvement with the arts had this signalling function is apparent from contemporary comments on the growth of interest in the arts in Britain in the early eighteenth century. Aspects of these developments are discussed in this chapter, and they form the background for discussions of taste, and other theoretical attempts to come to terms with the arts.

The Growth of Interest in the Arts

In England in the first decades of the eighteenth century the interest in the arts practically exploded. The enlarged literary output, the rise of the novel and the new reading audience are well-known phenomena (see, for example, Watt 1967, chap. 2; Löwenthal 1961, chap. 3), but a similar development affected such areas as music, painting, printmaking, gardening, and architecture. Musical scores and instructional music books were printed and sold in increasing numbers, and the theatrical audience expanded rapidly. These activities testify to the spread of commercialized leisure activities, and,

according to Plumb, "to the growth of a middle-class audience—not a mass audience by our standards, but so large and so growing that its commercial exploitation was becoming an important industry, involving considerable capital" (Plumb 1982a, 284).

The growth of interest in painting in the last two decades of the seventeenth century was so impressive that Iain Pears talks about the *discovery* of painting in England in this period (Pears 1988). Paintings and other works of art were imported from the European continent, chiefly from Italy, but also from France, Germany and Holland. According to Roy Porter, "[m]agnates ransacked Europe—and the globe itself—for paintings, sculpture, furniture, jewellery. They patronized artists and poets, and collected antiques, scientific instruments, and books by the roomful. The second Viscount Palmerston snapped up 300 old masters for a bargain £8,000. Flanked by landscapers such as William Kent, Capability Brown, and Humprey Repton, they redesigned Nature, on occasion flattening entire settlements which spoilt the view" (Porter 1982, 75). Only the very wealthy could afford a genuine Poussin (or what they believed to be a genuine Poussin). The bulk of the art market, and the most profitable part for the dealers, consisted of paintings and prints which were within reach of a middle-class audience. It was not, Pears shows, the relatively few, very exclusive works of art (such as paintings by Poussin or Claude Lorraine) which were the driving force behind the growing interest in painting, but that "overwhelming majority of the pictures" which were sold to "the more modest customers" (Pears 1988, 106, 148–49).

A commentator in the *London Journal* observes that painting and music, together with poetry considered among the "most polite Arts," have become the "darling Amusements of the Town, and engross the Affections of the *Beaumonde*" (3 July 1725). Music in particular has gained a large audience. The anonymous writer questions the vast sums of money spent on this form of entertainment, and raises a theme which is repeated by many other commentators: many pretend to admire the polite arts, but are unable to pass true judgment on them. That taste and an interest in the arts in general was a requirement for the new urban living is also evident from James Bramston's satirical poem, *The Man of Taste* ([1733] 1972). Intended, no doubt, for the benefit of others who aspire to acquire taste, the poem is a derisive first-person description of the accomplishments of a man of taste. The narrator is an uneducated person of humble origins who does all the right things: He has a "*gout* for criticism," a smattering of French, reads Swift, but does not understand Milton (90). Mandeville provides him with moral guidance (92), and he has a taste for music, architecture, gardening, and painting—all in the contemporary fashion, "[f]or what is beautiful that is not new?" (94). He is also a collector of paintings:

> In curious paintings I'm exceeding nice,
> And know their several beauties by their *Price*.
> *Auctions* and *Sales* I constantly attend,
> But chuse my pictures by a *skilful friend*.
> Originals and copies much the same,
> The picture's value is the *painter's name*. (94–95)

Conspicuous consumption has, it appears, taken the place of true achievement. The identification of the value of a painting with its monetary worth is also a target for satire in Miller's *Of Politeness* (1738). Before a young man returns from his trip to Italy he must buy something,

> something must be bought
> Before we *Latium* quit—no matter what,
> But *something* must, to shew our Taste at home,
> And prove we have not been in vain at *Rome*.
>
> . .
>
> *Bustoes* that each a Nose or Chin had lost,
> And *Paintings* of much Worth, for—much they cost.
> ([1738] 1972, 217)

Some contemporary observers thought the concern for acquiring "the fine Taste" interfered with the acquisition of more useful and practical accomplishments, such as knowledge of the laws and the principles of commerce (see *London Journal*, 21 May 1726).

The commercialization of writing is a source of repeated complaints for Shaftesbury: "In our days the audience makes the poet, and the bookseller the author, with what profit, or what prospect of lasting fame and honour to the writer, let anyone who has judgment imagine" (Shaftesbury [1711] 1963, 1:172–73; see also 1:197, 2:162). Shaftesbury, though a defender of the right to public criticism, did not always approve of the public's choices. Shaftesbury's dilemma is central in the discussions of taste: how can it be avoided that the public's freedom to criticize and judge leads to complete chaos? Is it not, after all, possible to find some common standard which at least all rational human beings should follow?

With the collapse of the old authorities and the increasing number of voices wanting to be heard, it was difficult to determine which standards were to be followed. The discussions about taste throughout a considerable part of the eighteenth century are an expression of this problem: Who is setting the standards? Which standards are to be set? Before entering into the discussion about taste it is, however, useful to introduce a distinction which can provide a theoretical framework for it.

The Expressive Order and the Presentation of the Self

Consider the impression a person makes if you know that he or she often does one of the following: listens to jazz, attends the opera, reads poetry, reads comic books, listens to heavy metal music, watches art programs on American public television, or visits galleries with abstract paintings.

The art with which we surround ourselves expresses more than just differing tastes. Since the beginning of the eighteenth century, it has been apparent that patterns of consumption of art works, clothing and other commodities are not guided exclusively by utilitarian considerations. (Mandeville was, as discussed below, probably the first to discuss this phenomenon at length.) Nowadays teenagers deliberately, and with great care, follow an informal "dress code" to advertise their affinity with specific groups within a complex web of subcultures. The business suit has much the same function

Artistic preferences often express a conscious attempt to project a certain view of oneself. President Clinton and Hilary Rodham Clinton have the distinction of bringing abstract art to the White House in the form of a painting by Willem de Kooning. Ronald Reagan preferred pictures of cowboys and Indians (*New York Times*, 24 March 1994, B1, B5). For image-conscious contemporary politicians these choices are hardly coincidental. Similarly, listening to rock music in the late 1960s (and later to, for example, punk rock, heavy metal, or rap music) was not just a matter of preferring one type of music to another, but a sign of belonging to a certain group which rejected values associated with the established order of society. As competent social agents, we are perfectly familiar with this phenomenon, and we draw more or less well-grounded conclusions about people based on their artistic preferences.

The impression we create operates not just in relation to our perception of other people, but is also an important part of the view we have of ourselves. Our attempts to create an image of ourselves, and to manage the impression we create, is not necessarily a conscious process, but, as David Novitz observes, even unconscious choices sometimes have far-reaching political consequences (Novitz 1992, chap. 6). By attending the opera, or reading Robert Musil or James Joyce or other literary works that are complex and difficult to read (and therefore not widely read), I can create a picture of myself (to myself and others) as a sophisticated and knowledgeable individual. Having certain artistic preferences becomes an important part of my personal narrative, though I do not suggest that this is the only reason I can have to read Musil or Joyce. I wish to draw attention to how this phenomenon worked in connection with the emergence of the modern conception of art.

Locke made the idea of social acceptability central to his moral philosophy (see *Essay* 2.28.7; Tully 1993, 210), and called it the "*law of opinion or reputation.*" This law actually (though perhaps it ought not to) governs belief and action and what people in given societies actually call vice and virtue. This law also makes far-reaching reforms of behavior and manners possible. Through change in habitual behavior people could gradually be brought to a state where they themselves could follow patterns of acceptable behavior. As Foucault, Taylor, Tully, and others have argued, what emerges from this is a new idea of the self. The rise of aesthetics and the growth of interest in the arts became part of this development. Shaftesbury, Richardson, and Hutcheson all offered the prospect of making a positive impression as a reason for an interest in the arts.

For a theoretical understanding of these developments, I will employ a distinction between "expressive order" and "practical order" developed by the English philosopher Rom Harré. Against the background of this distinction, it becomes clear that the growing theoretical and practical concern with art is an important part of changing notions of the presentation of the self, notions which in turn become an integral part of aesthetics.

In *Social Being* Harré distinguishes between the practical and the expressive aspects of an activity. The practical aspects of an activity are those directed to material and biological ends, while the expressive aspects are those directed to ends such as the presentation of the self as rational and worthy of respect, as belonging to a certain category of beings:

> In the expressive aspects of social activity we make a public showing of skills, attitudes, emotions, feelings and so on, providing, sometimes consciously, the evidence upon which our friends, colleagues, neighbours, rivals and enemies are to draw conclusions as to the kind of person we are. (Harré 1979, 21)

The expressive order and the practical order are equally important for human existence, and in the execution of a specific task they are both present. The distinction is therefore frequently an analytical distinction. For most people it is very important to have a job, not just because it is a necessity to maintain a livelihood. In many industrialized countries there are social systems which make it possible to stay alive even if one is unemployed. But to most people having a job is essential to their feeling of self-worth; it is closely tied to a perception that they are useful and needed members of a community.

Harré points out that Marx and Engels made a mistake when they based their view of history on the assumption that, as they put it in the *German Ideology*, "life involves above all else eating and drinking, housing, clothing and various other things." Harré comments:

> Of course life involves eating and drinking, but not "above all else." Above all else it involves honour and the respect of persons. One hardly needs reminding that those who conceive themselves to lack these expressive goods have sometimes refrained from eating and drinking altogether. Human beings can waste away and die from shame, humiliation and loneliness as much as they can from physical privation. (Harré 1979, 33)

Harré finds Marx's theory illuminating for the practical order, but not for the expressive order. To understand the expressive order Harré turns primarily to Thorstein Veblen (1857–1929). Marx considered work to be the all-consuming activity for most people throughout most of human history, but his view is not

borne out by more recent observations by anthropologists and historians. Until the Industrial Revolution the amount of time used in providing the means of subsistence was fairly small. In pre-modern Europe, three to five months every year were considered Saints days, and were kept festival (Hill 1958, 42). In contemporary (or near contemporary) pre-industrial societies, for example, of the Kung in Southern Africa or in Melanesian society, anthropologists have estimated that it is no more than 10 percent. That, as Harré comments, "leaves a lot of social space and time for dressing up, gossiping and chasing other people's spouses" (1979, 21). In some parts of medieval Europe as much as a third of the year was taken up by carnivals or festivals (Bakhtin 1984). The discipline and organization required to bring about the Industrial Revolution presupposed extensive disciplinary measures already advocated by Locke in the late seventeenth century (Tully 1993, 235–41).

The notion of "expressive order" is similar to the notion of *dignity*, as this has been used by Charles Taylor (see Taylor 1989, 15f.). Taylor understands dignity as closely connected to the sense of identity characteristic of the modern world, and it is opposed to the traditional conception of *honor*. Though the standards of dignity are, of course, socially and historically defined it is for each individual to choose wherein exactly his or her dignity consists, whereas honor is based on the fulfilment of certain typical, institutionally defined patterns of behavior (Berger 1983). The significance of the expressive order and of dignity can therefore also be understood as an element in the transformation to the modern world.

Harré's notion of the expressive order incorporates a point often made by hermeneutically oriented philosophers of the social sciences, according to which understanding of social and historical phenomena cannot be achieved without taking into account the notions the actors have of themselves as actors. The expressive order provides an entry into the self-understanding of the actors. Values embodied in the expressive order serve as motivations for actions and are therefore necessary to understand and explain these actions. The idea of an expressive order allows us a view of social activities which is not individualistic (there are historical and social patterns to be observed), but, since it conceives of individuals as actively creating themselves and as being motivated by what they believe to be valuable, it does not dissolve individuals into a suprapersonal social structure either.

For the British upper and middle classes in the eighteenth century the expressive order acquired paramount importance. For Lord Chesterfield (Philip Stanhope, 1694–1773) the goal of the education of a gentleman was to learn how to please. His dictum that "manner is everything" is well known, but mistakenly he is often presumed to hold extreme and exceptional views. In fact, most elements in Chesterfield's conception of proper behavior and education were, when he wrote his letters in the mid-eighteenth century, well established in writings on conduct and education, and Chesterfield derived, as V. B. Heltzel shows, many of his views from, for example, Locke and Shaftesbury (Heltzel 1925; see below).

When the social and moral order breaks down in the seventeenth century, the expressive order falls into confusion. The presentation of the self characteristic

of a society where (for example) the court is a central social unit is no longer valid. The role ascribed to art (including literature) in writers from Addison and Shaftesbury to Fanny Burney, Jane Austen, and Charlotte Brontë, is evidently one where part of the interest in art is to create a certain impression of oneself, by which one wishes to be judged by others. In *Pride and Prejudice*, the gradual change in Elizabeth's perception of Darcy is influenced by her discovery of the tasteful manner in which he has furnished his house and planned the surrounding garden (chap. 43).

It is not just in retrospect that changes in conceptions of the presentation of the self appear important. In late-seventeenth-, early-eighteenth-century society people were (as we shall see) acutely aware of it: they discussed manners, breeding, politeness, and whether or not one could be a gentleman by birth or if it required following specific patterns of behavior.

Standards of Taste

Discussions about taste in much of the eighteenth century were not confined to the evaluation of art, but were part of an attempt to forge a new expressive order and find new principles to regulate conduct. The presentation of the self was a matter of great concern in late-seventeenth-, early-eighteenth-century Britain, but the issue was framed as a discourse about manners, breeding, politeness, and the character of the "fine gentleman." With Addison and Hume as influential instances I show that discussions of taste did indeed have this wider social aspect.

"It matters not whence we came, but what we are . . ."

The awareness that time-honored standards of social behavior were no longer viable, and that something new was in the making, found many different expressions in the eighteenth century. As an example, consider the following passage from one of Shaftesbury's notebooks, perhaps written during one of his stays in Holland in 1698 or 1703–4. Everyone, he says, is referring to "the world," but it is not clear where this world is, who it is composed of—or if everyone is even referring to the same world!

> But where then is this emphatical world? what is it? or who?—Is
> it the beau monde? is it the court and drawing-room? is it the
> chocolate-house world? the coffee-house world? the quality
> world or the common-people world? the scholar world? the vir-
> tuoso world, or the politic, negotiating, managing, busy world?
> the foreign or the home world? . . . Whom of these, then, or
> which am I to consider? whom or which of these will I make the
> world? shall it be the greater number, the mere people? . . . Are
> the courts or even the senates, parliaments, and public stations,
> the passages to virtue and true honour, as well as to fame, for-
> tune, and honour of another kind? (Shaftesbury 1900, 68)

Much of the new eighteenth-century literary genre, the novel, deals with exactly
this problem: Defoe's *Roxana* (1724), Fielding's *Joseph Andrews* (1742), Fanny Bur-
ney's *Evelina* (1778) and *Cecilia* (1782), and many other novels, have social dislo-
cation as their theme. Changing locations in these novels are usually a narrative
device for social change. The hero's or heroine's more or less satisfactory solution to
the problem typically emerges through encounters with a variety of different social
types: the merchant, the old-fashioned aristocrat, the miser, the spendthrift, and so
forth. These characterizations reveal the significance of money and patterns of
consumption: how money is acquired and spent is a central theme for, for example,
Defoe and Burney. Money is in a sense the main character in *Roxana* and *Cecilia*,
and money mediates human relationships. In short, the problem of standards was
not just—as in the title of Hume's famous essay—a problem connected to taste,
but a general one of regulating social life.

The radical changes in the expressive order are also reflected in the changing
ideas of what it is to be a gentleman. Originally the status of gentleman could only
be obtained by birth, and gentility denoted good birth. "The idea of the gentle-
man . . . had its roots in words that denoted good birth and membership in a fam-
ily" (Castronovo 1987, 5). Defoe describes this notion of gentleman in *The
Compleat English Gentleman:*

> Our modern Acceptation of a *Gentleman* then . . . is this, A person
> BORN (for there lies the Essence of Quality) of some known, or
> Ancient family; whose Ancestors have at least for some time been
> rais'd above the Class of Mechanics. (Defoe [1729] 1972, 13)

Defoe was uncertain as to the length of time one must be able to trace one's pedi-
gree. Too close a scrutiny of one's ancestry will show that even the most noble
descend from something ordinary. Even the tallest of trees has its roots in the
dirt, and the most beautiful of flowers are raised "out of the grossest Mixture of the
Dunghill and the Jakes" (14).

When Defoe wrote his *Compleat Gentleman*, it was already commonplace to question birth as the sole criterion with which to judge a gentleman. The middle class still aspired to be accepted as gentlemen, but wanted to liberate the conception of gentleman from its traditional ties to birth and nobility. The "middling sort of people" therefore increasingly attacked the idea that being a gentleman designates gentle or noble birth, and the notion that the status of gentleman must be *achieved* gained currency. Steele thought that the name of gentleman should not "be affixed to a man's circumstances, but to his behaviour in them. . . . There are no qualities for which we ought to pretend to the esteem of others, but such as render us serviceable to them: for 'Free men have no superiors but benefactors'" (*Tatler* 207 [5 August 1710]; see also *Tatler* 66 [10 September 1709]).

Abel Boyer (1667–1729) summed up his criticism of birthright in pronouncing that "it matters not whence we came, but what we are" (Boyer 1706). The only true qualities are those of one's body or mind, and not what position or title one happens to be born with. Jeremy Collier (1650–1726, the author of *A Short View of the Immorality and Profaneness of the English Stage* [1698]) also criticized received notions of nobility. Hereditary nobility is no reason to respect a person (Collier 1698, pt. 1, 55). Only present merit matters (63), and a gentleman should primarily shine by his superior personal qualities (101). The author of an essay in the *London Journal* (26 October 1728) finds reason to congratulate his countrymen in the fact that they have gone farther than any other nation in Europe "in shaking off this Impertinence" of basing a person's merit on birth alone. Chesterfield thought the idea of superiority from birth silly (Heltzel 1925, 2).

Many traditional accomplishments (swordsmanship, horsemanship, duelling) were connected to warfare and the notion of honor, characteristic, as Goldsmith points out, of a landed aristocratic society (Goldsmith 1985, 151). New, more peaceful forms of accomplishments were advocated, particularly those connected to trade (see Taylor 1989, 285–86). Traditional conceptions of moral and social values and of honor disappear (Berger 1983, 173). Long-standing social boundaries and established values and authorities loose their appeal, their ability to solve disputes, and to serve as models of social behavior for individuals to follow.

Increasingly, then, there is a move away from traditional patterns of social recognition, particulary those connected with birth and rank, and a move towards behavioral criteria—criteria which are initially of a much more elusive character, and open to dispute. Heltzel dates the move away from birth and origin to around the middle of the seventeenth century, particularly the period after 1660 (Heltzel 1925, 7, 12–13, 37).[1] Locke was the first who "elaborated the conception of good-breeding as an essential requirement in the education of a gentleman" (Heltzel 1925, 441).

Taste and Social Interaction

The profound reorientation in the expressive order is evident in changes in books on conduct, as well as in the increasing role played by the arts and the display of taste in the behavior of the gentleman. Discussions about taste were nothing new in England in the early eighteenth century. Sir Robert Howard and John Dryden had been involved in a controversy about the conception of taste in the 1660s. In the Preface to his tragedy *The Great Favourite, or the Duke of Lerma* (1668), Howard criticized those who would "endeavour to like or dislike by the Rules of others." In judging tragedies, comedies and so on, as well as their manner of composition, "there can be no determination but by the Taste" (Spingarn 1908, 2:106f, cited in Klein 1967, 10). Dryden rejected this in *A Defence of an Essay of Dramatic Poesy* (1668). Distinctions should not be based on what people like or dislike.

It is not, however, until the first decade of the eighteenth century that the discussion about taste truly takes off. According to Klein, John Dennis' *A Large Account of the Taste in Poetry, and the Causes of the Degeneracy of it* (1702) is the first attempt to define taste (Klein 1967, 18). John Harris's *Lexicon Technicum* from 1704 has no entry under "taste," but one under the French term "grand gout," an indication that a notion of aesthetic taste was still a relatively new phenomenon in England. A few years later Addison reports that the notion of "the fine taste" often arises in conversation (*Spectator* 409 [19 June 1712]; Bond 1965, 3:527).

Originally, taste is not exclusively an ability to judge works of art, but extends to mastery of proper behavior and proficiency in judging the appropriateness of the conduct of others. This concept of taste is probably influenced by the writings of the Spanish Jesuit Baltasar Gracián (1601–58), whose *Agudeza y arte de ingenio* appeared in English translation in 1681. *Agudeza* is a faculty or power similar to "wit" as defined by Locke (see below), since it results in the creation of metaphors (Barnouw 1993, 56). Already Castiglione's *The Book of the Courtier* had established the analogy between "social comportment and artistic expression" (Barnouw 1993, 58). Addison compared the purpose of good breeding with that of "architecture, painting, and statuary": both should "lift up human-nature, and set it off to an advantage" (*Tatler* 108 [17 December 1709]). The truly accomplished gentleman has to present himself as a work of art.

The principles distinguishing judgements of taste, as well as the qualities that leads to behavior in accordance with principles of tact or taste, were difficult, if not impossible, to specify or express in words. The elusive character of the true gentleman is sometimes characterized with the expression that he has a certain *je ne sais quoi* (e.g., by Chesterfield [see Heltzel 1925, 434] and Hutcheson [1726, 250]; see also Eagleton 1990, 41–44). To Dominique Bouhours, the *je ne sais quoi* represents "an essential element in personal appeal" (Barnouw 1993, 69). Similarly, perfection in a work of art can be felt, but the specific cause of the generated feeling is unknown to most people, and therefore called *je ne sais quoi*, as Shaftesbury explains ([1711] 1963, 1:214).

As mentioned, the change in standards was caused in part by the opening of the upper ranks of society to people with money and education regardless of their family background. The possibility of dressing and appearing as a gentleman (even if one strictly speaking wasn't) gave cause for concern. Increasing imports as well as growth in domestic production of textiles for the first time made it possible for a large number of people to have a choice in how they dress. In the 1690s the taste for colourful fabrics imported from East India became widespread (McKendrick 1982a, 14). Another reason for this development is the disappearance of sumptuary laws, in itself illustrative of the changing perception of social status and social necessity. The laws regulated consumption according to station. A certain social stratification was necessary, and this required legal sanctions. When consumption becomes a matter of ability to pay, this stratification is therefore no longer deemed essential, and "the concern to preserve hierarchy by legal means lost its impetus" (Berry 1994, 241). Sumptuary laws can on the contrary come to be seen as illegitimate restrictions on personal liberty. Though many found this and similar developments morally and politically reprehensible, the economic significance of fashion and conspicuous consumption was quickly discovered by contemporary observers. In *Discourses upon Trade* from 1691 Sir Dudley North, echoing Locke, observed that

> the main spur to Trade, or rather to Industry and Ingenuity, is the exorbitant Appetites of Men, which they will take pains to gratifie, and so be disposed to work, when nothing else will incline them to it; for did Men content themselves with bare Necessaries, we should have a poor World. (p. 14, cited in McKendrick 1982a, 15; see also Kaye's citation from North in Mandeville [1714] 1924, 1:109n1)

Another significant factor was that the new cultural center was the City, in England almost exclusively London. In a traditional rural society patterns of social interactions are simpler. In the secluded country houses, which form the setting of, for example, Jane Austen's *Emma* and *Pride and Prejudice*, the exact social location of all the actors is always known by everyone involved. Whenever anyone enters a room, their income, social position, family background, and so on are already known, and their place in the social intercourse is therefore already defined. Not so in an urban setting. Cecilia, in Fanny Burney's novel of that name, is, by the death of her parents, removed from a rural background similar to those in Austen's novels. Upon her arrival in London, she discovers that she is completely unfamiliar with the expressive order regulating social life in the metropolis. Though she is introduced by name to people at a social gathering she is unable to converse with them because she knows nothing "of their histories, parties or connections" (Burney [1782] 1986, 18). Since everyone is dressed fashionably, she gets no clues from that either.

The difficulty of placing people socially in the city was already observed by Mandeville: everyone strives, particularly through conspicuous consumption of clothing, to appear better than their social position merits:

> [F]ine Feathers make fine Birds, and People, where they are not known, are generally honour'd according to their Clothes and other Accoutrements they have about them; from the richness of them we judge of their Wealth, and by their ordering of them we guess at their Understanding. It is this which encourages every Body, who is conscious of his little Merit, if he is any ways able, to wear Clothes above his Rank, especially in large and populous Cities, where obscure Men may hourly meet with fifty Strangers to one Acquaintance, and consequently have the Pleasure of being esteem'd by a vast Majority, not as what they are, but what they appear to be. (Mandeville [1714] 1924, 1:127–28)

From the dissolution of the old expressive order new behavioral criteria emerge. The boundaries of human activities are redrawn, and it is this redrawing which constitutes the fine arts as a category. The new criteria were discussed extensively in the many courtesy books of the late seventeenth and early eighteenth centuries, and they partly reflect the greater prominence given to the expressive values characteristic of the middling sort of people, a position in better agreement with their actual power and influence.

Jonathan Richardson

Jonathan Richardson's *Two Discourses* (Richardson 1719) is among the first of more systematic writings designated to encourage the gentleman's interest in painting, and, at the same time, provide guidelines for the solution to a number of practical problems encountered by those buying pictures. According to Moshe Barasch, "Richardson's work met with obvious success" (Barasch 1990, 55). Richardson's *Essay on the Theory of Painting* was originally published in 1715, reprinted in 1719 in an enlarged edition (the one referred to here) which was reprinted in 1725, and a French translation was published in 1728.

Richardson could assist in determining whether or not a painting was genuinely a Titian or a Poussin, in judging the artistic merits of a painting, and in deciding if it would retain or possibly increase its value. Until around 1700 the question of choice and evaluation of pictures had limited interest because of the limited availability of pictures (Pears 1988, 160; see also Gibson-Wood 1984). Richardson claims that his work is the first of its kind (Richardson 1719, 2.8), and he may well be

right about this, at least if the claim is that his book is the first in English to deal *exclusively* with art criticism and connoisseurship. According to Heltzel, the appreciation of art plays only a minor role in the conception of the accomplishments befitting a gentleman in the period until around mid-eighteenth century (Heltzel 1925, chap. 2). An interest in the arts could not be asserted without argument.

The Connoisseur: An Essay on the whole Art of Criticism as it relates to Painting promotes the new science of connoisseurship to gentlemen with an interest in painting (Richardson 1719, 2.7). The essay's practical advice is intended to assist in acquiring competence as a judge of painting, particularly how to "know the Hands of the several Masters, and distinguish Copies from Originals" (3). In the tradition of Bacon and Locke, Richardson thought that one should rely as much as possible on one's own judgment, and not on someone else's or on authority. Prejudices and false reasoning aside, "one Man may be as Good a Judge as Another if he applies himself to it" (16). What those who are considered to be good judges may have to say regarding the merits of a painting should be disregarded, as should the fact that a picture may have been very expensive, or that it is or has been part of a famous collection (20–21). The fact that a painting is done by a great master is not of importance, since not even everything Raphael made was of equal merit. Richardson also points to a principle which has received much attention in later philosophy of art and literary criticism, the so-called intentional fallacy: "In making our Remarks upon a Picture, or a Drawing, we are only to consider what we Find, without any Regard to what, perhaps, the Master Intended" (24).

Besides being a good investment (2.47–48), connoisseurship will generally "promote our Interest, Power, Reputation, Politeness, and even our Virtue" (2.217), and it will increase the respect and esteem granted to the one who possesses this skill (219–20).

> And accordingly in Conversation (when as it frequently does) it turns upon Painting, a Gentleman that is a *Connoisseur* is distinguish'd, as one that has Wit, and Learning. . . . Not to be a *Connoisseur* on such occasions either Silences a Gentleman, and Hurts his Character; or he makes a much Worse Figure in pretending to be what he is Not. (Richardson 1719, 2.222)

Richardson thus recommends connoisseurship to the gentleman partly because it will improve his social standing. But is it really in our interest to refine our taste, Richardson asks. Very few things will serve to satisfy the refined taste, while the unrefined taste will be satisfied with the most simple and crude things. Are the "Noisy, Tumultuous Pleasures of the Vulgar . . . Equivalent to those which the most Refin'd Wit taste" (38)? The answer is that they are not, because the vulgar or unrefined taste is not capable of receiving pleasure from things of a sublimer nature, pleasures that, to those receptive to them, are infinitely larger than the simple, vulgar pleasures of the bear-garden (38–39).

That the gentleman would improve his social standing by taking an interest in painting was also offered as a reason for developing such an interest by Marshall Smith in *The Art of Painting according to the Theory and Practice of the best Italian, French and Germane Masters* (London, 1692; see Pears 1988, 36–37). Chesterfield recommended that his son develop a taste for painting, sculpture, and architecture, because they "become a man of fashion very well," though he should not have a too detailed knowledge of these arts, particularly of the "mechanical parts" (see Heltzel 1925, 208).[2]

Richardson's recommendation that the gentleman take an interest in painting, and, in general, the possession of taste, becomes part of new behavioral ideals which replace the old criterion of birth. Beginning with Locke, the most important purpose of education becomes good-breeding or politeness, along with the acquisition of skills more pertinent to the new society (particularly some knowledge of trade or a craft). It was a repeated criticism of the education at Oxford and Cambridge that it was useless (Heltzel 1925, 98f.). "Usefulness" is one of the standards most frequently invoked when the pursuit of an interest or a project needs justification. The emphasis on usefulness may initially seem opposed to the attainment of good-breeding (it does not strike us as something useful), but in the early eighteenth century politeness and breeding were essential for a man to make his way in the world. Breeding and politeness, as well as taste, could be obtained only through actual experience in interacting with those already in possession of these qualities. This is evident in Addison's and Hume's discussions of taste, to which I now turn.

Taste, Human Nature, and Social Privilege in Addison

In calling his papers on taste and the arts "The *Pleasures* of the Imagination," Addison departed from a tradition which understood imagination and fancy as "morally dubious" (Berry 1994, 122): They were dubious because they related to mental desires that were potentially limitless, and therefore contrary to the Christian and classical notions of the ideal life as a state wherein one is no longer moved by new desires. If, however, the imagination could be subjected to rules and principles rather than be left to wander aimlessly and purposely from object to object, it might be possible to render it harmless or directly beneficial. As we shall see in the following discussion, this again ties in with attitudes to fashion, trade, and consumption.

Addison recommends the pleasures of the imagination because they are different from sensual pleasures, but nevertheless compatible with a life of leisure. They make it possible to be idle without leading to "Vice and Folly" (Bond 1965, 3:538–39). The pleasures of the imagination

do not require such a Bent of Thought as is necessary to our
more serious Employments, nor at the same Time, suffer the
Mind to sink into that Negligence and Remissness, which are
apt to accompany our more sensual Delights, but, like a gentle
Exercise to the Faculties, awaken them from Sloth and Idle-
ness, without putting them upon any Labour or Difficulty.
(539)

Addison evidently does not want to lay himself open to possible accusations that he
recommends slothfulness and idleness. "Sloth" and "Idleness" are among the most
frequently used terms of condemnation in the Puritan vocabulary, and Locke had
explicitly disqualified the slothful and idle from political power. It was to the
industrious God gave the earth. The pleasures of the imagination inhabit a middle
ground between those of sense and those of the understanding, between real labor
and direct indulgence in sensual pleasures.

Theoretically, Addison's influential considerations on taste connect to his
analysis of wit, which in turn is based on Locke's analysis of the concept. Locke's dis-
tinction between "wit" and "judgment" occurs in the course of his discussion of
the various faculties of the mind (*Essay*, 2.11). The ability to differentiate among dif-
ferent ideas is, according to Locke, an important element in any form of knowledge.
The mistaken assumption that two ideas are only one is an important source of
error. It can lead one to think that something is an innate idea, when in fact it is com-
posed of two different ideas, neither of which is innate: "so far as this faculty [of dis-
criminating ideas] is in itself dull or not rightly made use of, for the distinguishing
one thing from another, so far our notions are confused, and our reason and judge-
ment disturbed or misled." Conversely, the possession of this ability results in "exact-
ness of judgement and clearness of reason" (2.11.2). Whereas we can call judgment an
analytical skill, wit is, according to Locke, the ability to put things together. Wit lies
mostly in the "assemblage of ideas, and putting those together with quickness and
variety, wherein can be found any resemblance or congruity, thereby to make up
pleasant pictures and agreeable visions in the fancy" (ibid.). Wit is typically the skill
of the poet, since one form of this "putting together" is metaphor or allusion. Wit is
related to what at the time was called "fancy" or "imagination" and was not ranked
high by Locke. Those who possess a great deal of wit often do not have the clearest
judgment or the deepest reason. Metaphor and allusion are nevertheless appreci-
ated by all because "no labour of thought" is required. It just strikes us as pleasant or
beautiful and does not require any examination:

The mind, without looking any further, rests satisfied with the
agreeableness of the picture and the gaiety of the fancy; and it is a
kind of affront to go about to examine it by the severe rules of
truth and good reason; whereby it appears that it consists in some-
thing that is not perfectly conformable to them. (*Essay*, 2.11.2)

Addison added some further distinctions to Locke's definition of wit and judgment. Because not every idea playing on a resemblance can properly be considered wit, Addison distinguishes between false and true wit. True wit must also contain something which "gives Delight and Surprize to the Reader" (no. 62; Bond 1965, 2:264). Just repeating some worn out metaphor, or presenting some rather obvious resemblance between two objects does not constitute wit. Addison's analysis of taste is based on this notion of wit. Wit creates agreeable pictures or beauties, but requires in turn a faculty to judge the products of wit. This faculty is "taste."

Addison's discussion of taste is not restricted to what we would call the fine arts—the concept is not available to him. His discussion of the imagination includes not only most of the arts classified within the modern conception of art (poetry, painting, sculpture, architecture, and music), but also gardening and natural beauty, as well as some forms of historical and "scientific" writing. Addison defines "fine taste" (in writing) as "*that Faculty of the Soul, which discerns the Beauties of an Author with Pleasure, and the Imperfections with Dislike.*" The possession of "fine taste" makes it possible to experience the "pleasures of the imagination." The man of taste or "Polite Imagination" has the possibility of many pleasures "that the Vulgar are not capable of receiving."

For Addison, it is given that some judgments of taste are valid (true) and others false—it is obvious that some things conform to proper taste and others do not. But some people do not possess the faculty which makes this discrimination possible. For Addison, then, the problem relating to taste is not a matter of justifying the validity of individual taste-judgments but (1) to establish who has the faculty of fine taste, and (2) how those who do not have this faculty, or only have it to a small degree, may acquire or develop it.

Taste is a faculty which must, Addison says, "in some degree be born with us" (Bond 1965, 3:529). Beauty (and imperfections) are objective: "We [those with 'fine taste'] are struck, we know not how, with the symmetry of any thing we see, and immediately assent to the Beauty of an Object" (538), beauty "makes its way directly to the Soul" (542). If there should, after all, be any doubt about the quality of an object this is, in older writings, decided through the test of time, in more recent writings, by the "politer part" of society. To discover whether or not a person has taste, he should read the works which have passed the test of time, or which "have the Sanction of the Politer Part of our Contemporaries."

> If upon the Perusal of such Writings he does not find himself delighted in an extraordinary Manner, or if, upon reading the admired Passages in such Authors, he finds a Coldness and Indifference in his Thoughts, he ought to conclude, not (as is too usual among tasteless Readers) that the Author wants those Perfections which have been admired in him, but that he himself wants the Faculty of discovering them. (Bond 1965, 3:528)

Beauty, confronted with the faculty of taste, gives rise to the pleasures of the imagination. But even if a person does not experience pleasure, this absence cannot immediately be taken as an indication of the absence of beauty. It may be that the person in question does not have taste, and therefore, though confronted with beauty, does not experience the pleasure of the imagination. We must therefore have a criterion in addition to pleasure. The additional criterion is the conformity of the judgment of taste to the judgment of the "politer part" of mankind. Evidently, Addison's definition of taste is circular. Taste is defined by the agreement in judgment with those recognized to have taste. Consequently, taste (and politeness) are acquired by emulating those with these qualities, a point which is repeated by most writers on the subject. Writers about taste could afford to be circular in their definition of taste, because they would implicitly share with their readers the knowledge or the assumption that they belonged to the tasteful part of human kind. Taste was a quality belonging to a specific social stratum, and everyone knew where it was.

David Hume

Hume's discussion of taste in "Of the Delicacy of Taste and Passion" (first published in 1741) and in "Of the Standard of Taste" (first published in 1757), though much more systematic and detailed, has many similarities with Addison's treatment of the concept. The circular definition of taste is also present in Hume's writings. Much debate has focused on the question of whether this circularity (if present at all) severely damages Hume's argumentation, or if Hume does indeed escape from it intact. In a recent essay Richard Shusterman points out that most commentators on Hume consider the circular nature of the conception of taste an epistemological or ontological problem, whereas it should properly be considered a social or even a political problem—and this was in fact the way it was conceived in the first part of the eighteenth century (Shusterman 1993). The problem is similar to the problem discussed in connection with the emergence of experimental practices in science: how do we, in a world where there is no longer a central authority, create new forms of agreement?

That taste stretches beyond the confines of art is clear from the outset of "Of the Delicacy of Taste and Passion" (Hume [1777] 1987). A man of "delicate taste" reacts to the perfections or imperfections of a poem or a picture, but he reacts equally to forms of behavior: "A polite and judicious conversation affords him the highest entertainment; rudeness or impertinence is as great a punishment to him" (Hume [1777] 1987, 4–5). A refined taste allows us to judge the characters of men, as well as the different arts (6). A study of the arts (poetry, eloquence, music, or painting) will place us in a special category since "[m]any things, which please or afflict others, will appear to us too frivolous to engage our attention," and we will obtain "a certain elegance of sentiment to which the rest of mankind are strangers" (6–7).

Hume's intention with "Of the Standard of Taste" is twofold: he wants to reject the idea that we consider all judgments of taste equal, and he wants to show that there is indeed a standard of taste which must be, and actually is, followed by people of "good sense." If, however, the adherence to a standard of taste is, as Hume thinks, confirmed by experience or observation, another, equally conspicuous, phenomenon requires explanation: Why is there, after all, disagreements about judgments of taste? This is the second major concern of the essay. Hume wants to explain the origin and nature of differences in judgments of taste, that is, how it is possible that there can at the same time be fairly universally followed standards of taste, and some who, in their judgments of taste, nevertheless deviate from them.

Hume, as Addison, considers taste a faculty all human beings have, though not to the same degree. Some people have a very delicate taste, some hardly any at all. Though judgments of taste vary, this variation appears, Hume claims, much larger that it really is. In most questions there is actually fairly universal agreement:

> Whoever would assert an equality of genius and elegance
> between OGILBY and MILTON, or BUNYAN and ADDISON, would
> be thought to defend no less an extravagance, than if he had
> maintained a mole-hill to be as high as TENERIFFE, or a
> pond as extensive as the ocean. (Hume [1777] 1987, 230–31)

Of course, there may be people who prefer, say, Bunyan to Addison. In fact, even Locke's popularity pales by comparison with that of Bunyan. *The Pilgrim's Progress* went through one hundred and sixty editions before the end of the eighteenth century, but did not have the same educated audience as Locke (Watt 1967, 50). It seems, then, that many of Hume's contemporaries did indeed have a very high opinion of Bunyan, though perhaps not for his "genius and elegance." But anyone who prefers Bunyan to Addison can justly be considered "absurd and ridiculous" (Hume [1777] 1987, 231). Hume considers this an empirical observation, which contradict what we profess in principle, namely that all judgments of taste are on an equal footing. It is also an empirical observation that, generally speaking, only those works of art which follow certain rules are found to please. The nature of the rules to be followed is determined by "general observations, concerning what has been universally found to please in all countries and ages" (231). Since the question is no longer one of "genius and elegance," but merely one of "pleasing," it is apparent that the universality of the judgment has been restricted, since those who find Bunyan more pleasing than Addison have been excluded from the ranks of those who have a claim to be taken seriously. Though ostensibly arguing in the name of universal human nature, Hume gives voice only to those who have what he considers appropriate preferences. The rules are "founded only on experience and on the observation of the common sentiments of human nature" (232), but they are not always followed by everyone.

In order to form true judgments, it is necessary to be in a certain state of mind. It requires a "perfect serenity of mind, a recollection of thought, a due attention to the object" (232). Prejudice or authority may also hamper the judgment. In spite of apparent differences, it is therefore possible for Hume to maintain that there are "certain general principles of approbation or blame, whose influence a careful eye may trace in all operations of the mind" (233). Those who find Bunyan more pleasing than Addison may then be either prejudiced, misled by authority, or otherwise distracted, or they may simply not have examined the case at hand carefully enough.

In addition to these reasons, differences in judgments of taste may also be due to the differing levels of development of the faculty of taste in different individuals. Some have very acute senses of taste, what Hume calls "delicacy of taste" (e.g. 235), some do not. How do we know if a person has "delicacy of taste"? Hume's answer is basically the same as Addison's. Since we have established that there is a standard of good taste, those who are pleased, or in whom a sense of delight or pleasure occur when confronted with objects conforming to the standard of taste, have this delicacy. If a person is not so affected, he does not have delicate taste (235): "He must conclude, upon the whole, that the fault lies in himself, and that he wants the delicacy, which is requisite to make him sensible of every beauty and every blemish, in any composition or discourse" (236). The possession of delicacy of taste is a very desirable quality in a man, and it can be developed by practice. In fact, it is only one who has had extended exposure to modern and classical works of art who is truly able to judge the value of a work (238).

Hume starts with the apparent paradox, that we say that in matters of taste all judgments are equally good, while in practice we don't hesitate to exclude some judgments. As a matter of fact, "the taste of all individuals is not upon an equal footing" (242). Hume then gives a number of reasons why this process of exclusion is justified: certain general principles of taste can be observed empirically, but some people are prejudiced, some subservient to authority, some people lack the requisite delicacy of taste, etc., which prevents them from following the universal standard (243). Gradually a picture of the competent judge—the "good critic"— emerges. A person who is able to rise above what Hume considers prejudices and personal preferences shows "good sense" (240) and can become a good critic. Hume has in mind a well-travelled, well-educated person, free of what he considers prejudices, someone who allows "nothing to enter into his consideration, but the very object which is submitted to his examination" (239). This exclusion of any other concerns in the consideration of works of art is an important ingredient in much later philosophy of art, and a component in my characterization of the modern conception of art.

But where do we find such critics, Hume asks, returning to the initial question about standards. He does not directly answer the question, but again refers to experience and observation. It is as a matter of fact widely agreed that some people are better equipped to make judgments of taste than others (242). Men "of delicate

taste" are rare, but "they are easily to be distinguished in society, by the soundness of their understanding and the superiority of their faculties above the rest of mankind" (243).

Since the only way to determine whether or not a person has delicacy of taste is the conformity of the judgments made by this person to a set standard, the possession of taste becomes, above all, a criterion for belonging to a certain group of people, those who have good sense. It is the joint verdict of men of good sense and delicate sentiments which sets the "true standard of taste and beauty" (241). As Shusterman points out, the demand that the good critic be free of prejudices is actually a demand that the good critic has the *right* prejudices (Shusterman 1993, 106).

The qualities Hume demands of the good critic is in real terms a requirement to share large parts of the dominant culture, to have had a sufficient amount of time at one's disposal to develop the requisite type of knowledge, and to have received a certain type of education. Hume's standard of taste may be based on consensus, but not, as he claims, among all human beings, but only among an elite group.

In a recent essay Ted Cohen has criticized the type of interpretation here given of Hume's discussion of taste (Cohen 1994). Cohen finds Hume's theory of taste appealing and defensible, in particular "against the kind of criticism made by Richard Shusterman" in the essay I too have referred to (Shusterman 1993). Through a discussion of the story of the kinsmen of Sancho Panza, Cohen wishes to reassert Hume's project. In the story, Sancho's kinsmen taste some wine and one of them detects a slight taste of iron, the other a taste of leather. On emptying the cask, it turns out that, indeed, there was a small key in it with a small leather thong attached to it.

Hume uses the story from Don Quixote to assert a similarity between mental and physical taste. When Hume says that there is a great resemblance between physical and mental tastes he means that mental taste relies on properties hidden in the objects we pronounce beautiful, similarly to the way in which the key with the leather thong affected the taste of the wine. Beauty and deformity as such are not, as also Cohen observes, "qualities in objects" (Hume [1777] 1987, 235; Cohen 1994, 148), but they *are* based on "certain qualities in objects, which are fitted by nature to produce those particular feelings" (Hume [1777] 1987, 235). We don't know for certain what these qualities are—we cannot simply empty the cask and discover the key—so we must rely on social observation, the "established models" of what pleases or displeases. This makes it more difficult to prove the validity of the mental taste-judgments, but it does not affect their validity as such. With this argument Hume clearly ascribes a natural basis to the socially conventional.

But the parable with the wine tasting is misleading. The story about the wine leads us to believe that it is perfectly obvious what the criteria are because the set or criteria relating to wine seems narrower. But what exactly is the judgment of taste relating to a work of art about? Is it 'genius and elegance' as Hume suggests in his comparison of Milton and Addison to Bunyan and Ogilby? Is it what

pleases? Many different things can please different people for a variety of reasons. It is when we seek to specify exactly what pleases and the reasons it pleases that we run into problems. Every time we seek to specify the respects in which one work can be said to be better than another we encounter the problem of rendering one particular approach to art legitimate, another illegitimate, as we saw in connection with the discussion of Sibley and Tilghman. Perhaps the values and pleasures thousands of people have found in *The Pilgrim's Progress* are not accessible to Hume and Cohen, just as Shusterman argues that much of the value and significance of rap music today is closed to those of us who are not a part of that social context from which it emerged. Consequently, no one has seriously considered whether it might have values customarily associated with the fine arts (Shusterman 1992, chap. 8).

Hume's opinion of Bunyan was shared by the 'polite' throughout the eighteenth century, but in a recent discussion of Bunyan and his work he is actually considered "a writer of genius" (Hill 1988, 367). It is telling that the ascendance of *The Pilgrim's Progress* to a classic of English literature happened in the nineteenth century when those classes to whom his work spoke gained political and economic prominence (Hill 1988, 379).

Some feminists point out that works of art by women have been excluded from the traditional canonical presentation of the history of art, supposedly because of their lack of artistic merit. But including them in the historiography of art is not a matter of showing that they do in fact live up to the standards presumably guiding the inclusion of the works of male artists. In question is the very standards that determine inclusion or exclusion. It is those standards that must be carefully examined and perhaps rejected, revised, or undermined, because the standards have incorporated into them oppressive practices masquerading as "universal and objective" (Brand 1994, 96; see also Pollock 1988, 11, 23).

Cohen accuses Shusterman of dogmatism because he rejects the idea that a standard of taste is obtainable. Bourdieu's empirical investigations, as well as other similar examinations, show that there is no universally followed standard of taste, but this does of course not mean that it is in principle impossible to find one. It is virtually impossible to prove the impossibility of a task to a philosopher. Philosophers often pursue a task long after everyone else have found the evidence for its impossibility too overwhelming or have found that it is no longer worth their while.

Since the early eighteenth century much effort has through educational institutions, public support for symphony orchestras, operas, ballets, art exhibits, suppression of popular culture, and so on, been concentrated on promoting certain forms of art and literature as superior. In spite of all these efforts it just is not true that there are things which, as Hume claimed, have been found to "universally please in all countries and ages." Considering the general failure of these efforts in the last 300 years, it hardly seems a hasty a priori judgment to observe that no standard of taste is forthcoming. The empirical evidence falls heavily on Shusterman's side.

Taste and the Social Order

In England in the late seventeenth century, older values characteristic of the expressive order lose their validity. Though the process stretches back at least a century, the search for new values to fill the void in the expressive order becomes more rapid and more evident in the period after 1660. When birthright is no longer a viable social criterion, other criteria take its place. Having the same artistic preferences, the same taste as others, becomes a sign of belonging to the right segment of society. Though the philosophers and the patrons of coffeehouses imagined they spoke for and expressed values characteristic of mankind as such, they were clearly expressing a world view which was restricted to their own social group. As Habermas points out, even if education was the only criterion for entry into the public sphere, this in fact reduced access to those who owned property, since education was not generally available—"formal education at that time was more a consequence than a precondition of a social status, which in turn was primarily determined by one's title to property. The educated strata were also the property owning ones" (Habermas 1989, 85). Hume's demand that the good critic be a man with some practice and experience, is similarly a requirement which can only be met by a person of some education and with sufficient leisure time. The ability to converse about painting and poetry becomes a sign of what Veblen calls conspicuous leisure. It indicates that those who possess these skills have not spent the time in which they are not observed by their peers in doing anything mechanical or debasing.

Pears sees the interest in painting as derived from a "process of cultural unification of the upper ranks of English society" (Pears 1988, 3). To have certain preferences, interests, and knowledge in common serves to distinguish those who belong from those who do not belong to the elite, at the same time as it justifies the existence of the elite. "Possession of taste not only indicated education and hence virtue but also implied and signified the fitness of its possessors to rule" (Pears 1988, 36). Appreciating art in the appropriate manner becomes an important token in the social intercourse of the enlightened bourgeois. It signals a level of sophistication, but above all it signals membership.

Shaftesbury and the Morality of Art Appreciation

M any of the questions relating to taste, judgment and the arts received a more thorough treatment in Shaftesbury's philosophy. With Shaftesbury "we have arrived at a really critical point in the development of aesthetics, a point at which minds and problems had to part" (Cassirer 1951a, 315; see also Kivy 1976, 9).

I mentioned in the introduction that a central part of the modern conception of art is the idea that art has its value in itself, and not just as a vehicle for, say, moral or religious enlightenment. Though disputed, this notion of art's autonomy is still an important part of the modern conception of art. According to this idea, when we contemplate art we adopt a specific "aesthetic attitude" which serves to bracket whatever practical, moral, religious, political, or other concerns we may have, and we attend to the object in an aesthetic manner only. This way of attending to works of art (or other objects) is sometimes called disinterested contemplation. Lord Shaftesbury is often considered the first to call attention to the phenomenon of "disinterested perception" as it relates to aesthetics. This justifies regarding him as the founder of aesthetics, since a specifically aesthetic form of experience can be conceived as possible only with the emergence of the notion "aesthetic disinterestedness."

But a critical reexamination of Shaftesbury's writings does not support the view that Shaftesbury separates the contemplation of art from moral concerns in particular. Shaftesbury's concern was, on the contrary, *to situate the contemplation of art within a morality acceptable to his contemporaries.*

Aesthetics and Disinterestedness

Throughout the eighteenth century Shaftesbury was one of the most widely read philosophers, not just in Britain, but also in Holland, Germany, and France. The first edition of the *Characteristics of Men, Manners, Opinions, Times* was published in 1711, and eleven editions had been published by 1790. It was translated into French in 1769 (several of the individual treatises comprising the *Characteristics* had been translated earlier), and a complete German translation appeared in 1776–79. Much of this attention was due to Shaftesbury's moral, political, and theological views, but his views on taste and the arts were influential too.

One of the most authoritative recent interpretations of Shaftesbury's philosophy was advanced by Jerome Stolnitz in a series of essays from the 1960s. According to this interpretation, which has to some degree obtained the status of the received view, Shaftesbury's influence in philosophy of art is due mainly to the fact that he introduced the concept of "aesthetic disinterestedness."[1] Historically, "disinterestedness" is essential to the creation of aesthetics as a theoretical discipline and to our conception of art (Stolnitz 1961a, 131). Shaftesbury's use of the term disinterestedness is not, as Stolnitz also points out, connected to art in particular, but is initially part of an argument in ethics, directed against the idea that "interest rules the world" (Shaftesbury [1711] 1963, 1:77), an idea which in the early eighteenth century was associated primarily with Hobbes. From its origin in ethics and religion, "disinterestedness" becomes a key concept in aesthetics. According to Stolnitz, aesthetics is the most important part of Shaftesbury's thought: "[T]he whole impulse and bent of Shaftesbury's thought, from the very beginning, was toward the aesthetic. . . . He applied his aesthetic insights to ethics, but not to ethics exclusively" (Stolnitz 1961a, 133). It attains this status, according to Stolnitz, by shedding its moral and religious content and letting the aesthetic come "into its own for the first time" (134).

Stolnitz's interpretation of Shaftesbury has not been without its detractors. George Dickie in particular has criticized aspects of Stolnitz's work, especially concerning the historical role of the British theorists, such as Addison, Shaftesbury, Hutcheson, Burke, and Alison (see Dickie 1974, 1984; for Stolnitz's responses, Stolnitz 1978, 1984). Stolnitz claims that they were the first to advance the idea of disinterestedness and were, therefore, precursors of Kant and Schopenhauer, who refine and develop the work already begun by the British. Since disinterestedness, according to Stolnitz, is a defining concept of aesthetic theory, aesthetics proper can be said to have its origins in Britain in the first half of the eighteenth century (Stolnitz 1961a, 131). Dickie, on the contrary, thinks Schopenhauer is the first to advance a developed theory about "aesthetic attitude" which is defined in terms of disinterestedness (Dickie 1984, 195). Although the issue of the historical role of the British and the character of the development of aesthetics is complicated and lies beyond my immediate topic, I do assume that Stolnitz is correct about the influence of the British. My major dis-

agreement with Stolnitz concerns the character and role of "disinterestedness" and Stolnitz's claim that Shaftesbury liberates the aesthetic from the moral.

Dickie has little to say about Shaftesbury, in part because of Shaftesbury's Platonism, in part because Dickie simply does not think that any conception of aesthetic perception or disinterested contemplation is present in Shaftesbury's writings.

I agree with Stolnitz that it is misleadingly one-sided to characterize Shaftesbury as a Platonist, and use that as a reason to set him aside in the historical development (Stolnitz 1978, 413). Dabney Townsend has argued convincingly that in the historical context sharp distinctions between Platonism and empiricism make little sense (Townsend 1982, 206). In addition, this distinction makes it impossible for Dickie to account for the actual influence Shaftesbury had on the theoretical development in the remaining part of the eighteenth century.

In order to evaluate Stolnitz's interpretation of Shaftesbury's conception of disinterestedness, I will first examine the idea of interest and its role in the early eighteenth century. When this is done, I return to Stolnitz's interpretation of Shaftesbury.

The Nature of "Interest"

In Shaftesbury's days, the idea that "interest rules the world" was often identified with, but by no means limited to, the name of Hobbes. Even the inhabitants of Locke's more civilized state of nature (as compared to Hobbes') decide to leave it because interest and selfishness make the enjoyment of their property insecure (Locke [1689] 1960, 395–96).

The meaning of "interest" was not the same in the eighteenth century as it is today, where we generally identify that which we have an interest in doing with that which we are inclined to do or desire to do. In the seventeenth and eighteenth centuries, following one's interest could be the exact opposite of following one's passions, as illustrated in an incidence in Fanny Burney's *Cecilia*. In a conversation with Cecilia, Mrs. Delvile tries, without directly saying so, to make it clear to Cecilia that her son cannot possibly marry her, even though they may all desire it. Mrs. Delvile concludes: "How few are there, how very few, who marry at once upon principles rational and feelings pleasant! Interest and inclination are eternally at strife" (Burney [1782] 1986, 488, also 510).

In this passage, interest has to be followed because of one's position in society. It is an imposed obligation. Following one's feelings or inclinations would have destructive consequences; in the situation in *Cecilia*, young Delvile would not be able to carry on the family name. The interests control and counteract desires and passions. The task of reining in and controlling people's unruly passions had traditionally been an important legitimation of coercion by the state or the church,

justified on the grounds that it was for the greater good of the whole (Hirschman 1977, pt. 1). Bernard Mandeville later became a prominent advocate of the view that individuals should be left to freely follow their private passions, since such freedom would lead to harmony and prosperity (though not to virtue) on the greater scale.

In the early eighteenth century, interest was closely connected with the possession of wealth. Shaftesbury defines the term "interest" in this manner:

> In luxury and intemperance we easily apprehend how far thought is oppressed and the mind debarred from just reflection, and from the free examination and censure of its own opinions or maxims, on which the conduct of a life is formed.
>
> Even in *that complicated good of vulgar kind which we commonly call interest, in which we comprehend both pleasure, riches, power and other exterior advantages,* we may discern how a fascinated sight contracts a genius, and by shortening the view even of that very interest which it seeks, betrays the knave, and necessitates the ablest and wittiest proselyte of the kind to expose himself on every emergency and sudden turn. ([1711] 1963, 2:345; my italics)

Interest is also defined as "desire of those conveniences by which we are well provided for and maintained," or in more general terms as "self-love." A certain moderate self-love is not necessarily bad, but driven to extremes it becomes dangerous. Exclusive concern for one's private interest becomes "cowardice, revengefulness, luxury, avarice, vanity, ambition, and sloth" (1:317). Interest in particular leads to avarice, the sense in which Hume too used the term (Hirschman 1977, 37).

Shaftesbury thought that nature, assisted by education, would regulate itself in finding a balance between too much and too little self-love. The purpose of education is to enable one to live a "natural and regular life" ([1711] 1963, 1:325). For Shaftesbury, as for Locke (who had supervised Shaftesbury's education), the purpose of education is to make it possible to lead a life according to reason, which for Shaftesbury meant that which was contrary to interest.[2] The person inclined to indulge in luxury will, besides ruining his health by, say, overeating, receive little pleasure from it and be an unhappy and unnatural creature:

> As to the consequences of such an indulgence: how fatal to the body, by diseases of many kinds, and to the mind, by sottishness and stupidity; this needs not any explanation. . . . '[T]is easy to conclude "that luxury, riot, and debauch are contrary to real interest, and to the true enjoyment of life." (1:323, 329)

According to Hirschman, in the course of the seventeenth century the meaning of "interest," though initially wider, becomes identified almost exclusively

with the acquisition of material wealth and the pursuit of economic advantages (Hirschman 1977, 38). But paradoxically, the term 'interest' gradually develops the function of legitimizing what had hitherto been known under such negative terms as 'avarice' or 'greed' because it was seen as a control on greater evils, such as ambition, lust for power, or sexual desire (Hirschman 1977, 41).

Though the conception of the interests as a check on the passions is present in Shaftesbury's writings—for example in the passage above, where he points out that luxury, and so on are "contrary to real interest"—Shaftesbury does not view passion as solely negative and destructive. In *Sensus Communis: An Essay on the Freedom of Wit and Humour* (first published in 1709), Shaftesbury wants to show that throughout history and in different societies there is a certain sense of the public good, "a social feeling or sense of partnership with human kind" ([1711] 1963, 1:72). By nature, man is a social creature and finds pleasure in the company of others. We have a natural instinct to take care of one another. The formation of society has not come about through a contract as Locke and, in particular, Hobbes claimed, but has grown gradually out of the natural inclination men and women have to keep each other's company, and to enjoy the "pleasure found in social entertainment, language, and discourse" (1:74–75). Shaftesbury's view of human nature at times comes close to that of the "noble savage," which can be corrupted by civilization. He talks about that "simplicity of manners and innocence of behaviour which has been often known among mere savages, ere they were corrupted by our commerce and by sad example" (1:226). That "mere savages" should be innocent was contrary to received religious dogma. It was official doctrine of both the Anglican and the Presbyterian churches that man, because of Adam's fall, was unable of his own strength to be virtuous, but was unremittingly evil. Salvation for men and women is only possible through the grace of God, though the threat of eternal damnation or the promise of salvation can serve to mend their ways.[3] Locke similarly believed that without the belief in an omnipotent God who would punish transgressions, people were incapable of moral actions. This belief was therefore necessary for virtue and social order (Tully 1993, 208–9).

Shaftesbury argues against a view of good acts that conceives of these as grounded only in the self-interest of individuals, the view that good acts should be done "for the sake of a bargain" ([1711] 1963, 1:66), or because of a view of "future reward and punishment" in heaven or hell (2:55), actually a form of bargain too.[4]

> If the love of doing good be not, of itself, a good and right
> inclination, I know not how there can possibly be such a thing
> as goodness or virtue. If the inclination be right, 'tis a pervert-
> ing of it, to apply it solely to the reward, and make us con-
> ceive such wonders of the grace and favour which is to attend
> virtue, when there is so little shown of the intrinsic worth or
> value of the thing itself. (1:66)

It is well known that Shaftesbury believed that human beings have a "natural moral sense" (1:262), a sense of "right and wrong," and are naturally inclined to act virtuously. Acting without any regard for the possible personal benefit one might get from an act, either in this world or beyond, is to act disinterestedly (1:67–69). In particular one must strive to love God and virtue in a disinterested manner, that is for "God or virtue's sake" (2:55).

From Morality to Aesthetics

As already mentioned, the core of Stolnitz's interpretation of Shaftesbury's conception of aesthetic disinterestedness is that the idea from its origin in ethics becomes "properly aesthetic" (1961c, 105). Stolnitz does not claim that a clear cut case of the use of disinterestedness in the modern, aesthetic sense can be found in Shaftesbury's writings, but only that he is the starting point for this development of the concept, regardless of the intentions which he might have had. Stolnitz's claims about disinterestedness rest, then, partly on an understanding of what Shaftesbury said (a textual claim), partly on a claim about the actual history of the reception of the concept or idea "set into motion." I deal first with the claim about Shaftesbury's text, second with the claim about the history of the reception of "disinterestedness."

How does the notion of disinterestedness evolve into a concept of a particular manner in which works of art can be perceived? Following Stolnitz, in the passage from *The Moralists* (published 1709) referred to above, in which Shaftesbury discusses the disinterested love of God and virtue, the meaning given to disinterestedness comes close to a meaning which makes it possible to use the term also in connection with aesthetics. In this context Shaftesbury does not use "disinterestedness" to mean "benevolence" or acting to further the common good of mankind, the sense in which the concept is often used in the moral context. Here it refers only to *a suspension of any private interest*, to something which is "not motivated by self-seeking" (Stolnitz 1961c, 106). The sense of disinterestedness we are looking for is "opposed, not to benevolence, but to the falling away of self-concern" (107).[5]

In addition to the deliberations about the disinterested love of virtue and God, the aesthetically relevant notion of disinterestedness can also, according to Stolnitz, be seen in another passage from *The Moralists* (a passage central to Stolnitz's interpretation). Here "the aesthetic comes into its own for the fist time: aesthetic perception is no longer run together with moral and religious virtue, 'disinterestedness' leaves behind its origins in the Hobbes controversy" (Stolnitz 1961a, 134).

In *The Moralists*, even more than in his other works, Shaftesbury discusses a bewildering array of different topics, presented in part in the form of a dialogue between Theocles and Philocles, as recounted by Philocles to Palemon. Theocles

represents the "correct" line of reasoning. In their conversation, Theocles and Philocles touch upon the nature of poetry and beauty. Poets and other lovers of the Muses and the Graces copy nature ([1711] 1963, 2:125). The things in nature we find beautiful, things which can "passionately" strike us, are shadows of a deeper kind of beauty:

> [W]hatever in Nature is beautiful or charming is only the faint shadow of that first beauty. So that every real love depending on the mind, and being only the contemplation of beauty either as it really is in itself or as it appears imperfectly in the objects which strike the sense, how can the rational mind rest here, or be satisfied with the absurd enjoyment which reaches the sense alone? (2:126)

In other words, true enjoyment excludes mere sensuous gratification. Opposed to sensuous pleasure there is a higher, rational kind. Theocles further explains the rational kind of enjoyment in a passage part of which is quoted by Stolnitz:

[T.:] Imagine then, good Philocles, if being taken with the beauty of the ocean, which you see yonder at a distance, it should come into your head to seek to command it, and, like some mighty admiral, ride master of the sea, would not the fancy be a little absurd?

[P.:] Absurd enough, in conscience. The next thing I should do, 'tis likely, upon this frenzy, would be to hire some bark and go in nuptial ceremony, Venetian-like, to wed the gulf, which I might call perhaps as properly my own.

[T.:] Let who will call it theirs, replied Theocles, you will own the enjoyment of this kind to be very different from that which should naturally follow from the contemplation of the ocean's beauty. . . . But to come nearer home, and make the question still more familiar. Suppose (my Philocles) that, viewing such a tract of country as this delicious vale we see beneath us, you should, for the enjoyment of the prospect, require the property or possession of the land.

[P.:] The covetous fancy, replied I, would be as absurd altogether as that other ambitious one. (2:126–27)

Shaftesbury wishes to distinguish between the admiration of something for its beauty and the desire to possess or own it.[6] One objection to this distinction that comes to mind is that there is a kind of beauty, the admiration of which seems naturally to

lead to a desire to possess the object (2:127–28). Shaftesbury's oblique reference is probably to sexual attraction, a type of attraction which is nevertheless natural, and so in Shaftesbury's moral universe good.[7] It appears, then, that a contradiction arises: what is natural has been praised as good, but according to the passage just quoted, that which is natural now seems to be bad, linked as it is to dangerous desires. To this objection Theocles answers:

> [T.:] Far be it from us both . . . to condemn a joy which is from Nature. . . . But 'twas not here . . . that we had agreed to place our good, nor consequently our enjoyment. We who were rational, and had minds, methought, should place it rather in those minds which were indeed abused, and cheated of their real good, when drawn to seek absurdly the enjoyment of it in the objects of sense, and not in those objects they might properly call their own, in which kind, as I remember, we comprehended all which was truly fair, generous, or good.
>
> [P.:] So that beauty, said I, and good with you, Theocles, I perceive, are still one and the same (2:128).[8]

Speaking for Shaftesbury, Theocles, rather than wishing to carve out an independent realm for the contemplation of beauty, wants to reassert a point frequently made by Shaftesbury: the unity of the good and the beautiful (rational beauty). To know what is true, good, or beautiful requires insight into "inward numbers" (1:217). Knowledge of truth, beauty, and goodness is insight into an actual order in the universe, characterized by given numerical proportions, particularly symmetry:

> [W]hat is beautiful is harmonious and proportionable; what is harmonious and proportionable is true; and what is at once both beautiful and true is, of consequence, agreeable and good. (2:268–69)
>
> [T]he most natural beauty in the world is honesty and moral truth. For all beauty is truth. True features make the beauty of a face; and true proportions the beauty of architecture; as true measures that of harmony and music. In poetry, which is all fable, truth still is the perfection. (1:94)[9]

It is my contention that Shaftesbury, rather than separating the contemplation of beauty from the sphere of morality, wants to place it solidly within the realm of an acceptable morality. He wants to assert that there is a moral way of admiring

things, a way which is not to be identified with luxury, covetousness, avarice, ostentation, and similar—to Shaftesbury and most of his contemporaries—immoral qualities.

Taken in its most literal sense, Shaftesbury's argument seeks to separate the desire for possessions and property from the (rational) appreciation of something for the sake of its beauty. Why was this separation important to Shaftesbury? As I have shown above, the notion that "interest rules the world" was common in the late seventeenth and early eighteenth centuries, and "interest" was in particular connected with wealth. It was a commonly held opinion in contemporary discourse that appreciation and desire to possess could be conflated, or that the one (appreciation, admiration) would naturally lead to the other (desire to possess). Shaftesbury was opposing views held by three of the most influential philosophers of his time, Locke, Hobbes, and Descartes. Though his arguments were directed against the philosophers they were, at the same time, part of a tangled contemporary controversy, to which I will return shortly. But first I must say a few words about the philosophers.

The Philosophers of Self-Interest

In his *Essay* Locke defines joy as a "delight of the mind, from the consideration of the present or assured approaching possession of a good; and we are then possessed of any good when we have it so in our power that we can use it when we please" (*Essay*, 2.20.7). To be pleased with something we need, in other words, property of that which we think a good. When someone takes delight in the happiness of his friends or children he is said to love them, but love is actually often an expression of the "delight we find in ourselves" (*Essay*, 2.20.5). The notion of joy or enjoyment expressed by Locke comes close to the one Theocles argues against in the quotation above from *The Moralists*.

Locke's view has strong similarities to views expressed by Descartes and Hobbes. In *The Passions of the Soul*, a work we know from comments in the *Characteristics* ([1711] 1963, 1:191) that Shaftesbury despised, Descartes says that most passions are caused by our encounter with different objects. But whether or not objects "excite diverse passions in us" depends, not on the objects, but only on the possible use we think they may be to us, "because of the diverse ways in which they may harm or help us, or in general be of some importance to us." The beauty of flowers, which are of no use to us, "incites us only to look at them," whereas the beauty of fruits incites us to eat them (Descartes [1649] 1975, 357, 371).

In *Leviathan*, Hobbes identifies the use of the term beauty with that of containing a promise of something good (Hobbes [1651] 1968, 121). To Hobbes there is no absolute good (120, 160), but everyone desires power, because power is the only means by which it is possible to secure whatever we may individually consider

good (150, 161). What is good is simply what we desire, "whatsoever is the object of any mans Appetite or Desire" (120). Appetite moves us towards objects. The appearance of something good gives rise to pleasures, most of which—such as what is pleasant in *"Sight, Hearing, Smell, Tast, or Touch"* (122)—are of a sensual kind. Hobbes allows for pleasures of the mind, but these are just expectations or imaginations of sensuous pleasures. Hobbes also identifies possession of a high degree of wit and fancy with desire for power and riches: "The Passions that most of all cause the differences of Wit, are principally, the more or less Desire of Power, Riches, of Knowledge and of Honour. All which may be reduced to the first, that is Desire of Power. For Riches, Knowledge and Honour are but severall sorts of Power" ([1651] 1968, 139). The absence of a desire for riches, etc. consequently leads to a lack of fancy and judgment. In sum, Hobbes' view is close to the view expressed by Locke in the passage from the *Essay* quoted above. It is, then, a common assumption in Descartes', Hobbes', and Locke's discussions of pleasure and enjoyment that these are mostly sensuous and based on individual self-interest.

Shaftesbury's argument that we have an ability disinterestedly to observe something beautiful, and that this beauty is (or can be) of a nonsensuous, rational kind, can now be seen to serve an important function in his general philosophical strategy: it underlines and illustrates his criticism of the view, prevalent in the last half of the seventeenth century and in the eighteenth century, that human beings always act only on the basis of "interest" or "self-love." Criticism of the view of human nature as guided by "interest" had occupied Shaftesbury since his first published work.[10] When we see something beautiful, and appreciate it in the proper manner, we have, according to Shaftesbury, an instance where we are beyond any narrow self-interest. Disinterestedness is, therefore, not a category which lifts aesthetic contemplation beyond the reach of morality, but one that places it squarely within it. Even when the concept is ostensibly used in its most directly aesthetic sense, it has a clear moral content.

But which moral content? I have briefly related Shaftesbury's standpoint to those of Locke, Descartes, and Hobbes, but the discussion about pleasure and the possibility of disinterested contemplation had, as mentioned earlier, much more than philosophical significance. It was an important part of a cultural struggle about the direction England should take after the revolution of 1688, and about the formation of those new ideals of behavior I have discussed above. I will use the German *Bildungsideal* to designate the ideals Shaftesbury and his contemporaries referred to with terms such as "good-breeding," "manners" and "politeness." For Shaftesbury, morality and manners cannot be separated, and the content of Shaftesbury's moral-aesthetic view must therefore be understood through an examination of this *Bildungsideal.* Shaftesbury's conception of the virtuoso gentleman becomes part of a new *Bildungsideal,* and an interest in the arts is a central ingredient in this ideal.

In promoting his alternative, Shaftesbury is maneuvering among a number of positions, opposing the vulgar habits of the people as well as the luxurious liv-

ing identified with the court. He agrees with the need for reform and shares the Puritan disdain for many forms of popular culture, but did not share their total rejection of refinement. Shaftesbury defends his position by showing that their moral suspicions of the arts and refinement were unjustified. Art appreciation is not morally suspect; it does not lead to libertinism.

The Reformation
of Manners

Discussions about the arts cannot be separated from that broader political process in which a new England was formed or envisioned after 1688. It was in this context that the urgency for Shaftesbury to address the relationship between morality, manners, and beauty arose. The forging of a new moral and social order, and of what I have called a new expressive order, came to the fore in the movement for the reformation of manners. In the last decade of the seventeenth century and the first decades of the eighteenth century, the societies for the reformation of manners represented the most significant attempt at a reformation of behavioral patterns. It is necessary to address Shaftesbury's relationship to these societies because his position in part grew out of his theoretical engagement with them. Against the background of these historical considerations emerge a new interpretation of Shaftesbury's philosophy and a deeper understanding of the philosophical and historical context out of which aesthetics as a philosophical discipline grew.

The Moral Revolution

The political revolution in England in 1688 was accompanied by what has been called a moral revolution, an essential part of which was the reformation of

manners (Bahlman 1957). For those most eager in the reformation of manners, manners and morality were, to the extent that they were distinguished at all, seen as two sides of the same issue.[1]

In a larger historical perspective the interest in the reformation of manners is part of the demise of a centuries old popular (or folk) culture in Europe (see Burke 1978, particularly chap. 8). Throughout the Middle Ages, the official ecclesiastical and political culture was parallelled by a less serious undercurrent of folk-culture or popular culture. It is important to appreciate this aspect of medieval and renaissance culture in order to understand the Enlightenment's preoccupation with the reform of manners. The "laughter culture" or "carnival culture," as Bakhtin calls it, was characterized by total opposition to the serious, political, feudal and ecclesiastical forms and ceremonies (Bakhtin 1984). For the duration of the carnivals the usual hierarchies dividing people were suspended, and momentarily everybody was equal. This popular culture was also a culture of the market place, for example Bartholomew Fair in London,[2] but it was not restricted to the lower classes. Both the nobility and the clergy participated widely in popular culture, particularly during festivals (Burke 1978, 24f.; Malcolmson 1973, 13).[3] In addition to popular culture the upper classes had a separate culture in what Burke calls the "great tradition" of the classical heritage as it was transmitted in the schools and universities, and in the form of courtly music, poetry, and theater, from which the lower classes were of course excluded.

The reform movement of the late seventeenth century was not the first such attempt, but in the sixteenth century reforming Puritans had met with less success (see Burke 1978, 207). The upper class was then still united with the mass of the people against the reformers, and in 1633 Charles I issued a proclamation defending the rights of the people to their traditional entertainments (Malcolmson 1973, 11).

In the late seventeenth century the change in manners was not just left to chance, but implemented in a systematic way by the societies for the reformation of manners. The first such society was formed in London in 1690, but the idea rapidly spread to other parts of Britain (Bahlman 1957, 31). Most of the members of the reforming societies were not Anglican. Socially they seem to have been composed mostly of tradesmen and apprentices (Bahlman 1957, 69), and they were most successful in the cities, particularly in London (Malcolmson 1973, 160–61).

The societies promoted the Puritan values of industriousness and seriousness, and the discipline necessary for work in larger manufacturing industries with a division of labor more complicated than in a rural economy. Terms like "frugality," "squandering," and "spendthrift" became widely used for the first time towards the end of the sixteenth century, the first to designate a positive attitude to a certain form of behavior, the latter two to express "a new disapproval of the aristocratic ideal of conspicuous consumption" (Skinner 1988b, 114–15). Though these values were Puritan in origin they became widely accepted. They were not limited to

dissenters, but were ultimately accepted by the Church of England, as can be seen in, for example, the Charity School Movement (Malcolmson 1973, 90). In the process Puritanism loses whatever revolutionary aspirations it originally had.[4]

In a proclamation from 1689 King William emphasized the significance of the reformation of manners:

> We most earnestly desire and shall endeavour a general refor-
> mation of manners of all our subjects as being that which must
> establish our throne and secure to our people their religion,
> happiness, and peace, all which seem to be in great danger at
> this time by reason of that overflowing of vice which is too
> notorious in this as well as other neighbouring nations.
> (Quoted from Bahlman 1957, 15; see also Woodward 1699)

Another proclamation "For preventing and punishing Immorality and Prophaneness," issued by William in February 1697, was essentially an encouragement to enforce the existing laws. It urges mayors, sheriffs, justices of the peace, and everybody else for that matter, "to be very Vigilant and Strict in the Discovery and the Effectual Prosecution and Punishment of all persons who shall be Guilty of Excessive Drinking, Blasphemy, Prophane Swearing and Cursing, Lewdness, Prophanation of the Lords Day, or other Dissolute, Immoral or disorderly Practices" (Woodward 1699). The order had to be read in church at least four times a year. Since many people, if left to their own devices, would prefer to play football or dance rather than go to church, profanation of the Lord's day and popular culture were closely connected in the minds of many Puritans (Malcolmson 1973, 9).

The repeated announcements urging the enforcement of existing laws indicate that it was far from simple to establish basic principles of good behavior with the unruly Britons. An important task of the societies for the reformation of manners was to secure the enforcement of laws against profaneness, drunkenness, swearing, and so on. Through a net of informers, these societies went about their work, and in 1704 Woodward reports that no less than thirty thousand persons had been convicted for profane swearing and cursing, and about the same number had been punished for other forms of disorderly behavior (Woodward 1704, 32). In 1720 Woodward claims 75,270 prosecutions since 1691 (Bahlman 1957, 56). In addition to securing the enforcement of the laws, the societies distributed religious tracts and "Dissvasives from the Vices of the Age" (Woodward 1704, 32), of which Woodward's accounts of the societies and his reports on their progress are examples.

A reformation of manners was seen as a necessary prerequisite for social stability. Lewd and vicious persons had a spirit which was not conducive to subordination but to the levelling of social differences (Bahlman 1957, 42).[5] The Puritan divine Richard Baxter (1615–91) found that those participating in the popular festivals are led into "idleness, riotousness and disobedience to their Superiors."[6]

According to Tawney, Baxter condemned luxury, unrestrained pleasure, and personal extravagance; for "every penny which is laid out . . . must be done as by God's own appointment" (Tawney 1984, 241–42).

The discussion about manners was, thus, inseparable from political discussions and the struggle to shape the new England after 1688. In the words of Tawney, the ideal is "a society which seeks wealth with the sober gravity of men who are conscious at once of disciplining their own character by patient labour, and of devoting themselves to a service acceptable to God" (Tawney 1984, 114).

The reformers of the late seventeenth century directed their efforts not only to the people, but also to the elements of the upper classes who retained a connection with popular culture. The Puritans were concerned with reforming the people at large, but their attacks were often directed against the powerful in society. Though the initial reform of manners had approval and encouragement from the highest places, it was soon feared that it might go too far.

The theater was one of those places where high and low would meet in common entertainment, and it was one of the institutions the Puritans most vehemently opposed. Shaftesbury notes that the state of the royal theater is in many ways no different from that of the popular circus or bear-garden (Shaftesbury [1711] 1963, 2:315). Indeed, many people seem to indiscriminately frequent both places. Shaftesbury emphasizes that there is nothing wrong with theater in itself: "The practice and art is honest in itself. Our foundations are well laid" (1:315). But in theater, poetry and other arts, as well as in manners and in life in general, politeness requires obedience to certain standards of good taste.

Shaftesbury occasionally comments on still existing forms of popular culture. His familiarity with carnivals is evident from his reference to the carnivals at Paris and Venice (1:57). Shaftesbury considered carnival a ridiculous practice, and adds that "he who laughs and is himself ridiculous, bears a double share of ridicule" (ibid.). The carnivalesque laughter has, according to Bakhtin, the exact opposite feature. As opposed to, say, modern satires, the carnivalesque laughter does not differentiate between the object and the subject of ridicule. You are laughing at yourself and the world. The carnivalesque laughter is connected with popular culture, and opposition to it is only one part of the changing attitude to popular culture and the turn to modernity.[7]

Art, Manners, Morality, and the Politics of Luxury

In the early eighteenth century the category of the fine arts did not yet exist. Where we see a category which sets off, for example, some forms of painting and sculpture from our wardrobe and the way we furnish our homes, these were at

the time seen as manifestations of the same phenomenon. For most people "art" also included gardening, for example, and Hutcheson discussed dress, equipage, and furniture on a par with painting and sculpture (Hutcheson 1973, 88). In Shaftesbury's use of "art" some of the ancient meaning of skill is preserved. Surgery and horsemanship are called arts (Shaftesbury [1711] 1963, 1:105; 2:9), but most of what we would include among the fine arts are also called arts by Shaftesbury: painting ([1711] 1963, 1:94, 214, 219; 2:242), music (1:227), architecture (1:227; 2:63, 242), sculpture (statuary) (1:214, 227; 2:242), poetry (passim). Rhetoric is also an art (1:188). Music (1:104) and painting (Shaftesbury 1969, 20) are also sometimes called sciences, along with ethics, dialectics, logic ([1711] 1963, 1:168), and morality (1:187, 220), revealing that the two terms could be used almost as synonyms, in the broad sense of skill ("is there no skill or science required?" [2:130]).

In the earlier parts of the eighteenth century considerations of art were closely connected to the issue of luxury. In general, as Remy Saisselin points out, what we would consider arts, for example paintings, "were only one manifestation of the taste of the rich and the great for possessions, pleasures, magnificence, and pretty women" (Saisselin 1992, 52–53). The discussion of dress and fashion played a particularly prominent role (see for example Collier, *Upon Cloaths* [in Collier 1698]; for an overview see McKendrick 1982b).

Interest in the arts was often seen as directly connected with the life of the idle rich, or as a mere display of wealth, and therefore morally suspicious. Much of the hostility to the arts or to particular kinds of art were connected to this association with a particular class and to the courtly life. Attitudes to luxury and art went together: those suspicious of luxury were also suspicious of the arts and vice versa. To change one, the other had to change, or one had to liberate the category of art from the category of luxury.

Showing not only that involvement with art was not adverse to virtue, but on the contrary might contribute to it, was a good argument for the appropriateness of the gentleman's occupation with the arts. Could this be done, Shaftesbury could hope to deliver a moral justification for the growing interest in the arts in England in the early eighteenth century.

"Luxury" is a central term in contemporary condemnations of the life of the aristocracy, and it undergoes profound changes in meaning in the course of the eighteenth century (Berry 1994; Saisselin 1992; Sekora 1977, pt. 3). Discussions of luxury date back at least to Plato. Both Plato and Aristotle thought that luxury would lead to softness and thus disqualify one for a military life which necessitates courage. It is therefore not surprising that the attitude to luxury begins to change when the emphasis is no longer on a military life, and when commerce comes to play an increasing role (Berry 1994, 58–60).

Advocacy of trade and consumption represented a radical departure from classical and Christian ideals of a harmonious and ascetic life (Berry 1994, 120f.). The imaginary ideal was often envisioned as a life in rural simplicity wherein the basic human needs for food, clothing, and shelter are fulfilled, but in which unsettling new

needs do not constantly require fullfilment. This ideal retained its appeal late in the eighteenth century, and is expressed, for example, in Oliver Goldsmith's poem "The deserted Village" from 1770. Goldsmith portrayed the destruction of the simple, idyllic, but contented, life of the peasant resulting from the accumulation of wealth and the indulgence in luxury. Happiness, innocence, health, naturalness, simplicity, ignorance (of wealth and ambition), agriculture and virtue are contrasted with wealth, trade, pomp, opulence, art (as opposed to nature), vice, and luxury.

Luxury originally had a definite negative sense. It was a source of destruction and depravity in the individual as well as in the state (Sekora 1977, pt. 1). Luxury is riot, excess, extravagance, debauchery—the sense in which Shaftesbury uses the term (see for example [1711] 1963, 1:82, 201–6, 219–20n, 321–23). By the mid-eighteenth century, when Hume, continuing a trend begun by Mandeville and Hutcheson, wrote his essay "Of Refinement in the Arts," luxury was no longer a term with exclusively negative connotations, but now had the sense of refinement and polish, at least when not taken to extremes. (The initial title of Hume's essay was actually "Of Luxury".)

Luxury plays a central part in the discussions about the role of the arts and in Shaftesbury's writings. Shaftesbury wants to reject both the vulgar taste of the multitude and a courtly and aristocratic culture that has some of the features identified with the vulgar, but which is more frequently identified with luxury. For Shaftesbury the primary seat of luxury is the court:

> 'Tis otherwise with those who are taken up in honest and due
> employment, and have been well inured to it from their youth.
> This we may observe in the hardy and remote provincials, the
> inhabitants of smaller towns, and the industrious sort of com-
> mon people, where 'tis rare to meet with any instances of those
> irregularities which are known in courts and palaces, and in
> the rich foundations of easy and pampered priests. ([1711] 1963,
> 1:313)

In *Second Characters, or the Language of Forms*, the reign of King Charles II is condemned as one of luxury and pleasure (Shaftesbury 1969, 20): "it is not the nature of a court (such as courts generally are) to improve, but rather corrupt a taste" (Shaftesbury 1969, 23). In an introduction to a collection of some of Shaftesbury's letters, John Toland (1670–1722) says that Shaftesbury sometimes expressed an "uncommon aversion" for the court (Shaftesbury 1721, xv).[8] Shaftesbury identifies punning, a particular form of wit, with the court, and condemns it, though he considers it mostly a thing of the past ([1711] 1963, 1:46). Addison, too, condemned punning and identified it with the court of King James the First (*Spectator* 61 [10 May 1711] and 62 [11 May 1711]).

Thus Shaftesbury shared many radical, Protestant values, and he shared most of their political goals. Besides being extremely well connected with the

English Whig leadership (evident from, for example, the correspondence in Shaftesbury 1900), he was a personal friend of some of the Calvinists in exile in Holland, for example Pierre Bayle (1647–1706). Jean Le Clerc (1657–1736) translated and published writings by Locke and Shaftesbury, and reviewed Shaftesbury's writings favorably in the *Bibliothèque Choisie* (Fowler 1882, 136). Shaftesbury was also a friend of the English Quaker merchant Benjamin Furley (1634–1714). Furley lived in Rotterdam, and Locke had stayed in his house while a refugee in Holland. Furley's home in Rotterdam was the meeting-place for "English republicans, Dutch Dissenters and French refugees" (Jacob 1981, 149). Shaftesbury and Furley corresponded for the rest of their lives. Furley's home might also have been where Shaftesbury met Toland, a radical Whig and republican and, according to Margaret Jacob, a Freemason (Jacob 1981, 152). The Freemasons played an important part in spreading to the continent what they took to be the principles of the revolution of 1688. Shaftesbury did not approve of all parts of Toland's politics, but he did support him financially (Shaftesbury 1900, xxiii–iv, cf. Brett 1951, 42).[9] Many Huguenots came to England following the revocation of the Edict of Nantes in 1685 (though many came before). In England they supported the Whigs— some of them even came to England with William's army in 1688 (Arnstein and Willcox 1983, 6). From London (and Holland) they would continue to exert their political influence on the continent with propaganda in support of the English spirit, English liberties, and the English political system (Koselleck 1989, 64–65).

Though Shaftesbury shared the political goals and many of the Puritan values of the middling sort of people, he did not share the religious fanaticism of some of them, and he did not think that use of power was an appropriate way to enforce religious beliefs. As Locke, Shaftesbury thought that everything, including religious beliefs, should be open to critical scrutiny:

> There can be no impartial and free censure of manners where any peculiar custom or national opinion is set apart, and not only exempted from criticism, but even flattered with the highest art. 'Tis only in a free nation, such as ours, that imposture has no privilege; and that neither the credit of a court, the power of a nobility, nor the awfulness of a Church can give her protection, or hinder her from being arraigned in every shape and appearance. ([1711] 1963, 1:9)

If a certain point of view is true it will hold up to scrutiny, so there is nothing to fear from free criticism: "Let but the search go freely on, and the right measure of everything will soon be found" (1:10). Though Shaftesbury defended freedom of expression, he also imposed limitations on this freedom. Shaftesbury is writing in defence "only of the liberty of *the club*, and of that sort of freedom which is taken amongst gentlemen and friends who know one another perfectly well . . . [W]hat is contrary to good breeding is . . . contrary to liberty" (1:53).

It is often pointed out that Shaftesbury's *Letter Concerning Enthusiasm* (written 1707) is an attack on the excesses of the French Prophets (not to be confused with the Huguenots, who disapproved of the Prophets). It is certainly true that Shaftesbury was strongly opposed to claims about miracles and religious revelations (see particularly Shaftesbury [1701] 1981), but given the charged moral and political atmosphere in England in the first decade of the eighteenth century, his *Letter* was interpreted as a general attack on the attempts to reform manners. Ironic statements, such as the remark that "[i]f the knowing well how to expose any infirmity or vice were a sufficient security for the virtue which is contrary, how excellent an age might we be presumed to live in!" ([1711] 1963, 1:9), could easily be read by contemporaries as a criticism of the efforts of the reforming societies. Part of the motivation of the reformers was to save souls that might otherwise go to hell, a project Shaftesbury also ridiculed:

> [A] new sort of policy, which extends itself to another world and considers the future lives and happiness of men rather than the present, has made us leap the bounds of natural humanity; and out of a supernatural charity has taught us the way of plaguing one another most devoutly. It has raised an antipathy which no temporal interest could ever do; and entailed upon us a mutual hatred to all eternity. And now uniformity in opinion (a hopeful project!) is looked on as the only expedient against this evil. *The saving of souls is now the heroic passion of exalted spirits; and is become the chief care of the magistrate, and the very end of government itself.* (1:15; my italics)

Shaftesbury clearly opposes the interference of the magistrate or other civil authorities in religious controversies as this was sanctioned by royal proclamations and by the reforming societies. He was therefore castigated as an enemy of propriety and morality as such and a defender of moral decadence.

One such attack came from Mary Astell in a pamphlet from 1709. Astell, according to her recent biographer, did not at first know who the author of the *Letter* was, but thought it might be Steele or Swift (Perry 1986, 224–25).[10] Astell was a Tory, but shared the Puritans' pious morality, and their suspicion of fashion and empty flattery. She was also a reformer, and she opened a charity school in 1709 (Perry 1986, 238). Astell's pamphlet often distorts Shaftesbury's views, and in retrospect it seems that the disagreements between Astell and Shaftesbury are less significant than they were initially perceived to be. Astell read Shaftesbury's letter as an expression of the decay in manners and morals which had taken place in the time since the disappearance of the "Ancient *English* Peerage" (Astell 1709, 83). These ancient peers of England "subdu'd themselves, as well as their Enemies. Their Health was not consum'd in Debauchery, nor were their Estates squander'd in Vanity, Gaming and Luxury" (Astell 1709, 83–84). By contrast, the present aristocrats are

"Covetuous, Boasters, Proud, Disobedient, Unthankful, Unholy, without Natural affection . . . lovers of their own selves" (82). The position Shaftesbury defends is repeatedly identified with that of a "libertine," a "great man," or simply a gentleman. The pleasures of a true Christian are of a lasting character, while those of the libertine (such as Shaftesbury) are of a fleeting and disappearing kind (89–90). Christianity is opposed to luxury and sloth. The libertine enjoys only "Brutal Pleasure" (139), or "Pleasures of Sensation" and is always a "Slave to the Appetites" (140).

Astell was not the only one suspicious of the rich. A similar attitude is expressed in an early eighteenth-century book on courtesy, *The English Theophrastus*, published in three editions between 1702 and 1708. Many of the ideas advanced in it are similar to Shaftesbury's, and the demand for the book supports the assumption that they were widely accepted ideas in the early part of the eighteenth century.[11] In it we read that the "generality of Mankind sink in Virtue as they rise in Fortune. How many hopeful young Men by the sudden Accession of a good Estate have deviated into Debauchery, nay turned absolute Rakes" (Boyer 1702, 71–72). It is different with those who have acquired wealth by their own industry. "It is not for acquiring Wealth, but for misemploying it when he has acquired it, that a Man ought to be blamed" (78). The book is clearly addressed to a middle class audience. The "Middle State both of Body and Fortune" is declared to be the best (75), and notions of nobility and birthright are dispelled.

Again, similar sentiments are expressed by Jeremy Collier. A high position in society only deserves respect if it is a result of one's own achievement. Hereditary nobility does not guarantee a person's moral uprightness—on the contrary, if people with a noble title have a certain air about them it is probably because they have never done an honest day's work, and is the result of a "Slothful and Effeminate Life" (Collier 1698, pt. 1, p. 58). Differences in social position, Collier repeatedly emphasizes, are necessary for the promotion of industry and the support of government (pt. 1, pp. 16, 62, 100). But the important thing is present merit, not whatever one's forefathers, however deserving, may have done. Distinction is necessary as a reward for merit and industry. If it were not possible to better one's position in society nobody would be industrious (p. 63). One should not exhibit one's superior position. For private persons to appear "Pompous in Equipage or Habit, is but a vain-glorious Publishing of their own Grandeur" (p. 100). One should conceal rather than make an ostentatious display of wealth. Besides, outward appearance is no reliable guide to people's position in society, since "every one has the liberty to be as Expensive, and Modish as he pleases. . . . [O]rdinary People, when they happen to abound in Money and Vanity, have their Houses and Persons as richly Furnished, as those who are much their superiors" (p. 102). Dressing beyond one's station in life, Collier thought, was not just immoral, but could have the most dangerous political implications. To do so "looks like a Levelling Principle; like an Illegal Aspiring into a forbidden Station. It looks as if they had a Mind to destroy the Order of Government, and to confound the Distinctions of Merit and Degree" (Collier 1698, pt. 1, p. 111).

For Collier, morality, manners, and politics are closely connected—even down to the level of the choice of dress. But in fact Collier's observation is correct: When enough money (or ability to consume) is the only barrier to appearing as one of the mighty of this world, distinctions based on rank are in jeopardy. The possibility of deceiving appearances are great, unless some other, perhaps subtler, way of drawing distinctions is created.

The evidence I have offered thus far shows us that the case for refinement and an interest in art needed to be made, and its association with decadence and luxury had to be broken. The historical context sketched provides the reasons why Shaftesbury would present an argument about the morality of art appreciation in the manner suggested by my interpretation. It shows why a moral justification for the involvement with art was a politically and personally urgent task for Shaftesbury.

That Shaftesbury saw a need to address these questions can also be inferred from some of the changes made between the publication of *The Sociable Enthusiast* in 1703 or 1704 and the publication of *The Moralists* in 1709. *The Moralists* is essentially an extended version of *The Sociable Enthusiast*.[12] One of the questions elaborated on in *The Moralists*, as compared to the earlier version, is the distinction between the pleasures of sense and the pleasures of reason. Shaftesbury vehemently attacks those who seek only sensuous pleasures, and calls them "our modern Epicures." Among the "purely mental" satisfactions Shaftesbury mentions the work of the mathematician, the toils of the "bookish man," and "the artist who endures voluntarily the greatest hardships and fatigues" (92 [Standard Edition]; 2:32 [Robertson Editon]). In fact, the "satisfactions of the mind" and the "enjoyments of reason and judgement" should not properly be called pleasures at all. These pleasures are not accessible to the Epicureans—they have called them pleasures only to dignify the term pleasure and, by implication, to give themselves a license to practice pleasures of a more vulgar kind (SE 92; RE 2:33).

The type of accusations here exemplified by Mary Astell and others are the kind Shaftesbury tried to keep at a distance in his explanation of disinterested contemplation of art and nature, and they add force to my argument that Shaftesbury's purpose was not to separate the contemplation of art from morality, but instead to place it within an acceptable morality, a morality which would free artistically interested gentlemen from accusations of luxury and sloth.

Politeness

A s shown in chapters 8 and 9, notions of social status were rapidly changing in England in the seventeenth century, reflected in, among other things, a change in the conception of what it is to be a gentleman. When social status and its manifestations are uncertain, questions of the presentation of the self—what I have called the expressive order—become particularly important. In this context, Shaftesbury had good reasons to argue for the moral appropriateness of an interest in art.

The positive alternative advanced by Shaftesbury converges around the concept of "politeness," which refers to an ideal of appropriately sophisticated and pleasing behavior in social interaction. An interest in art and the possession of taste became central ingredients of politeness. But many of Shaftesbury's contemporaries saw the connection between manners and morality or virtue as negative. Politeness was all appearance, and no soul. Against them, Shaftesbury wanted to show that it did not have to be like this, that rightly understood, politeness and virtue were one. From Shaftesbury's defence of the arts emerges a new *Bildungsideal* which embodies a view of the social order.

Politeness, Art, and Virtue

Shaftesbury saw himself as a part of a new England which had come into being after 1688. Many things, particularly in the political and economical spheres,

had greatly improved: "We are now in an age when Liberty is once again in its ascendant" ([1711] 1963, 1:145). But much was still to be desired. England's financial and political growth had not been accompanied by a comparable growth in taste and politeness (2:249, 314). Since, however, "[a]ll politeness is owing to liberty" (1:46), England was now in a favorable position to take that leadership position which once belonged to Greece. Politeness, for Shaftesbury, can only blossom under conditions of liberty. Where freedom prevails—such as in England or among the ancients—urbanity and politeness will be the dominant forms of expression (1:50–51, cf. 142–43; Shaftesbury 1969, 105). Where liberty is wanting (such as in Italy), rustic forms of expression (raillery, etc.) abound.[1] Shaftesbury sees it as one of his principle tasks to bring England to a position of cultural leadership among the nations of Europe.[2]

Politeness is an elusive concept. It is sometimes used in the sense of "civilized" or "cultured," as when Shaftesbury describes ancient Greece as a polite nation. In this sense politeness describes a high degree of development towards an ideal. In Shaftesbury's time however, terms like "politeness" and "good breeding" were more often expressions for desirable patterns of social behavior. As Klein remarks, "'politeness' was not a form of nostalgia, but a program for modernity" (Klein 1984, 213). Politeness relates to the behavior of individuals. It expresses an ideal of behavior, education, and sociability, a *Bildungsideal*. It is synonymous with good breeding, manners or gentility, and occasionally with gallantry (Hume). Politeness or breeding is the criterion for membership in the elite.

Manners or politeness show themselves in all areas of behavior, from the taking of snuff (discussed by Steele in *Tatler* No. 35), to the principles of literary criticism (as in Addison's discussion of the critic in *Spectator* 291). According to James Forrester, the essence of politeness consists in the right timing and discreet management of "a Thousand little *Civilities, Complacencies*, and *Endeavours* to give others *Pleasure*" (Forrester 1745, 10).[3] For Forrester it is possible to explain only negatively what politeness is. Its actual mastery must be achieved by emulation, "from Company and Observation" (40), particularly by interacting with "the Ladies."

Forrester addresses an audience familiar with the language of banking and trade and often uses economic metaphors. The concern for the minutiae of manners is compared to the concern for small amounts of money: "People are too apt to think lightly of Shillings and Pence, forgetting that they are the constituent Parts of a Pound" (9). By politeness one can defend and achieve a good reputation or fame. "Fame is a kind of Goods, which, when once taken away, can *hardly* be restored" (26). "*Conversation* is a Sort of *Bank*, in which all who compose it have their respective Shares" (31). His position represents the commodification of interpersonal relationships. Politeness became, in our sense of the term, an *image*: it is the manner in which you present your self on the market in the hope of increasing your value.

For Locke, too, the most important accomplishment in politeness or breeding is to please others, to do what is expected of us in social intercourse. Locke emphasized that the most important parts of breeding are, first, "a disposition of

the mind not to offend others; and secondly, the most acceptable and agreeable way of expressing that disposition." This state is achieved chiefly by emulation of "persons above us," by observation of those "who are allowed to be exactly well-bred" (Locke [1693] 1963, 134).

Locke was sufficiently steeped in the puritan tradition to modify the emphasis on appearance which gradually became the sole content of the tradition of politeness. Locke's entire regimen of education is an earnest attempt to acquire self-discipline (as is Benjamin Franklin's), and to make one's behavior reflect a genuine good-will and regard for all people. For Forrester, as later for Chesterfield, what you actually think of other people is irrelevant. The rules for politeness Forrester offers "are intended . . . to guide Men in *Company*," rather than when they are alone. "What we advance tends not so directly to amend People's Hearts, as to regulate their Conduct" (Forrester 1745, 20).

Not surprisingly, many writers in the early eighteenth century criticized what they took to be the lack of connection between morality or virtue on the one side and politeness on the other. In *The English Theophrastus* we read:

> Politeness, or Good-breeding, does not always inspire a Man
> with Humanity, Justice, Complaisance and Gratitude, but yet it
> gives him the outside of those vertues, and makes him in
> appearance what he should be in reality. (Boyer 1706, III; cf.
> Klein 1984, 190–91)

The lack of connection between virtue and politeness or good manners was a theme for Mandeville: manners and good breeding consist "in a Fashionable Habit, acquired by Precept and Example, of Flattering the Pride and Selfishness of Others, and concealing our own with Judgment and Dexterity. . . . Good Manners have nothing to do with Virtue or Religion; instead of extinguishing, they rather inflame the Passions" (Mandeville [1714] 1924, 1:77, 79). Manners were, however, a clever tool for civilizing people in a modern commercial state (Hundert 1994, 73–74).

Many authors of the period saw a contradiction between the emphasis on appearance or self-presentation and sincerity or moral uprightness (Klein 1984, 190). In a book Addison called "one of the best" books in the world, the enormously popular *The Whole Duty of Man*, Richard Allestree (1619–81) emphasized the obligation of humility, a duty violated by pride.[4] Pride in the goods of Fortune (wealth and honor) add nothing to a man, except "outward pomp and bravery" (Allestree 1684, 54). It is a virtue to be content with our position in life, and not be ambitious and covetous (60–61). Allestree advised the observation of modesty in apparel. To follow fashion in dress is "a most ridiculous folly," though differences in dress are necessary to distinguish between people of different stations in society. Everybody should dress in accordance with their place and calling, but not strive to dress better than their position allows for, or strive to appear as their superiors (77–78).

It is exactly because the issue of the relationship between manners, polite-ness and virtue and sincerity had significance far beyond choice of dress and appearance it becomes so important. It touched on the whole issue of religious conformity and social stability, and on the relationship between appearance and reality in a period where one's religious stand often followed political opinions. One could hide Catholic, and consequently Jacobite, sympathies under a cloak of the most auspicious manners. The relationship between appearance and reality was important in the debates about religious conformity and toleration. Man-deville revelled in the observation that there was no connection between appear-ance and true character, a point also made by those who opposed imposition of strict rules of religious conformity, since the outward practice of Christian virtue was no reliable guide to the underlying motives (Hundert 1994, 30). This raised the prospect that even atheists could be governable subjects, a conclusion drawn by Pierre Bayle. Any man, regardless of belief, "could make a good subject, since civil conduct required only the outward conformity to standards of propriety produced by social pressure and intersubjective expectations, underwritten by law" (Hundert 1994, 31).

Gentlemen of Fashion

The connection between manners, politeness, and virtue was thus quite problematic in the contemporary world. Shaftesbury (as well as Addison and Steele) wanted to show that politeness was compatible with virtue, and that a central part of politeness is an interest in the arts and the formation of a correct taste. Conversely, a proper (disinterested) approach to art reflects back on the moral character of the spectator, as one who is able to overstep the narrow bound-aries of self-interest.

One of the stated goals of the *Characteristics* is to "recommend morals on the same foot with what in a lower sense is called manners, and to advance philosophy . . . on the very foundation of what is called agreeable and polite" ([1711] 1963, 2:257). For Shaftesbury, philosophy was not an abstract discipline but should be devoted to the question of self-presentation. The purpose of philosophy is to "teach us ourselves," and to teach us self control and a degree of consistency in our behavior (1:184, cf. 2:274–75).

> To philosophise, in a just signification, is but to carry good-
> breeding a step higher. For the accomplishment of breeding is,
> to learn whatever is decent in company or beautiful in arts;
> and the sum of philosophy is, to learn what is just in society
> and beautiful in Nature and the order of the world. ([1711]
> 1963, 2:255; see also 2:3–5)

Through breeding or politeness, we gain insight into the principles of proper conduct, beauty, and justice. The basis for these principles is the discovery "within ourselves [of] what in the polite world is called a relish or good taste" (2:252), to discover the "foundation of right and wrong taste" (1:216). Those who are accomplished in all these areas and have obtained the proper taste must of neccessity also have reached true moral principles and can thus unite politeness and virtue. Though politeness and virtue are not united in everybody, it is in principle an achievable goal for all. Poor people may need the threat of a devil and a hell "where a jail and gallows are thought insufficient" (2:265; cf. 1:84–85), but it is possible for those who are not among "the mere vulgar of mankind" (1:84) or corrupted in other ways (for example by attending university) to conduct their lives in accordance with the natural order of things and become "gentlemen of fashion":

> By gentlemen of fashion, I understand those to whom a natural good genius, or the force of good education, has given a sense of what is naturally graceful and becoming. Some by mere nature, others by art and practice, are masters of an ear in music, an eye in painting, a fancy in the ordinary things of ornament and grace, a judgement in proportions of all kinds, and a general good taste in most of those subjects which make the amusement and delight of the ingenious people of the world. Let such gentlemen be as extravagant as they please, or as irregular in their morals, they must at the same time discover their inconsistency, live at variance with themselves, and in contradiction to that principle on which they ground their highest pleasure and entertainment. (1:89–90)

Shaftesbury's reasoning clearly relies on the assumption, central to his entire philosophy, that nature provides specific measures of right and wrong in morality, truth, and beauty. Gentlemen who do not live in accordance with these principles must eventually "discover their inconsistency," for living in accordance with these principles is also conducive to human happiness, while violating them leads to misery.

The formation of the right taste is not restricted to painting, music etc., but extends to areas such as behavior, countenance, and carriage:

> [I]n the very nature of things there must of necessity be the foundation of a right and wrong taste, as well in respect of inward characters and features as of outward person, behaviour, and action. . . . Even in the Arts, which are mere imitations of that outward grace and beauty, we not only confess a taste, but make it a part of refined breeding to discover amidst the many false manners and ill styles the true and natural one, which represents the real beauty and Venus of the kind. (1:216–17)[5]

The "gentleman of fashion" who unites these characteristics may become what Shaftesbury calls a "virtuoso." The task of the virtuoso is, among other things, to inform himself about the true standards in the arts and sciences. A virtuoso is essentially the same as a "real fine gentleman,"

> the lovers of art and ingenuity, such as have seen the world, and informed themselves of the manners and customs of the several nations of Europe; searched into their antiquities and records; considered their police, laws and constitutions; observed the situation, strenght and ornament of their cities, their principal arts, studies and amusements; their architecture, sculpture, painting, music and their taste in poetry, learning, language and conversation. (2:252–53; see also 1:217–18, 2:129; Shaftesbury 1969, 22)

A person who goes through this process becomes a "man of breeding and politeness." Although this is, in principle, a goal attainable by all, it is clear that in practice it is restricted to those with substantial amounts of time and money to spare. To become "a real fine gentleman" is a social privilege. Since the good and the beautiful are the same, a person who has the right taste in arts and manners at the same time has insight into what virtue is, and, unless he is a very unnatural person, acts accordingly: "Thus are the Arts and Virtues mutually friends; and thus the science of virtuosi and that of virtue itself become, in a manner, one and the same" ([1711] 1963, 2:253).[6] Only for the person capable of rising above the vulgar and sensuous is a "refined contemplation of beauty" possible ([1711] 1963, 2:128).

Politeness and Conspicuous Consumption

The eighteenth-century gentleman exemplifies what Thorstein Veblen calls conspicuous leisure: certain types of activity, in particular certain types of work, by which one may earn a living are seen as debasing. It is necessary to display one's distance from such activities, and this is done through "conspicuous leisure." The display can be accomplished indirectly, through "immaterial evidences of past leisure" such as being well versed in classical literature or languages, which have no practical application (Veblen 1931, 45). Knowledge of classical languages and literature is among the requirements Addison mentions for achieving "polite Learning" (*Spectator* 291). A knowledge about the "latest proprieties of dress, furniture, and equipage" is required, as is mastery of manners, breeding, polite usage, and formal and ceremonial observances (Veblen 1931, 45).

Veblen remarks that in periods in which conspicuous leisure is of particular importance, and eighteenth century England would be an instance of such a

period, the emphasis on manners is greater (Veblen 1931, 46). This is because manners, "the knowledge and habit of good form" (48), are themselves evidence of (past) conspicuous leisure. They can be acquired only through extensive exposure, and are therefore also a safeguard against impostors.

> Refined tastes, manners and habits of life are a useful evidence of gentility, because good breeding requires time, application, and expense, and can therefore not be compassed by those whose time and energy are taken up with work. A knowledge of good form is *prima facie* evidence that that portion of the well bred person's life which is not spent under the observation of the spectator has been worthily spent in acquiring accomplishments that are of no lucrative effect. (48–49)

As mentioned in passing, Steele's and Addison's project in some of the *Spectator*-papers must also be seen in the context of the advancement of politeness and manners. Dr. Johnson saw Addison's papers in *The Spectator* as a continuation of Casa's and Castiglione's writings on the conduct of the courtier, and the first English contribution to this genre.[7] Göricke drew a similar conclusion. The ideal gentleman envisioned by Addison and Steele retained elements of the leisured courtier described for example by Castiglione (1478–1529) in *Il Cortegiano* (English translation 1561). A gentleman is still not supposed to earn a living by manual labor (*Tatler* 66; Göricke 1921, 23), but the courtly ideal is strongly modified under influence of what are in effect puritan values, and particularly influenced by what Göricke calls *das Nützlichkeitsideal:* education must be *useful* for the fulfilment of particular tasks in life (an idea Göricke traces back to Milton [Göricke 1921, 14f.]). Already in the *Tatler*, Steele had declared himself "of the Society for the Reformation of Manners," but complained of the severity of some of their judgments, particularly in relation to the theater (*Tatler* 3, 14–16 April 1709). Addison and Steele develop a historical compromise between puritan sternness and religious zeal, and the traditional leisured life of the aristocracy. Their views were less harsh than the one proposed by the Puritans. A writer in the *London Journal* observed:

> 'Tis well known what good Effect the Essays in the *Tatlers* and *Spectators* had on the Manners of this Town. There was such a Delicacy in the Raillery, such a Becomingness in the Reproofs, that Men were shamed out of Folly and Vice, upon the Principles of Good Behaviour; and Society was freed from the Insults of Fools and Rakes, without their being allarm'd with the Terrors of Religion, or the Threats of the Law. (*The London Journal* 321, 18 September 1725)

Understandably, this new ideal had great appeal for the new upper class, and Shaftesbury's (and Addison's) new *Bildungsideal* was the one which became victorious in the course of the eighteenth century. Plumb (born in 1911) observes that Addison "was the model essayist in thought as well as style" when he was a boy at school (Plumb 1982a, 284). The new *Bildungsideal* offered an alternative to the traditional values of the gentry, though it retained aristocratic elements.

Through this process, high and low culture increasingly separate. The upper classes no longer participate in popular culture, but come to view it contemptuously. The popular becomes vulgar, and attempts at its systematic oppression increase.

The term "polite arts" expresses a social approval of the occupation with certain forms of art. William Aglionby used the term "polite arts" for painting, architecture, sculpture, music, gardening, conversation, and "prudent Behaviour" (see Klein 1984, 201n39). We find almost the same classification of the "polite arts" in Shaftesbury, though he also expressed some concern that painting is a vulgar art (Shaftesbury 1969, 18). The "polite arts," which from the mid-eighteenth century simply become the "fine arts," represent in this way a new historical form of the old distinction between the vulgar or mechanical arts, and the liberal arts. The classical division of the arts into liberal and vulgar, or mechanical, arts depended on whether or not they relied on physical or manual effort (Tatarkiewicz 1980, 88–89; Barasch 1985, 23). Those requiring manual effort were considered inferior, and consequently inappropriate activities for the elite. As long as the arts are "polite," their connection to a social elite is apparent. Though less apparent, they retain this connection when they become the "fine arts," as Roger Fry discovered in the early parts of this century.

To draw some conclusions from our examination: Shaftesbury was not interested in showing the existence of a form of aesthetic perception independent of morality. On the contrary he wanted to show that the appreciation of certain kinds of art, those conforming to the true standard of taste, were part of the development of a virtuous character. In his argumentation Shaftesbury was waging war on a number of fronts: against the philosophers of "private interest," against the "rustics," people with a "gothic" taste, the entertainments of the people, popular literature, and against the indulgence in luxury identified with the court and parts of the aristocracy.

Shaftesbury did not really think that everyone would be able to appreciate art in the required manner, but this restriction did not show that the principles of taste were not universal, only that some people did not have a fully developed faculty of taste, the conclusion also drawn by Addison and Hume (as we saw in chapter 9). In short, the preferences of a social group or class, those thought to be "polite," is identified as human nature, and those who do not live up to this standard are consequently regarded as less than fully human. As a matter of historical fact the polite were also the privileged in society. Since the standards of politeness are the standards with which all people must be measured, social privilege is identified with human nature.

Shaftesbury could hope to convince his readers that there was no necessary contradiction between the way a person chooses to present him- or herself and moral virtue, between outward appearance and inward character. By emphasizing that the person who has, among other things, proper taste in art and who follows accepted etiquette, is a "real fine gentleman," Shaftesbury contributes to fill a gap in the expressive order. He offers a new set of values for the presentation of the self in social interaction within the elite which rejects birthright as a valid criterion. He serves, as he himself put it, "the polite world and the better sort in those pleasures and diversions which they are sometimes at a loss how to defend against the formal censors of the age" (Shaftesbury 1969, 4).

Stolnitz is mistaken about the contents of the notion of disinterestedness. This idea, and the related idea of the autonomy of art, emerged as part of the forging of a new form of life. They developed as part of the political and social aspirations of the emerging middle class in England in the eighteenth century, as these are expressed, for example, in the conception of "politeness," and remain in their development inseparable from the social fabric of which they are a part. "Disinterestedness" is not as disinterested as it appears.

Hutcheson and the Problem of Conspicuous Consumption

Hutcheson continued the Shaftesburian theme of the unity of the good and the beautiful, and as did Shaftesbury he wanted to give moral legitimacy to the contemplation of art, a task forced upon him by the social and political circumstances of the early eighteenth century. The interpretation of Hutcheson to follow rests, then, on the historical context discussed thus far and what is added to that discussion in the present chapter. But it also has a textual premise: most commentators on Hutcheson treat the two treatises in Hutcheson's *Inquiry into the Original of our Ideas of Beauty and Virtue*, the first "Concerning Beauty, Order, Harmony, Design," the second "Concerning Moral Good and Evil," as discussions of unrelated subjects.[1] But Hutcheson considered morality and beauty to be intimately connected and frequently discussed *the moral sense* of beauty. The connection is central to both Hutcheson's theory of beauty and to his conception of morality.

Hutcheson's main concern in the first treatise was to develop a theory of beauty based on Locke's epistemology and psychology, but the treatise also contains important considerations on the arts. These comments must be interpreted in light of the contemporary controversy about luxury, and particularly in light of the unsettling treatment of that subject given by Bernard Mandeville (1670–1732) in *The Fable of the Bees.*

Luxury, Conspicuous Consumption, and Mandeville's Fable

It is gradually becoming clear that Mandeville was one of the most signifi-
cant writers of the eighteenth century. Positively or negatively, he influenced every
major thinker from Hutcheson, Hume, Adam Smith, and Bentham to Rousseau
and Kant (see Hundert 1994). We can only understand how Hutcheson's theory of
beauty connects to moral (and social) concerns if we appreciate the significance of
Mandeville's work and the discourse about commerce, luxury, consumption, and
politeness that surrounded it. In England in the eighteenth century the debate
about luxury was also a debate about the new political and economical order, in
which money, trade, and commercialism played an increasing role.

The poem which is now a small part of Mandeville's *The Fable of the Bees:
or, Private Vices, Publick Benefits* was originally published in a pamphlet in 1705 as
The Grumbling Hive: or, Knaves Turn'd Honest, but caused little attention. Not
until the edition of 1723, which was presented to the Middlesex Jury as a threat to
religion and morality, did Mandeville's work gain the notoriety it retained
throughout the eighteenth century. This edition contains twenty-two remarks
explaining and elaborating the poem, and a number of essays, for example "A
Search into the Nature of Society" wherein Mandeville attacks Shaftesbury, and
"An Essay on Charity and Charity Schools." It was this edition which brought
forth a stream of periodical essays and books, most of them intending to show
that Mandeville was wrong in his assertion that private vices turned into public
benefit.[2]

In *The Fable* Mandeville elaborated in great detail, and with considerable
glee, the discrepancy between, on the one hand, the interest in trade, the accu-
mulation of riches, and their conspicuous consumption and, on the other, tradi-
tional, still professed, moral values. As Mandeville saw it, luxury greatly benefited
trade. The moral condemnation of luxury was ignored in practice, Mandeville
pointed out, and he was understood to advise his readers to give up the tradi-
tional view of luxury and urge them to indulge in vices for the sake of improved
trade. Mandeville was not suspicious or hostile towards the new commercial activ-
ities developing in England at the time, but he does in fact not offer us a new set of
moral values to accompany these activities. The acceptance of the traditional
dichotomy between vice and virtue is a presupposition for the effectiveness of his
satire.[3]

As already mentioned in the discussion of Shaftesbury (chapter 11), the
problematic nature of conspicuous consumption derived from the fact that it was
in conflict with that tradition in the history of morality which condemned luxury.
Mandeville defined luxury as "every thing . . . that is not immediately necessary to
make Man subsist as he is a living Creature" (Mandeville [1714] 1924, 1:107). He
admits that this is too rigorous a definition, but nevertheless finds it justified on the

grounds, that if we depart from it, it will be impossible to draw a line between what is and what is not luxury, since anything can be considered a necessity of life for someone (1:108).

Mandeville claimed that there was a choice between virtue (as traditionally understood) and wealth, but it was not possible to have both. If people were to live in accordance with the principles of virtue they acknowledged, they ought, as was traditionally required, to live in poverty or at least simplicity. In practice, most chose to live in relative comfort and ignore moral prescriptions. Paradoxically, the private vices exhibited in the pursuit of the material comforts of life turn into public benefits, because the sum of private vices forms the basis for the wealth of the nation and therefore makes economic growth and a comfortable existence possible, at least for some people.

Christopher Berry has documented that the views Mandeville expounded were not original with him. Prior to Mandeville, Nicholas Barbon (in *A Discourse of Trade* [1690]) and, even earlier, John Houghton (1681–83) had pointed out that what, on a personal level, was considered a vice, is beneficial to trade. Similarly to Mandeville, Houghton pointed out that pride, prodigality, and luxury create wealth for the nation. Barbon also expanded the idea of want or necessity to include not only the traditional bodily needs (food, clothes, and lodging), but also wants of the mind. The wants of the mind are the most extensive, since the basic bodily needs are met with relative ease (Berry 1994, 111–12).

What particularly prompted a redefinition of luxury was the increased significance of trade. Luxury is a necessity for a wealthy and thriving trading nation, Mandeville thought. Without pride and luxury, trade would "in a great Measure decay" (1:124). The encouragement of trade will also bring growth in the arts and sciences: "promote Navigation, cherish the Merchant, and encourage Trade in every Branch of it; this will bring Riches, and where they are, Arts and Sciences will soon follow"(1:184). Hume and Montesquieu, both very familiar with Mandeville, also emphasized the connection between trade, a growing taste for luxuries, and a consequent growth in the arts (Mattick 1993b, 158). But wealth is always obtained along with its inseparable companions, luxury and pride. Consequently, one cannot hope to achieve growth in the arts and sciences, and simultaneously retain high moral principles:

> Where Trade is considerable Fraud will intrude. To be at once well-bred and sincere, is no less than a contradiction; and therefore while Man advances in Knowledge, and his Manners are polish'd, we must expect to see at the same time his Desires enlarg'd, his Appetites refin'd, and his Vices encreas'd (1:185)....
> Vice in general is no where more predominant than where Arts and Sciences flourish. (1:269)[4]

The notions of "politeness" and "good breeding" were, as we saw, central in the moral universe of Shaftesbury, Addison, and Steele. In *The Female Tatler*

(1709–10), Mandeville attacked Steele's *The Tatler* for relying on these ideas (Jack 1989, 29; Goldsmith 1985, 36). In the second part of *The Fable of the Bees* Mandeville declares, through his mouthpiece Cleomenes, that "Politeness of Manners and Pleasure of Conversation . . . are the things he laughs at and exposes throughout his Book" (2:102). He attacks in particular the *Beau Monde* and the followers of fashion. Their mastery of politeness and good breeding does not mean that they have subdued their passions, but only that they, in the hope of better fulfilling them, have found a shrewd way of concealing them: "a Man need not conquer his Passions, it is sufficient that he conceals them. Virtue bids us subdue, but good Breeding only requires we should hide our Appetites" (1:72; see also 2:108–9). "[B]y being well bred, we suffer no Abridgement in our sensual Pleasures, but only labour for our mutual Happiness, and assist each other in the luxurious Enjoyment of all worldly Comforts" (1:73). Politeness is, in short, nothing but self-love and hypocrisy, masquerading as sophistication and benevolence (see also 2:138f.).

Mandeville exposed many acts as hypocritical. A life in prosperous contentment or happiness, it follows from his theorizing, is contrary to a virtuous life. Joseph Butler and other who argued against this in effect did so by refusing the name of vice to the activities Mandeville and traditional morality considered vices. By doing this they effectively made self-interest coincide with virtue and claimed (as had Shaftesbury) that happiness and virtue must be one, that a vicious person cannot be happy. Consequently they redescribe (in particular) commercial activities and make them benign or commendable.

This brief overview of the contemporary debate about luxury, particularly as it centred around *The Fable of the Bees*, provides the background for an interpretation of Hutcheson's conception of the moral sense of beauty. Mandeville's satirical exposition of the discord between purported principles and actual practice was an attack on those most guilty of indulgence in luxury and conspicuous consumption, that part of society which considered itself polite. To counter Mandeville's arguments, and present an argument which would free the polite and well-bred from the moral suspicion cast on them by Mandeville, Hutcheson also sought to redefine luxury, and thereby shed its odious and dangerous connotations. Since art collection and an interest in the arts were becoming central ingredients in the conception of politeness, a refutation of Mandeville could in part take the form of a defense of an interest in the arts, by showing that this interest was not morally suspicious. This demonstration was, in part, what Hutcheson attempted with the development of his conception of the moral sense of beauty. In this context, Hutcheson's reflections on art and beauty in the *Inquiry* can be understood as important moves in the redefinition of attitudes to luxury and conspicuous consumption, a redefinition, Sekora states in his examination of the history of the conception of luxury, which "represents nothing less than the movement from the classical world to the modern" (Sekora 1977, 1).

The Moral Sense of Beauty

To Hutcheson, who in his epistemology mostly followed Locke, pleasure and pain are simple ideas which cannot be analyzed any further. It is, however, possible to examine what experience and self-reflection tell us about their mode of operation, and their role in our lives.[5] It is an investigation of this empirical nature that Hutcheson proposed to undertake in the *Inquiry* and he goes beyond Locke and other "modern philosophers," who, according to Hutcheson, have treated this subject very superficially. The "modern philosophers" usually restrict themselves to a distinction between rational and sensible pleasures, but have little to say about either of them: "We are seldom taught any other notion of rational pleasure than that which we have upon reflecting on our possessions, or claim to those objects which may be occasions of pleasure" (1973, 23–24; see also 1726, 118). According to the view opposed by Hutcheson (and Shaftesbury), pleasure arising from contemplation of any object is, as we saw, reducible to (for example) desire to possess the object or pride in already possessing it, the view of Descartes, Hobbes, Locke, and Mandeville.

Hutcheson attacked the view that human beings were basically selfish and motivated exclusively by self-interest in practically all his writings, from his "Reflections on the Common Systems of Morality" (Hutcheson [1724] 1994) and his discussion of laughter in the essays in the *Dublin Weekly Journal* (originally published in 1725, now in Hutcheson 1750 and 1973) to his developed moral philosophy. In "Reflections on the Common Systems of Morality," a preview of the *Inquiry*, Hutcheson complains that knowledge of contemporary moral philosophy does not seem to produce morally upright persons. The systems of moral philosophy are ineffectual in providing people with guidance in their pursuit of happiness. To compel people to love God by threats of terror and bribes can only serve to promote hypocrisy ([1724] 1994, 99). God is not as bad as he is made out to be, and neither are, generally speaking, human beings. Following in the footsteps of Hobbes, most moralists have a bleak view of humanity. "We scarce hear any thing from them of the bright side of humane nature" (100). Men do indeed often act maliciously or with self-interest towards each other, but this is more a result of education than of nature. Naturally, people are benevolent, and act on the basis of positive sentiments such as friendship and gratitude or "national love" (101).

As previously mentioned, the idea of the corruption of human nature was official doctrine of the Presbyterian Church. Just as the philosophers, the Church held that all actions were ultimately directed by self-love. Even beneficent acts "are tainted with underlying motives of selfishness" (Mautner 1994, 13). By choosing the safe topic of criticizing Mandeville, Hutcheson therefore reached much further. According to James Moore, "Hutcheson's early treatises and letters [published in the *London Journal* and the *Dublin Weekly Journal*] mounted a systematic and a powerful attack on the ideas and the materials used for the instruction of youth in the presbyterian academies and Scottish universities" (Moore 1990, 53).

Hutcheson's claim that we possess a moral sense of beauty is part of his refutation of the doctrine of the depravity of human nature. The sense of beauty is an internal sense, different from our physiological senses of sight, hearing, taste, and touch, but it works somewhat similarly to the external senses. In the same way as we cannot choose to make "a bitter potion" taste good to us, the idea of beauty arises independently of our will. It is possible to prevent a person from *desiring* something beautiful by, say, threatening with some form of punishment, but that does not mean that the person stops *perceiving* the beauty. In fact, the desire to possess the object would never have arisen if the object was not perceived to be beautiful. Those who argue that beauty can be reduced to interest have, therefore, turned things upside down. We do not judge things to be beautiful because we desire them, but we desire them because they are beautiful. Even if something is directly harmful to us, we can still perceive it to be beautiful:

> So propose the whole world as a reward, or threaten the great-
> est evil, to make us approve a deformed object, or disapprove a
> beautiful one: dissimulation may be procured by rewards or
> threatenings, or we may in external conduct abstain from any
> pursuit of the beautiful, and pursue the deformed, but our *sen-
> timents* of the forms, and our *perceptions*, would continue
> invariably the same. (1973, 37)

The pleasure we receive from perceiving anything beautiful is therefore "distinct from that joy which arises upon prospect of advantage" (ibid.). We may, of course, try to gather beautiful objects around us in order to obtain the pleasure from perceiving them, but this is secondary to the actual sense of beauty:

> Our sense of beauty from objects, by which they are constituted
> good to us, is very distinct from our desire of them when they
> are thus constituted. . . . Had we no sense of beauty and har-
> mony, houses, gardens, dress, equipage might have been rec-
> ommended to us as convenient, fruitful, warm, easy, but never
> as *beautiful.* (37–38)

In Hutcheson's moral philosophy the contemplation of beauty shows, for example in opposition to Hobbes and Mandeville, but also against the conservative Calvinists in the Presbyterian Church and at the University of Glasgow (where Hutcheson had studied and later became a professor), the possibility of disinterested, benevolent behavior and attitudes. The sense of beauty is structurally similar to our moral sense, since both are disinterested. In our application of our sense of beauty and our moral sense we are able to pass judgment about the beauty or morality of an action independently of the personal benefit we may derive from it, or even contrary to any benefit we may derive from it. We can deem an act morally good

if it is contrary to our personal interest, or we can consciously choose to perform an action contrary to morality if we think it will benefit us, and at the same time know that the action is wrong. Our judgment about the moral quality of the action is therefore independent of private interest. Hence, morality is not reducible to self-love or interest.

Passing judgments about the nature of moral actions by way of reasoning is a long and laborious process. But we can recognize moral actions instantly because they have a beauty of their own. To perceive a virtuous action gives us a pleasure independent of any advantage we may or may not receive from it—virtuous actions are *beautiful*. Hutcheson repeatedly emphasizes the close connection between beauty and virtue:

> [W]e have a distinct Perception of *Beauty* or *Excellence* in the kind Affections of *rational Agents*." (1726, 118–19)
> "If there is no *moral Sense*, which makes rational [4th. ed.: "benevolent"] Actions appear *Beautiful* or *Deform'd*; if all Approbation be from *Interest* of the Approver, '*What's* HECUBA *to us, or we to* HECUBA?'" (121–22, see also 126, sec. 5; p. 181, "the moral Beauty of Actions, or Dispositions"; pp. 163, 176, 190, 191)

Reasoning would lead to the same conclusions regarding the morality or immorality of actions, but most men are unable to follow a complicated line of thought. This is the reason why "the Author of nature" has conveniently joined virtue and beauty: virtue has been made into a lovely form (1973, 25). Hutcheson, therefore, often employs the term "moral sense of beauty" (ibid.), and he claims that, as this notion is found in Shaftesbury's writings, it has offended many, who have been accustomed "to deduce every approbation or aversion from rational views of private interest."

Because moral actions appear beautiful to us, and because the judgment that something is beautiful is disinterested, that is, because it cannot be reduced to the self-interest of the one making the judgment, the beauty of moral actions becomes further evidence that moral actions cannot be reduced to self-interest. The argument for the disinterestedness of the judgment of beauty becomes a part of an argument in morality. It does not lift the judgment of beauty (the "aesthetic" judgment) out of the realm of morality, but places it within it.

Among the different kinds of beauty there is one of particular significance, which is dealt with at greater length in the second treatise. In treatise I Hutcheson promises to show in treatise II that "that most powerful beauty in countenances, airs, gestures, motion, . . . arises from some imagined indication of morally good dispositions of the mind" (1973, 45). In the passage in treatise II with the promised demonstration (1726, 250–53), Hutcheson identifies external beauty in a person with "certain *Airs, Proportions, je ne scai quoy's* [sic]," which we take to be expressions

of moral qualities such as "*Sweetness, Mildness, Majesty, Dignity, Vivacity, Humility, Tenderness, Good-nature*" (1726, 250). We form the idea of a connection between outward appearance and the moral qualities of a person on the basis of an association of ideas. By education, custom, or habit, two or more otherwise unconnected ideas can become connected by the association of ideas, but Hutcheson does not directly say whether or not this association is justified.

I believe Hutcheson did not directly address the question of the reality of an *imagined* connection between, say, on the one hand, gestures, motion, and so on, and, on the other hand, a certain moral disposition, simply because he did not consider the question of great importance. Some of the conclusions we draw are clearly *not founded* on anything in nature, but are solely due to habit and custom. In one of the "Remarks upon *The Fable of the Bees*" Hutcheson says that the belief that there is a connection between, on the one hand, wealth and "the finer sort of habitation, dress, equipage, furniture" and moral uprightness on the other hand, is a "foolish conjunction" (1750, 46). The same holds for our propensity to connect different forms of ceremonial behavior "and the *Affections* of *Mind* which they are by *Custom* made to express."

> Every thing we count agreeable, some way denotes *Cheerfulness, Ease*, a *Condescension*, and *Readiness* to oblige, a *Love* of *Company*, with a *Freedom* and *Boldness* which always accompanys an *honest, undesigning Heart*. On the Contrary, what is shocking in *Air* or *Motion*, is *Roughness, Ill-nature*, a *Disregard* of others, or a *foolish Shame-facedness*, which evidences a Person to be unexperienced in Society, or Offices of Humanity. (1726, 254)

This connection is also based on an association of ideas, which may vary greatly from culture to culture; there is no natural connection. What is important is not the validity of the presumed connection, but the mere fact that we, according to Hutcheson, have the propensity to assume such connections. The fact that we make such assumptions shows that we are really judging, neither the appearance of the person, nor the outward movements and so on, but the moral character of the person, which we, rightly or wrongly, think expressed in what we can observe. Beauty gives us the presumption of the existence of moral uprightness, and when we pursue beauty it is therefore actually to morality that we attach most importance (1726, 256). It is also in this connection that we find the reason why moralists of Hutcheson's and Shaftesbury's persuasion claim that it is virtuous to take an interest in art:

> [W]e are excited to do these [virtuous] actions, even as we pursue, or purchase Pictures, Statues, Landskips, from Self-Interest, to obtain this Pleasure which arises from Reflection upon the Action, or some other future Advantage. (1726, 116)

Similarly when we pursue wealth and power. In the last section of the first treatise, Hutcheson claims that the gratifications of the internal senses "are the chief ends for which we pursue wealth and power" (1973, 87). To satisfy the external senses a modest wealth suffices, and therefore "the only use of a great fortune above a very small one (except in good offices and moral pleasures) must be to supply us with the pleasures of beauty, order and harmony" (88). This is supplied through, for example, gardening, architecture, music, painting, dress, equipage, and furniture (ibid.). Our desire for wealth and power is not an expression of viciousness or a violation of moral principles, but is guided by moral concerns. We think, for example, that wealth and power will put us in a position where we are able to help friends and relatives. In general, people do not approve of wealth for its own sake, and they do not want it if it can only be obtained at the cost of virtue (1726, 247). We would not want wealth and power if we knew that it meant we had to give up friendship and the company of others. Consequently, Hutcheson concludes, the "love of society" is more important to most people than the desire for wealth: "'tis some Appearance of *Friendship*, of *Love*, of *communicating* Pleasure to others, which preserves the Pleasures of the *Luxurious* from being *nauseous* and *insipid*" (1726, 249). Even if a person performs a morally blameworthy action he or she will often intend to do good or at least give it the appearance (to themselves as well) of being morally commendable, even if this involves "some deluding Imagination of *moral Good*" (1726, 210).[6]

Since the motivating factors (the intention) in these cases are virtuous, Hutcheson can argue that those who make their wealth and power known are morally commendable. The display of wealth shows a benevolent disposition on the part of the one who displays, and, in the form of an economic spin-off, it does create beneficial effects: "so many Dependants *supported*, so many Friends *entertain'd, assisted, protected*. . . . We never affect Obscurity or Concealment, but rather desire that our *State* and *Magnificence* should be known" (1726, 150). Concealing a state of wealth is wrong, because it is a sign of a desire for private pleasures, some of which may be of doubtful moral value, and the desire for which show a lack of moral sense.

> The *Shame* we suffer from Meanness of *Dress, Table, Equipage*, is entirely owing to the same reason. This Meanness is often imagin'd to argue *Avarice, Meanness* of *Spirit*, want of *Capacity*, or *Conduct* in Life, of *Industry*, or moral Abilitys of one Kind or other. (1726, 234–35)

In other words, being well-dressed, and so on, reflects favorably on the moral character of the person. Because we generally assume a connection between "*external Grandeur, Regularity* in *Dress, Equipage, Retinue, Badges* of *Honour*, and some *moral Abilitys* greater than ordinary" (235), the display of "external Grandeur" is politically expedient. It is so awe-inspiring that it may serve to

keep one's inferiors in place with less effort than would otherwise be required. It can "quell the Spirits of the *Vulgar*, and keep them in subjection."

Similarly to Shaftesbury, Hutcheson argues that the enjoyment of beauty is only really possible for those of a virtuous character:

> [T]he Perceptions of *Beauty, Order, Harmony* . . . are, no doubt, . . . *noble Pleasures*, and seem to enlarge the *Mind*; and yet how *cold* and *joyless* are they, if there be no *moral Pleasures* of *Friendship, Love* and *Beneficence?* . . . The internal Pleasures of *Beauty* and *Harmony*, contribute greatly toward soothing the Mind into a Forgetfulness of *Wrath, Malice* or *Revenge*; and they must do so, before we can have any tolerable Delight or Enjoyment: for while *these Affections* possess the Mind, there is nothing but *Torment* and *Misery*. (1726, 244–45)

With the development of a benevolent moral attitude also develops a "Love of *Poetry, Musick*, the *Beauty* of *Nature* in rural Scenes, a *Contempt* of other selfish Pleasures of the *external Senses*, a *neat Dress*, a *humane Deportment*, a *Delight* in and *Emulation* of every thing which is *gallant, generous*, and *friendly*" (257).

The desire for luxuries or art is not a threat to virtue Hutcheson maintains. It is perfectly possible to combine, say, virtue and patriotism with interest in the arts:

> [L]ove of a country, a family, or friends never spoiled a taste for architecture, painting or sculpture; the knowledge of the true measures and harmony of life never vitiated an ear, or genius for the harmony of music or poetry. (Hutcheson 1750, 47)

In one of his essays on *The Fable of the Bees*, Hutcheson defines luxury as "the using more curious and expensive habitation, dress, table, equipage, than the person's wealth will bear, so as to discharge his duty to his family, his friends, his country, or the indigent" (Hutcheson 1750, 56). Hume's proposed redefinition of luxury is similar to Hutcheson's: something becomes a luxury when it exceeds one's ability to pay, and thus jeopardizes one's position and ability to, for example, take care of one's family (Hume [1777] 1987, 269, 279; see also Goldsmith 1985, 164). Hume agreed with Mandeville that conspicuous consumption contributed to the economical growth of a nation, and that the pursuit of commodities "which serve to the ornament and pleasure of life" is a spur to industry in the individual (Hume [1777] 1987, 272). For Hume, luxury is, as mentioned, a positive phenomenon, synonymous with "refinement in the arts." Hume's point of view was exceptional at the time when it was advanced, but today it represents the standard definition of luxury (Sekora 1977, 110).

Hutcheson's notion of the moral sense of beauty serves, then, a dual purpose. It serves, first, to counter the philosophers of self-interest. Even while we pursue the

pleasures of luxury or beauty, we are actually, on Hutcheson's account, often guided by benevolent moral principles, or at least see our own actions in a moral light. Secondly, the moral sense of beauty serves to justify the pursuit of luxury as long as it is within the limits of one's financial abilities. Hutcheson did not dispute that people pursue luxury and indulge in conspicuous consumption, but he did dispute the view of many of his contemporaries, that this should be seen exclusively in a negative light (see also Hutcheson 1750, 44–45).

A recommendation to keep expenses within the limits of one's financial abilities seems like sensible, even commonsensical advise, but in fact it reveals an ethos characteristic of what Norbert Elias calls "the professional bourgeoisie," particularly the merchant (Elias 1983, 66). Whereas the aristocracy's expenses are dictated by their social position, and the imperative to maintain an appearance and a form of life appropriate to their social position, merchants must balance income and expenses in order to maintain their social existence. In fact, exhortations to keep accurate account of income and expenses, as well as of one's time, were common in edifying literature in the early eighteenth century (see Marshall 1980, 230).

Because their social locus was the same, the assessment of conspicuous consumption and luxury was for Hutcheson and some of his contemporaries inseparable from their view on the propriety of an interest in art, in the same way as Mandeville's view on these issues was inseparable from his expressed contempt for those who considered themselves part of the polite world. Hutcheson's defense of art appreciation and art collecting therefore had to turn into a defense of luxury and conspicuous consumption. Hutcheson's aesthetic and moral theory becomes, as Shaftesbury's did, inseparable from the creation of a new social order in the eighteenth century.

The conflict between actual practice and moral principle which carries Mandeville's exposé in *The Fable of the Bees* is only disturbing if one accepts the validity of that morality which throws a dubious light on conspicuous consumption and luxury. Hutcheson's argumentation opposes this traditional morality and he was among the first of many in the eighteenth century who contributed to a reinterpretation of traditional morality. From Mandeville via Hutcheson to Hume and Adam Smith we can follow a line in which traditional economic and social values become redefined and in better agreement with the social and political realities of a capitalist society where commerce and conspicuous consumption are central elements. In fact, he says, pursuit of luxury and certain forms of conspicuous consumption, particularly the consumption of works of art, can be and often are guided by high moral principles, and have beneficial effects for the individual as well as for society in general. There is, thus, no contradiction between what benefits the public, and what benefits the individual. By presenting the lover of art, the polite person, as a social type worthy of respect, Hutcheson's argumentation contributes to a redefinition of the principles regulating self-presentation and self-understanding within the middle class. In the course of the eighteenth century art appreciation becomes, for many educated people, a central ingredient in their view of themselves—a view for which Hutcheson helped to pave the way.

From the Morality
to the Autonomy of Art

The examination of the origin of the modern conception of art has led to an apparent paradox: on one hand, the theoreticians of the early eighteenth century are among the first to give voice to what became the modern conception of art; on the other hand, our examination of some of the most influential of these theoreticians reveals that they did in fact not subscribe to a central element in the modern conception of art, the idea that the value of art is independent of any moral, political, or religious purposes that it may serve.

On this basis we might be tempted to conclude that perhaps the modern conception of art did not after all have its origin in the early eighteenth century. This conclusion would, however, run contrary to a very large body of historical research. Another possible conclusion then emerges: something is wrong with the way in which we think about parts of the modern conception of art. The claim that we value art exclusively for its own sake, that its value is purely intrinsic and beyond any social, political, or moral concerns is, if we are to draw this second conclusion, in some way deceptive. I will pursue this second line of reasoning in this and the following chapter, in accordance with the suggestion advanced in the introduction, that at the core of recent philosophy of art is a conception of art which contains unacknowledged philosophical, political, and cultural presuppositions, and that these presuppositions were shaped by the circumstances surrounding the genesis and development of the modern conception of art.

The conception of art and taste advanced in the theories of Addison, Shaftesbury, Hutcheson, and Hume evolved into the doctrine of "the autonomy of

art." Kant is often considered the first influential theoretician of art's autonomy, but many of the aspirations of Shaftesbury and others were actually retained by Kant and other German theoreticians of the later eighteenth century. Already Shaftesbury realized that there was a dilemma involved in the freedom of criticism and judgment, since the works approved of by the freely judging public were not always those Shaftesbury thought most worthy of attention. While advocating freedom of criticism in the conviction that this freedom would lead people at large to the correct standards of taste, the theoreticians of the early eighteenth century also disapproved of the types of art and conduct actually adopted by a large number of people. The standards on which Shaftesbury, Addison, Hutcheson, and Hume relied were actually the standards of a small elite. This dilemma becomes a source of conflict in Germany in the later parts of the eighteenth century and in England in the early nineteenth century (see Woodmansee 1994, chap. 6). The gap between reality and the ideal of the elite grows with the increasing commercialization of art and literature, and is in large measure the reason for the reorientation in aesthetic theory towards the end of the eighteenth century.

The Autonomy of Art

With the demise of older, feudal conceptions of the expressive order, the idea of taste, in relation to objects and manners, became, as we have seen, an important ingredient in the conception of the presentation of the self characteristic of the new social order. At the same time, taste demarcates social distinctions. Shaftesbury claimed that under the conditions of free criticism the true standards of taste and beauty would emerge. For Shaftesbury and Hutcheson beauty is important for the evaluation of morality and appropriate behavior. The sense of beauty is in part a spontaneous ability to judge manners.

Adam Smith (1723–90) extended aesthetic judgment to the social and economic order. When a system or a machine is particularly good at performing the task for which it was intended we find it beautiful and agreeable to contemplate (Smith [1759] 1976, 179). Order, regularity, and harmony have a beauty of their own, and we are often led to appreciate them for their own sake, beyond the ability something has to fulfil its purpose. In this psychological propensity Smith found an important reason why we admire the rich and powerful: their lives seem well organized and harmonious, "everything is adapted to promote their ease, to prevent their wants, to gratify their wishes, and to amuse and entertain their most frivolous desires." This appears to us as a harmonious ordering of a system or a machine, and it strikes us as something "grand and beautiful and noble," though it really does not provide the rich with any greater satisfaction than the poor person, whose needs are equally fulfilled. We deceive ourselves in our admiration of the rich and powerful, but it is a good thing that we do, because "this

deception . . . rouses and keeps in perpetual motion the industry of mankind" and from this all the sciences and arts developed (Smith [1759] 1976, 183). Echoing Mandeville, Smith held that through the restless pursuit of their own selfish interests the rich actually benefit society as a whole because they employ people to satisfy their own needs.

> They are led by an invisible hand to make nearly the same dis-
> tribution of the necessaries of life, which would have been
> made, had the earth been divided into equal portions among all
> its inhabitants, and thus without intending it, without knowing
> it, advance the interests of the society, and afford the means
> to the multiplication of the species. When Providence divided
> the earth among a few lordly master, it neither forgot nor aban-
> doned those who seemed to have been left out of the parti-
> tion. These last too enjoy their share of all that it produces. . . .
> In ease of body and peace of mind, all the different ranks of life
> are nearly upon a level, and the beggar, who suns himself by the
> side of the highway, possesses that security which kings are
> fighting for. (Smith [1759] 1976, 185)

Not from force or coercion, but from following our natural inclination for beauty and order, society has been organized to the satisfaction of all and in accordance with the principles intended by Providence. Lord Kames (Henry Home, 1696–1782) similarly thought that the fine arts had a "beneficial influence in soci-ety." By the fine arts Kames referred to poetry, painting, sculpture, music, gar-dening, and architecture. "By uniting different ranks in the same elegant pleasures, they [the fine arts] promote benevolence: by cherishing love of order, they enforce submission to government: and by inspiring delicacy of feeling, they make regular government a double blessing." A taste in the fine arts goes "hand in hand with the moral sense" (Kames 1785, 1:v, 6).

From Shaftesbury at the beginning of the eighteenth century to Smith and Kames in the last half of the century, beauty and the fine arts (polite arts in Shaftes-bury's terminology) became a sign of virtue, a promoter and upholder of social harmony, and a legitimation of the existing social order. But in the course of the eighteenth century the fact that the aesthetics of manners embodies a view of the social order, and thus is moral and social in nature, becomes less prominent in the theoretical contributions to aesthetics. The implied view of manners and morality become routine, self-evident expressions of what is simply agreeable or disagreeable (Eagleton 1990, 43). Terry Eagleton observes that with the decline of absolutism and the demise of central authorities, political power and the maintenance of social stability are no longer seen as externally imposed: the citizens must give the law to themselves. "We encounter the law," Eagleton comments in connection with a discussion of Burke's view of manners, "if we are lucky, only sporadically, as

an unpleasantly coercive power; but in the aesthetics of social conduct, or 'culture' as it would later be called, the law is always with us, as the very unconscious structure of our life" (Eagleton 1990, 42). As we have seen, aesthetic judgment was not restricted to works of art and nature, but was a central ingredient in the evaluation of behavior, as indicated by the centrality of taste in manners and the emergence of politeness as a standard of behavior.

The State of Germany

The German theoreticians continued the development begun by the British theoreticians (by whom they were deeply influenced), but the objectives they shared with their theoretical predecessors gained different expressions because they responded to conditions specific to the German language area. The reasons for this are numerous and complicated. In the eighteenth century Germany was not a unified nation-state, and there were no urban centres large enough to support an extensive literary and artistic culture. In 1800 the largest city in the German-speaking part of central Europe was Vienna with 231,000 inhabitants, whereas Berlin had 150,000 (Sheehan 1989, 115–16). London already had more than 500,000 inhabitants in 1700 and was close to one million in 1800. In Germany there was not an educated urban middle class large and wealthy enough to support a public sphere comparable to London's. Cultural life still centered around the hundreds of courts scattered throughout the area. From the courts sovereignty over territories of vastly differing proportions was asserted. Most of the rulers of these areas were preoccupied with securing and consolidating their own power, and connected to the states was a growing army of professional administrators or bureaucrats (35). The old aristocracy's power was threatened partly by this group, who made a career based on education and talent possible, partly by a group who had become wealthy in the commercial world. Similarly to England, this group would often acquire land and nominally become part of the world of the aristocracy (131–32). But, as in England in the early parts of the century, traditional rank and privilege were no longer accepted without question.

There is, then, a middle group outside the traditional aristocracy and the guild systems of the towns. It consisted mainly of those who had become wealthy through commerce and manufacture, free professionals, Protestant clergy, and those to whom education and publishing provided a livelihood, but they did not make up a self-conscious middle-class. Sheehan refers to them simply as the "non-nobles elite." It is nevertheless among this elite that a new set of values and attitudes gradually develop, and it is among them that we find "the chief creators and consumers of a new, national culture, which at once drew upon and helped to clarify their social experience and private sensibilities" (143). Kant (1724–1804), Herder (1744–1803), Schiller (1759–1805), J. G. Fichte (1762–1814), Hegel (1770–1831), Schlegel (1772–1829), and Schelling (1775–1854), all had their background in this stratum.

The new national culture they hoped to create was opposed to the many local forms of popular culture and to the aristocratic culture of the courts which was strongly influenced by French and Italian art. The court culture was of the type Habermas characterized as representational, and was intended to reinforce and express social divisions and political power (Habermas 1989, 39–40). "Life at court was filled with receptions and parades, banquets and balls, an endless variety of fêtes and galas that amused the courtly entourage and displayed the ruler's wealth and power" (Sheehan 1989, 150). The artists that provided the rulers with their drama, music, painting, and so on were generally not seen as different from any other craftsperson who worked for the ruler or supplied him with luxury goods.

In it against this background a new literary and artistic culture begins to emerge in Germany in the last part of the eighteenth century. More books in German were now printed, a market for works of art gradually emerged, and an extensive periodical press with criticism of literature, music, and art gained a foothold.

Writers and artists were liberated from the system of patronage, but only to discover, as Schiller did, that its replacement, the literary market, did not guarantee success and prosperity. The English writers, artists, and poets, from Pope and Addison through Hume, Fielding, and Hogarth to Reynolds and Gainsborough, are generally commercially successful in the new market conditions. They manage to live well, sometimes very well, independently of the patronage system. In Germany it was still almost impossible to live as a writer for the literary market, partly because it was very small, partly because no system of royalty and copyright existed. Moritz and many others looked with envy to England, where even ordinary people appeared to read Milton and Locke, while in Germany, Wieland, Moritz, Schiller, and Goethe often could not find readers outside a relatively narrow intellectual group. Sheehan suggests that the literary public towards the ends of the eighteenth century may have consisted of between 100,000 to 200,000 people or less than 5 percent of the total population (Sheehan 1989, 157). Those who belonged to the literary culture therefore assumed a precarious middle position between popular culture and the luxurious culture of the courts, and looked at both with disdain (159).

Though there is an explosive growth in literary production in Germany in the last half of the eighteenth century, the literary market becomes, to the chagrin of the intellectual elite, increasingly dominated by works exclusively intended for entertainment, works which do not, or only to a very limited degree, attempt to provide moral edification and enlightenment, the functions which literary theoreticians assigned to literature (Schulte-Sasse 1980, 97). Producers, as well as consumers, of works living up to the theoretical ideals of enlightenment saw themselves increasingly isolated, and the works of their choice did not meet with commercial success. Literature was now produced for an anonymous audience: those who were willing to pay for a book on the market or for a subscription to one of the many magazines. The emerging cultural industry began to undermine the

view of the bourgeois public sphere as homogeneous ("die als homogen vorgestellte bürgerliche öffentlichkeit," Schulte-Sasse 1980, 98). The public sphere narrows.

Under pressure from the commercialization of artistic production, and with the realization that most people do not live up to the ideal of taste and enlightenment, the theoreticians of the arts turn away from any concern for the audience (other than one of contempt). Their theoretical reflections become in part a reflection of the increasing alienation of artists and intellectuals. Shaftesbury, Addison, Hutcheson, Smith, and other British theoreticians can, and largely do, consider themselves part of what we might call mainstream society. They participate in the creation of the new social order, and they are, generally speaking, valued, influential, even powerful members of their contemporary society. By and large, they express the view of the ascendant social class, though the discussion of taste reveal that the homogeneity of this group is in question. In Germany such a conception was difficult to sustain for artists who found that their contemporaries were indifferent to their work.

In particular, the increasing commercialization of literature leads the German theoreticians to a less optimistic conclusion about the possibility of obtaining consensus about good taste. On the theoretical level there is in Germany an increasing criticism of "the mercenary spirit of the booksellers" (Geschhäftsgeist der Buchhändler," Schulte-Sasse 1980, 106), a criticism we find in the writings of Karl Philipp Moritz (1756–93), Kant, and Schiller. But discrepancies in artistic preferences and enlightenment are not explained in terms of the social, historical, political, and economical circumstances which lead to the commercialization of art and the "degradation" of the artist to a wage-laborer. Rather, the theoreticians writing about art and aesthetics see the inability of the majority of the public to reach the level of the intellectual elite as a matter of individual inadequacy. It is, as Kant implied in his essay "What is Enlightenment?" (Kant [1784] 1963), the responsibility of the individual to achieve enlightenment. Enlightenment is "man's release from his *self-incurred* tutelage" (my italics): "Tutelage is man's inability to make use of his understanding without direction from another. Self-incurred is this tutelage when its cause lies not in lack of reason but in lack of resolution and courage to use it without direction from another" (Kant [1784] 1963, 3).

It merits attention that the creator of one of the most complex epistemologies in the history of philosophy could think of no other reasons than laziness and cowardice to explain why "the greater portion of mankind (and . . . the entire fair sex)" remains in this state of bondage. Kant's explanation was essentially repeated by Schiller, though Schiller added that the generality of mankind lives in circumstances too difficult to leave much energy for nobler activities. Should this segment of mankind show any signs of "higher needs," they would eagerly swallow the formula prepared for such occasions by church and state (Schiller [1793] 1967, 51). Those who cannot appeal to necessity as an excuse deserve only contempt.

For artists such as Schiller and Moritz, the result of these developments is an increasingly antagonistic relationship between artist and audience. This turn is at the

core of the move from the type of disinterested approach found in Shaftesbury and Hutcheson to the development of the notion of the autonomy of art. The turn is a reaction to a social development which makes the situation of the artist increasingly difficult. The artists are forced into exile, but theoretically they become idealized.

Karl Philipp Moritz

The turn away from any concern for the audience is clearly present in Moritz's essay "Versuch einer Vereinigung aller schönen Künste und Wissenschaften unter dem Begriff des in sich selbst Vollendeten" (An Attempt to Unify all the Fine Arts and Letters under the Concept of Self-Sufficiency) from 1785. This essay may very well have had a considerable influence on Kant's aesthetics (see Woodmansee 1994, chap. 1).

Beautiful works of art have, Moritz explained in the essay, their purpose entirely in themselves, and not in their possible usefulness or in the fact that they may please. Use or pleasure are external to the work of art. Beauty "has its purpose not outside itself . . . but in virtue of its own inner perfection" (Moritz [1785] 1962, 4). We must, therefore, appreciate beauty in a manner akin to disinterested love, without any regard to what we may obtain from it or of what use it may be (5). In particular, we should not be concerned about obtaining any pleasure from the work of art. The work has its own laws of perfection, and the artist should be attentive to these, which may be contrary to what pleases. If the artist aims to make something pleasing he may be creating a work which is less than perfect (6). This is consequently not what he should strive for.[1] As Woodmansee points out, Moritz addresses a situation wherein the popular has become identified with the inferior, and wherein what Moritz considers true art has little hope of gaining a wider audience. Moritz's recommendation to disregard whether or not a work would please an audience has the appearance of making a virtue out of necessity. As many other writers, Moritz earned his livelihood writing travelogues and magazine articles, while the works he himself held in higher esteem were published only with great difficulty or not at all (Woodmansee 1994, 29f.). In the absence of any copyright laws, the successful works actually produced by elite writers often did not provide the writer with any income, since anyone could and did pirate commercially successful works.

Kant

The themes discussed by Moritz found expression in Kant's philosophy. The *Critique of Judgement* is Kant's account of the third of our three major intellectual

faculties, the ability to feel pleasure and displeasure. The two first are the faculties of knowledge and desire, corresponding to the domain of understanding and reason. They conform to the domain of intuitions (or phenomena) and the things in themselves respectively, but cannot give us a complete picture of objects or of the thinking subject. In part, then, the third Critique was necessitated by the anemic character of the first two Critiques, none of which really permits of a full picture of human beings. To a degree Kant's aesthetics then arises out of problems created by his own excessive tendency to systematize. But this is obviously not the only reason for this work. After his account of the True and the Good, Kant also wanted to explain our sense of the Beautiful, and our feelings of pleasure and displeasure.

According to Kant, the judgment of taste is subjective (sec. 1, 41–42), but this subjectivity is of a distinctive kind.[2] Subjective, in this context, does not mean arbitrary or purely private. Though subjective, the judgment of taste is also necessary, but its necessity is not of a conceptual or theoretical kind (in the sense in which scientific laws are necessary), and it is not based on rules or prescriptions. The necessity of aesthetic judgments is not based on general rules, but must, Kant says, be based on a subjective principle and on feelings, rather than on concepts. It can only be explained if we assume the existence of a common sense or a *sensus communis*, an assumed commonality in our nature which would explain the origin of our feelings of pleasure (sec. 20, 82).

In section 5 of the introduction, Kant argues that the principle of the formal purposiveness (formalen Zweckmäßigkeit) of nature is a transcendental principle of the judgment-power. It is necessary for the judgment-power to have such a transcendental principle to obtain a priori validity. The principle of purposiveness is, very briefly, the principle that our abilities to explain what is going on in nature are such that they accord with what is necessary to this explanation; our faculties, by an apparent coincidence, are such that we can understand and explain nature. We have to assume (we cannot be sure) that our faculties make knowledge possible, and the experience of this purposiveness (though we are not able to prove its existence) gives rise to a particular kind of pleasure (pp. 23f., 30). The feeling of pleasure connected with purposiveness is subjective, and expresses the play of the cognitive faculties in the reflective judgment. According to David Summers, Kant here relies on a long tradition "according to which the pleasure (or judgment) of a sense consists in something's being found to be in harmony with the structure of the sense itself" (Summers 1993, 134).

We want, Kant says, at least a trace or a hint that there *is* agreement between the principles of nature and our principles (sec. 42, 159). If I consider an object, and this consideration gives rise to the pleasure associated with the consciousness of purposiveness, I think that this pleasure cannot be something only I would experience, but must be connected to the object of my experience. The experience of pleasure is accompanied by a desire or a need to communicate this judgment. This imagined generality gives the judgment its subjective necessity, which is evident in the way we talk about beauty. We do not discuss beauty as if it was a

purely private experience, but as if it were something in the things we judge beautiful: "The object is then called beautiful; and the faculty of judging by means of such a pleasure (and so also with universal validity) is called taste" (31). Only that aesthetic purposiveness of fine arts which is thus based on our subjective nature (our intellectual equipment), can make a warranted claim to be bound to please everybody.

In its assumed objectivity the judgment of taste differs from the judgment that something is pleasing or entertaining. To distinguish the two, let us call the pleasure associated with the judgment of taste "delight," the other "enjoyment." If I find something enjoyable it makes no difference if the experience is shared by others, but when I say that something is beautiful I *demand* (fordert) that they agree with me (sec. 7, 52). It is ridiculous to say that something is beautiful to me alone. In Kant's attempt to distinguish the judgment of taste from the enjoyable (the merely entertaining or moving) we find the same theme as we encountered in Moritz. The entertaining or moving is an example of a barbarian taste: "Taste that requires an added element of *charm* and *emotion* [die Beimischung der Reize und Rührungen] for its delight, not to speak of adopting this as a measure of its approval, has not yet emerged from barbarism" (sec. 13, 65).

One might pause to wonder why it is so important for Kant to draw a distinction between the enjoyable (Angenehme) or entertaining (Reiz und Rührung) and the pure judgment of taste. The delight which gives rise to the aesthetic judgment is obviously not a bodily pleasure, but purely intellectual, since it is rooted in our cognitive faculties. But what is so wrong with the amusing, pleasing, and entertaining, that it must so emphatically be ruled out as barbarian? No doubt, a great part of the reason must be found in the previously discussed commercialization of literature, where the limited readership for the classics of German literature could easily be seen as a consequence of an exclusive interest in entertainment and lower forms of pleasure. It had become necessary to draw distinctions.

Kant's contention that free art must not be carried out for the sake of wages ("Lohnkunst,"[3] [1790] 1952, p. 164) must, similarly, be understood as a reaction to the growing commercialization of literature in particular. Free art must not be a "Lohngeschäft" ("contract work") (185), undertaken for the sake of a previously agreed payment. "Lohn" (wage) was opposed to the customary manner of compensating the writer, through payment of a honorarium (Woodmansee 1994, 42). The honorarium was not understood as being in proportion to the work performed, whereas wages in the contemporary understanding presupposed that the payment was in proportion to the performed service, which would then have to be measurable in terms or difficulty and duration. The popular literature in late eighteenth century Germany was exactly the kind of literature that was carried out for wages, since royalties were typically calculated by the page (Woodmansee 1994, 30).[4]

The expectation that others agree with our judgment of taste is, according to Kant, an expectation that we have our sense of taste in common with others, that the delight in "the free play of our powers of cognition" (sec. 20, 83) is a common

sensation. It is this common sense ("Gemeinsinn") which gives our judgments of taste their subjective necessity. Taste can be considered a form of *sensus communis* (sec. 40).

Sensus communis is, Kant tells us, not to be understood in the ordinary meaning of common sense or common understanding which has to it attached the idea of the vulgar or the simple. "Gemein" in German (as to some degree "common") has this dual meaning. To distinguish these two forms Kant also suggests calling the *sensus communis* related to taste a *sensus communis aestheticus*, as opposed to a *sensus communis logicus*. The aesthetic sense is in fact, Kant thinks, more deserving of the name of a common (in the sense of widely shared) human *sense* than the intellectual faculty. It is in the character of *sensus communis* that the explanation of the duality of judgments of taste must be found, the duality which consisted in it being at once subjective and objective. It is subjective in the sense that it is I who make it on the basis of my experience, but at the same time I do not think of it as exclusively mine, but one that other people must share. I feel a bond with humanity at large in the judgment of taste, a sense of community. It is in the judgment of taste we reach out to our fellow human beings. We become aware of our place in a human community, but we also reach a higher degree of self-awareness, or at least the judgment of taste has the potential for increasing our self-awareness, because the source of the pleasure is the perceived or experienced agreement between our mental faculties and nature. This agreement implies that nature is behaving in a law-like manner and that we can (and do) know the laws of nature. To deny these propositions is to be superstitious. Enlightenment is freedom from superstition. The aesthetic judgment can then become an important source of enlightenment, since it can encourage us to reflect on our intellectual faculties, hence think for ourselves, a key element in enlightenment (sec. 40, 152—cf. the passage above from "What is Enlightenment?").

This view gives the aesthetic an enormous importance in Kant's philosophy. Not only does it have the role of bridging the gulf between the two other parts of his philosophy (the moral philosophy and the philosophy of nature), but it is in the aesthetic realm that we realize our common humanity.

According to Kant, the judgment of taste thus has its basis in human nature. But there is another aspect to the judgment of taste, an aspect which occasionally appears in Kant's text. This aspect can properly be considered a social aspect, and it runs contrary to the claim that the judgment of taste (understood as a disinterested aesthetic judgment) is based on a common human ability.

The judgment of taste is disinterested ("ohne alles Interesse"). To make a judgment of taste I must take no interest in the existence or nonexistence of the thing judged about. I am not allowed, when for example observing a castle, to think in the manner of a Rousseau of "the vanity of the great who spend the sweat of the people on such superfluous things" (sec. 2, 43). In general, it is possible to pass judgments of taste only when one is beyond all desires and need, in the way only a full person is able to tell whether or not a meal is tasteful. To the hungry per-

son everything is tasteful (sec. 5, 49). The ability to make judgments of taste distinguishes human beings from animals—but it also distinguishes some people from others: a certain culture which is not always present among the ruder section of society is necessary (sec. 60, 227; see Shusterman 1993, 115–16).

The cultural difference is even more pronounced in relation to the other major type of aesthetic judgment discussed by Kant, the sublime. We encounter the sublime mostly in natural objects, or think we do, since strictly speaking it exists only in the mind. The idea or feeling of the sublime arises particularly when nature appears chaotic, "in its wildest and most irregular disorder and desolation" (sec. 23, 92). The feeling of the sublime can nevertheless be a pleasant feeling, though not in the restful manner in which we experience beauty: "The mind feels itself *set in motion* in the representation of the sublime in nature" (sec. 27, 107). Uncultivated people will only find terrible that which the cultivated person finds sublime. In the powers of nature, against which their own are nothing, they see only "misery, peril, and distress" (sec. 29, 115). The one who fears nature cannot judge about its sublimity, in the same manner as the one influenced by inclination and appetite cannot judge about the beautiful (sec. 28, 110). A certain amount of culture, and the development of moral ideas, are necessary to be able to judge about the sublime, Kant says (sec. 29, 115). Kant nevertheless insists that judgments of the sublime are not mere conventions, but that they have their basis in human nature (116).

The cultural and moral requirements are actually requirements to live in relative comfort, in circumstances where the forces of nature do not pose a direct threat, and where one does not have to make a living constantly confronting and struggling with nature as, for example, the peasant or the laborer does, and where one's immediate physical needs are secured. As Shusterman points out, what Kant advances in the name of universal human nature is actually a "socially distinctive acquisition, presupposing and motivated by sociocultural distinction" (Shusterman 1993, 116).

The connection between the ability to pass aesthetic judgments and social privilege becomes particularly clear when we consider Kant's view of the relationship between judgments of taste and moral judgments. Taste is a form of *sensus communis*, it is evidence of a certain feeling for one's fellow human beings. Taste is therefore also a vehicle (Beförderungsmittel, [sec. 41, 155]) for social intercourse. An isolated individual has no interest in his own appearance or the appearance of his dwellings. It is only in society that it is important not only to be human, "but [to be] a human being refined after the manner of his kind (the begining of civilization)" (sec. 41, 155). Many therefore assume, Kant comments, that there is a connection between an interest in beauty as such and the moral character of an individual. But others point out that this is not necessarily so. Some virtuosos of taste are morally corrupt and vain, so perhaps, Kant admits, a sense for the beautiful cannot as such be an indication of a good moral character (sec. 42, 157). But an interest in the beauty of *nature*, Kant claims, is always a mark of a good soul

(ibid.). If I discover something in nature which I find beautiful and admire or love it, I am not interested in using it or damaging it in any way. I take an interest in its own existence (sec. 42, 158), an interest Kant thinks is related to the moral point of view. It is however important that I leave nature as it is, and realize that what I see is nature's own product. This kind of interest in nature is not, however, common: It requires a level of culture, a disposition to the good or a susceptibility to it (sec. 42, 160; cf. Shusterman 1993, 117).

In the last paragraph of the first part of *The Critique of Judgement* Kant says that taste is actually a "critical faculty that judges of the rendering of the moral ideas in terms of sense (due to a certain analogy in our reflection on both)." The pleasure which gives the judgment of taste its general validity (though subjective), and brings it beyond the merely private, is actually a *moral* sensitivity. Consequently, the best preparatory education for the development of a true taste is the development of "moral ideas and the culture of the moral feeling" (sec. 60, 227).

Kant does not think it possible to find, or at least articulate, any particular standard of taste, but the assumption of a general agreement in taste nevertheless dominates his aesthetics. It is the assumption that others must agree with my judgment of taste which gives it its subjective necessity. The necessity is explained by Kant in terms of human nature. It flows from our shared intellectual equipment. Bürger points out that the appeal to universality is a bourgeois element in Kant's argumentation: "What is bourgeois in Kant's argument is precisely the demand that the aesthetic judgment have universal validity. The pathos of universality is characteristic of the bourgeoisie, which fights the feudal nobility as an estate that represents particular interests" (Bürger 1984, 43).

Kant has a considerable effect on the development of the idea that the value of art cannot be measured by simple utility or other yardsticks of ordinary life—art has a value of its own, particularly residing in the form of the work. Elements in Kant's thinking point in the direction of the romantic notion of art and artistic creation, for example his discussion of the work of art as a free creation by the artist-genius. According to Kant, fine art is the art of genius, and one characteristic feature of the creation by genius is that it is not known how the work of fine art is brought about, not even to the creator ([1790] 1952, sec. 46).

Kant's third critique is perhaps the most visionary of his works. It contains, at least as a possibility, a view of human community and of enlightenment achieved through aesthetic experience. Schiller seizes on this possibility in the development of his aesthetic theory.

Schiller

Schiller starts his letters *On the Aesthetic Education of Man* by announcing a political program: it is through aesthetics the solution to the problem of political

freedom must be found, "it is through Beauty that man makes his way to Freedom" (Schiller [1793] 1967, 9. But Schiller soon turns his attention away from the realm of practical experience and politics to the development of inner perfection in individual human beings and to increasingly abstract theories of beauty, morality, and the state.

People did not have the moral preparation necessary to take matters of government into their own hands. They needed moral and cultural education and enlightenment, and the purpose of the letters is to provide a method for this enlightenment. It would be nice if appeal could be made to human nature in this case, but naturally human beings are selfish, prone to violence (*selbstsüchtig und gewalttätig*, 14–15), and more likely to disturb social order than to uphold it.

Schiller points out that the simplicity characteristic of the ancients is foreign to the contemporary world (274). In the ancient world the cultivation of a full human potential was not reserved for exceptional individuals. No split (Zwiespalt) had yet appeared. Every individual represented his times. Now reason has separated and compartmentalized everything, a blow which was dealt to humanity by civilization itself (33). Schiller mentions specifically the development of science (specialization), state administration, and the separation of society into estates and professions. In the course of the eighteenth century the German states had developed a considerable bureaucratic system to control their powers and the class of civil servants had grown. The people who occupied these positions had, Schiller thought, rather narrow minds. Those preoccupied with business matters were similarly narrow-minded or hard of heart. The abstract thinker is often cold hearted (39). Schiller seems to find the division between the sciences and the arts particularly significant, because it affects the inner human being, the spirit and the heart. The violence exerted on people through this process is twofold: inner and outer (37).

Individual human beings are torn between, on the one side, duty, morality, reason and, on the other, desire, nature, and feeling, and they seek to become balanced human beings with a unified personality (17–19). One side of this duality can be suppressed, if for example the moral law, based on reason, holds sway, but a state based on the repression of the natural manifold is not complete. When feelings rule above law, we have a wild state, when laws rule feelings, barbarism (21). "The State should not only respect the objective and generic character in its individual subjects; it should also honour their subjective and specific character, and in extending the invisible realm of morals take care not to depopulate the sensible realm of appearance" (19).

Though he believed to live at a time when enlightenment and the spirit of free inquiry had disrupted fanaticism and habitual ways of thinking, Schiller also thought that in many respects the Germans were still barbarians (49–51). Something blocks the road out of barbarism, something hinders the appreciation of the truth even when it shines brightly. The cause must be in the minds of human beings, in lack of energy and courage, in natural inertia or cowardice, and Schiller concluded

that the way to the human head must go through the heart (51–53). It is necessary to expand the sensibility which opens people to the world and to enlightenment. This is the pressing need of the times, not just because this will be a means to improved practical insight, but because it will improve insight as such (53).

Political improvements presuppose ennobling of the character, which in a state of barbarism forces one to seek out a tool which is not already corrupted by the state or political system. The fine arts, Schiller declares, provide us with such a tool (55).

> All improvement in the political sphere is to proceed from the ennobling of character—but how under the influence of a barbarous constitution is character ever to become ennobled? To this end we should, presumably, have to seek out some instrument not provided by the State, and to open up living springs which, whatever the political corruption, would remain clear and pure. . . . This instrument is Fine Art; such living springs are opened up in its immortal exemplars. (55).

Schiller considers whether or not a sense of beauty really does go together with the moral sense such that a development of the first may lead us to expect improvements in the second, and admits that in periods where the arts flowered and taste ruled humanity was not characterized by political freedom and civic virtue (67). The historical record is not encouraging, but perhaps experience is not the proper judge in this matter.

Schiller's way out of this apparent paradox is to develop a theory of beauty and of human nature which allows for more than one kind of beauty (letters 11–16). The conclusion is similar to Kant's: beauty is a bridge or a crossing between sense (Empfindung) and thought (Denken) (123). This is not, however, to be understood as if the gulf between the two is to be filled by beauty (131).

In the course of his development of the notion of beauty and its relationship to sensory experience and reason Schiller drifts further and further away from the initial program of political liberation through the arts. The search for a way to freedom and enlightenment, out of barbarism, gradually became a search for ways to improve the character and eliminate bad manners and bad taste, though this improvement of humanity is in itself seen as a prerequisite for the improvement of the state. The aesthetic becomes an inner, intellectual faculty similarly to Kant's notion of the free play of our faculties of knowledge.

Schiller therefore declares (in letter 21) beauty in itself to be of no consequence for the will or for reason. It has no intellectual or moral goal, it finds no truths and helps us fulfil no duties. It is unfit to build either character or intellect. Precisely because the aesthetic makes no specific demand on reason or morality, because it teaches no lessons of truth or goodness it sets us free to create ourselves anew, "aus sich selbst zu machen, was er will." Not only that, it gives back the free-

dom to become what we *should* be ("zu sein, was er sein soll," 147). As with Kant, the aesthetic has the potential of becoming an important step towards enlightenment, since it forces people to think for themselves and not unthinkingly accept moral prescriptions or truths offered to them. The central ingredient in enlightenment, and here too Schiller agreed with Kant, is exactly the critical examinations of received beliefs and the ability to think independently.

The aesthetic presents us with the possibility of becoming human (149). But what is it we ought to be? What should we aim for when we create ourselves freely? No doubt, Schiller has in mind specific goals which must be chosen freely. But how do we get from the pure possibility to the more specific? As we recall, it was a central feature of Schiller's criticism of the contemporary world that it specializes and divides. The concern for utility and commerce leads to narrow-mindedness and coldness of heart, also in philosophy. Because the aesthetic is complete in itself and, as opposed to reason and morality, points to nothing beyond itself, it alone represents our humanity in its purity and integrity (151). This also becomes a measure of quality in works of art. A true work of art should provoke in us a sense of inner harmony or serenity and freedom, and not dispose us to perform any specific act or induce in us a specific feeling (153). If it does so dispose us, we have not had a pure aesthetic experience. Form must be everything and content nothing in a "truly beautiful work of art" (155), and the work of art must not instruct or have moral improvement as its goal (157).

By elevating the form of the work to everything Schiller, as we have seen with more contemporary aesthetic theory, in fact elevates a particular mode of approaching a work of art to the only legitimate one. He claims that the reason form must be everything is that a work of art considered for its content is limited to this or that specific instance and therefore limiting, whereas the form directs itself to all our mental faculties.

The aesthetic becomes a kind of mental exercise that makes the harder work of morality and truth easier. There is a way leading straight to truth and goodness, but for most people, Schiller thought, the passage would be easier if it went through the aesthetic. To enable people to experience beauty in the required manner is to open them to completely new activities and in effect requires that their nature change (163–65). The aesthetic state teaches us no particular truths, and no particular moral prescriptions but it makes of aware of our own intellectual abilities as pure form or as mere possibility which must be filled with a specific content. It is, as Eagleton explains this part of Schiller's thought, "a world of pure hypothesis, a perpetual 'as if,' in which we experience our powers and capacities as pure formal abilities, drained of all particularity" (Eagleton 1990, 107).

Freedom and brotherhood is now to be achieved through the commonality in taste. Again Schiller echoes Kant in claiming that the judgment that something is beautiful is not a private judgment but directed to all. It thus provides the foundation for a state of equality and freedom. Where taste rules, there is no room for privilege or absolute power (217). But as we saw with the British theoreticians of taste:

it is apparent that the judgment of all is actually not on an equal footing, since Schiller also thought that the majority of mankind still had an uncultivated taste. The uncultivated, popular taste seeks mere entertainment, restlessly moves from change to change, looking for the bizarre, grotesque, surprising, colorful, adventurous, strong and wild. It shies away from the ancient ideal Schiller recommended: simplicity and quiet (or tranquility) (211). Schiller's phrase is reminiscent of Winckelmann's description of the essence of Greek art as "noble simplicity and tranquil grandeur." It is, as observed by Barasch, perhaps an influence from the Pietistic tradition in German Protestantism, which sought spiritual transformation of the individual (Barasch 1990, 115–16). Schiller, too, was part of this tradition.[5] Another feature Schiller has in common with Winckelmann is the craving for wholeness and the search for a harmonious relationship between individual and society, and both saw their contemporary world as fragmented and divisive (Barasch 1990, 119). Schiller thought that the proper taste would bring harmony to society ([1793] 1967, 215), and finally realize a state of fraternity and freedom, though this freedom is of a purely spiritual kind. Schiller admits that no such state exists anywhere, except as a need in sensitive souls (219).

Schiller demands that we start all over again and do not accept received ideas of truth and morality on faith, but critically examine them and seek out our own truth. In this respect there is a great similarity between Schiller's project and that of for example Locke, Shaftesbury, and, naturally, Kant. Schiller demands that we think for ourselves. This is a far cry from Schiller's revolutionary rhetoric in the beginning of the *Letters*, but it is not without its revolutionary potential either as Woodmansee implies in her criticism of Eagleton. The *Letters* contain elements of a powerful criticism of some of the least attractive features of modernity. Criticism of fragmentation and specialization, of the dominance of science, of the disregard for poets and philosophers have been a recurrent theme ever since. This is of course why Schiller has appealed to many revolutionary spirits from Marx down to our own times.

Many of the elements central to the modern conception of art and artists emerge fully fledged in Schiller's *Letters*. When Schiller asserts that *form* must be everything and the content nothing in a "truly beautiful work of art," and that the work of art must not instruct or have moral improvement as its goal, he opposes, as Woodmansee points out, not just an ancient tradition dating back to Horace, according to which the poet must at one and the same time instruct and divert, but also a widely shared view among contemporary German writers, and a view Schiller had himself previously agreed with (Woodmansee 1994, 72). In his essay from 1784, "Die Schaubühne als eine moralische Anstalt betrachtet" (The Stage Considered as a Moral Institution), Schiller legitimizes theater by pointing out that it provides us with moral examples. The stage presents the strict principles of duty in an attractive, seductive dress (die strenge Pflicht in ein reizendes lockendes Gewand) because on stage vice is punished and virtue rewarded (Schiller 1975, 55). Schiller compares the function of the stage to the function of religion. Religion

is a pillar of the state, and without it the law would have no effect. But this is the very function the stage has, particularly in an age where religious belief is not as strong as it once was. The stage is an ally of religion in upholding the established order. It is reinforcement for the law and religion (Schiller 1975, 53–54). In the *Letters* the political and moral function of art is more abstract, but it is clearly there. The disinterested contemplation of art does not separate it from morality and politics. Even when, or particularly when, art is ostensibly autonomous and is appreciated for its form alone, it has a clear moral and political function though the function is indirect, less didactic.

In her discussion of Schiller, Woodmansee shows that many of the views Schiller advances in the *Letters* were present already in his devastating review of Bürger's poems (*Über Bürgers Gedichte* [*On Bürger's Poems*], 1790). Bürger wanted to be a popular poet, a poet for the people, but Schiller complains that the "people" Bürger professes to address no longer exists in Germany. The gap between the elect of a nation and its great masses have, due to the division of labor and differences in culture and enlightenment, become so great that it is no longer possible to speak to all of them in the same language. The poet must choose to stoop to the masses or seek the approval of the educated classes. In a letter to his philosopher-friend Fichte, Schiller complains that the taste of the German public is the most unpolished ever, and that he sees it as his task to take this terrible taste not as his model, but to work to improve it (3 August 1795; Schiller 1975, 403).

The artist should set an example and not pay "homage to the spirit of the age" or plunge "truth and beauty in the depth of a degraded humanity" (55). Schiller therefore recommends that the artist should look contemptuously on the judgment of his own time: "The artist is indeed the child of his age; but woe to him if he is at the same time its ward or, worse still, its minion! . . . But how is the artist to protect himself against the corruption of the age which besets him on all sides? By disdaining its opinion. Let him direct his gaze upwards, to the dignity of his calling and the universal Law, not downwards towards Fortune and the needs of daily life" ([1793] 1967, 55–57).

The review of Bürger's poems was written before the Terror associated with the French Revolution, at a time where, as Woodmansee observes, the French Revolution still stood as an ideal for many European intellectuals (Woodmansee 1994, 75). The Terror forms an important background to the *Letters*, but the anti-popular sentiments of the *Letters* precedes it. Woodmansee shows that the softening of the rhetoric cannot be explained exclusively as a product of Schiller's disappointment in the course of the French Revolution. Many of Schiller's views reflect his troubles as a writer and the fact that it was impossible for him to gain financial independence through the literary market alone. When Schiller said that the artist should disregard the judgment of his own time and everyday needs and create according to the ideals of art as such, it is difficult not to read it as making a virtue of necessity.

Compared to his earlier views, the program suggested in the *Letters* is abstract and without any concrete political content. But perhaps there is a more

charitable explanation than the one suggested by Woodmansee. Based on his own experience Schiller may simply have concluded that writing poems and plays, even successful plays, did not actually lead to the improvement in morality and taste that he wished for. The literary public in the German area was still quite small at the end of the eighteenth century, and the rising middle class was only moderately interested in cultural and artistic matters. The ideal aesthetic state that Schiller wanted was perhaps also an expression of the desire for that unified German nation-state, which did not yet exist. But Schiller could not point to any social forces that could bring about such a nation. Schiller and his fellow artists did not have the fortuitous conditions of the British writers of the early parts of the eighteenth century of becoming spokespersons for an ascending group which was interested not only in holding power, but also in expressing this power culturally.

With Schiller, the artist becomes a model of human perfection and autonomous self-realization. Against the corruption of the contemporary world, art and culture become, in the words of Raymond Williams, a model "of access to that ideal of human perfection which was to be the centre of defence against the disintegrating tendencies of the age" (Williams 1961, 59). In other words, the emergent doctrine of the autonomy of art is rooted in specific historical processes affecting the production, distribution, and consumption of art.

Charles Taylor points to an important connection between our modern understanding of our selves and the role of art and the artist. According to Taylor, it is characteristic of people in the modern age—roughly after 1700—that they understand themselves as having a particular inner nature in the form of "a punctual self" to which each individual has privileged access. Historically, this is very much connected with the rise of Protestantism, and its emphasis on the individual relationship to God, and the sincerity of faith, rather than adherence to a set of observable ceremonies. German Pietism was a religious movement of this kind. As a consequence individuals are expected to find and define their own version of the good or worthwhile life. "Each person is to be measured by a different yardstick, one which is properly his or her own" (Taylor 1989, 375).

Self-realization became a central category for the way modern people view their lives or the ideal life they wish to live. People can organize their lives around the notion that they have a self that they seek to realize or live in accordance with. I simplify greatly, but this is roughly what Taylor calls "expressivism." Around the late eighteenth century, still following Taylor, artists come to represent the ideal of this self-realization. This is particularly evident with Kant and Schiller. Artistic creation comes to be seen as the individual expression of a special kind of individual, the creative, artistic genius, and as something that as self-expression has a value in and of itself.

We find, thus, that there is a continuity between the concerns of Shaftesbury, Addison, Hutcheson, and Hume, and the concerns of Kant, Moritz, and Schiller. Our examination of the British thinkers from the first half of the eighteenth century revealed that in their discussions of taste and the arts they articulated a point

of view associated with a particular historical and social standpoint. The connection between morality and beauty in the writings of Shaftesbury and Hutcheson also contained a view of the social order, and they paved the way for a new conception of what I called the expressive order, compatible with that ascending social group to which they belonged, or with which they identified politically. Taste in particular embodies an attempt to create a new form of human community, united by a common taste and a common culture developed through public discourse. The view of culture, according to which possession of taste and the appreciation of works of art (if properly disinterested) is a commendable activity, or even a condition for membership among the cultured, becomes generally accepted in the course of the eighteenth century. With its general acceptance it no longer has to be defended against those who find its value dubious, or see it as a sign of a depraved craving for luxury. It becomes part of the social fabric which is simply taken for granted, and no longer has to be defended in directly social or political terms, as it did for Shaftesbury and Hutcheson. In the development that brings us from the late eighteenth century to the present, the social or political content of the notions of disinterestedness, aesthetic experience, and the autonomy of art can then seem less apparent. The conception of the disinterested contemplation of art and nature in the theories of Shaftesbury, Hume, Kant, and Schiller translated in the real world into social distinctions, since not everyone could obtain the required disinterested state. In our contemporary world the claim that one must approach art in a detached manner similarly presupposes social distinctions.

The autonomous conception of art (understood as a theory of the conditions of existence of art, and of the proper way of interpreting and engaging with art) is now taken to imply that art does not have a social and political function, or at least that its value is above and beyond whatever social and political function it may occasionally serve. To say that art is autonomous becomes a claim that its being as art does not depend on any ethical, political or social functions. But the notion of the autonomy of art and the notion that an "autonomous" manner is the correct manner wherein one should engage with art cannot be separated from the social order of modern society as it has been shaped since 1700. This conception of art marginalizes other forms of art, and connects art to notions of self-presentation, characteristic of the dominant culture. The historical narrative in this book has shown how a particular form of discourse about art gained cultural hegemony, and how this type of discourse is inseparable from social assumptions and aspirations, expressed in terms such as "politeness," "good breeding," culture, and civilization.

Art, Autonomy, and Ideology

Most contemporary British and North American philosophy of art rests on the assumption of the autonomy of art, and the idea that art must be approached in a specifically aesthetic or "disinterested" manner. The conception of art on which it relies is not normally advanced as a conception with a social and political nature, as belonging to a particular historical tradition and culture. But the contemporary conception of the autonomy of art and its disinterested contemplation does actually contain political and social presuppositions similar to those found in its historical predecessors.

Within the tradition the conception of art was inseparable from a *Bildungsideal*, and as such had the character of a prescription or norm. In contemporary philosophy this normative character is preserved, though rarely acknowledged as such. The conception of art is advanced as a matter of fact. In a sense to be specified, this gives the modern conception of art an ideological function.

Contemporary Philosophy and the State of the Arts

Danto observes that there is virtual consensus in Western aesthetics "that the essence of art is its ephemerality, outside the framework of use and purpose which

defines human life" (Danto 1986, 166). Art does not, according to this view, belong in the realm of ordinary things and events. According to David Novitz, one of the relatively few contemporary philosophers critical of this view, we are still in the grips of a "specific and very restricted view of the fine arts," which maintains that art exists for its own sake, and that "our understanding and evaluation of it should not concern itself with matters extraneous to the work" (Novitz 1992, 2). In the early parts of this century, Fry and Bell advocated this view in their theories of art, as did Edward Bullough in his famous essay "'Psychical Distance' as a Factor in Art and an Aesthetic Principle." Some form of it has later been defended by, among others, Ortega y Gasset (1956, 16), Beardsley (1987; Beardsley and Wimsatt 1987), Hampshire (1959; 1982, 244), Sibley (1987), Ingarden (1961), Stolnitz (1986), and Scruton. Scruton has argued that without the assumption of the autonomy of art, aesthetics (as a philosophical discipline) could not exist (Scruton 1983, 8). The present controversy about new forms of, for example, social or feminist art history and criticism is in large measure about this conception.

In the contemporary world, the idea that art is independent of political or moral values is occasionally used to keep the censor at a distance. In cases where the borderline between politics, morality, and art is blurred, as for instance happens in controversial art exhibits, both defenders and attackers of the works of art in question build their case on the maintenance of the distinction. The controversy over an exhibit entitled "Witnesses: Against Our Vanishing" held in New York City in November 1989 exemplifies this.

The exhibit dealt with AIDS and its consequences, and it was originally given a grant from the National Endowment for the Arts (NEA) in the United States. The grant was later withdrawn by Frohnmayer, then chairman of the NEA, ostensibly because of a law passed in the United States aiming to restrict public funding for artworks considered "homoerotic" or "obscene," and because of critical remarks in the catalogue about the Roman Catholic Archbishop of New York and certain American politicians. Frohnmayer's main objection to the show was that "a large portion of the content [of the show] is political rather than artistic" (*New York Times*, 9 November 1989, C28). One possible line of defense for the organizers of the exhibition would, of course, be to acknowledge a political element in the exhibit. AIDS is very much a political issue in the United States today, so how can the exhibit possibly avoid politics? But the executive director of the gallery where the exhibit was held shares (or at least pretends to share) Frohnmayer's desire to preserve the division between art and politics, and states that she "wholeheartedly believe[s] in this show. It has not changed from art to politics. It is art" (ibid.; see also *New York Times*, 10 November 1989, C33).

This conception of art as autonomous occurs in contemporary philosophy of art precisely in the idea that art should be appreciated and interpreted in a manner that does not relate it to political and social issues, or to the context in which art is produced and consumed. I have already in passing indicated how this is the case in some contemporary or near contemporary contributions to aesthetics, for example

in my discussion of Sibley's celebrated "Aesthetic Concepts." It was also implied in my criticism of Tilghman, who, in spite of appearances to the contrary, relies on a notion of the historical development of art which views this as autonomous. Levinson explicitly rejects including reference to "the social, political and economic structures that surround the making of art at different times" in his definition of art (1993, 411). Recently, the view that art has its value in itself and that it should be approached in a manner that does not relate it to practical, moral, or political concerns has been defended by Stolnitz (Stolnitz 1986).

The characteristic feature of the proper approach to a work of art is what Stolnitz calls its aesthetic disinterestedness. Popular entertainment or folk art is not approached in this manner, but merely for the sake of entertainment or relaxation. These types of art are not, therefore, abstracted from the interests of the group(s). Real, or authentic, art cannot be appreciated if it is used to gratify any ulterior desires (entertainment, relaxation) (30). Stolnitz assumes that the disinterested approach to works of art is better, more elevated, than the approach characteristic of folk or popular culture, where the works of art (if that is what they are) are closely connected to the "common interests, hopes, and fears of the group," as he says with a quotation from Arnold Hauser (Stolnitz 1986, 33). (It is, as Stolnitz is of course well aware, telling of the wide acceptance of this view, that a non-Marxist such as Stolnitz can invoke Hauser in defense of his view.) The person who seeks entertainment or demands to recognize his own world in the work of art,

> cannot divorce himself from the insistence that things must serve his desires, "biological" or aesthetic, and that they must do so quickly. His self, gripped by this need for "tendency gratification," dominates this experience. "Art music" and art of comparable quality in the other media, because it will not serve him, cannot then become the center of his attention. Its will is to be itself, faithful to its own integrity. Such art can be appreciated only by the percipient who can rise to the demand of taking on "for the time being" the self enjoined by the work. (Stolnitz 1986, 42)

When we interpret a painting, such as Picasso's *Guernica*, anything extraneous, for example knowledge about the history of the painting or biographical knowledge about Picasso, is irrelevant, even the fact that the title of the painting is the name of a city in Spain which was bombed during the Spanish civil war, an event *Guernica* is commonly assumed to refer to. "*Guernica* has nothing whatever to do with Guernica" (Stolnitz 1986, 37). In fact, Stolnitz thinks, the more ignorant a person is about things external to the painting, the better that person is able to appreciate the painting. Stolnitz assumes, as is generally assumed, that in the "disinterested" approach to the work of art no special interests are at stake, that it is possible to perceive a picture merely on the conditions which are somehow given by the picture itself.

Stolnitz clearly continues the tradition he argued started with Shaftesbury. But the discussion of disinterestedness in the work of Shaftesbury, Hutcheson, Kant, and Schiller showed that disinterestedness did not separate the perception of a work of art from the interests of a group. In fact, the opposite was true. Not only does it legitimize a specific approach to works of art, it also tends to exclude many forms of art, particularly political art. If clearly political works of art are created by canonical artists (such as Picasso), one must dissociate oneself from the political contents of the work.

It is clear that the idea of the uneducated gaze is false. Wartofsky, Bryson, and many others have argued that perception is always education, hence interested (Wartofsky 1979; Bryson 1983). Perception is not just a function of unalterable biological faculties, but is historically shaped. The evidence presented in this book points in the same direction.

Bourdieu agrees with the extensive work done by philosophers in the analytic tradition on the nature of perception (Goodman, Wartofsky, and others). Since Hanson's work in the 1950s (Hanson 1958) it has become clear that seeing is not a straightforward biological process, but that the gaze is educated. Seeing involves seeing *that* something is the case, and understanding of representations depend on knowledge of conventional techniques. In the area of aesthetic Bourdieu connects this insight to social differences.

Bourdieu distinguishes between four different forms of capital: economic, cultural, social, and symbolic. To possess cultural capital is to possess a form of social power distinct from the more direct power one has if one controls economic capital. Cultural capital "presupposes embodiment of distinctive and distinguishing sensibilities and characteristic modes of action," and it is a noneconomic, or at least not directly economic, resource in the social struggle for power, recognition, distinction, and profit (Calhoun 1993, 70–71).

The appreciation of the right kinds of art in the appropriate manner becomes a requirement for, and a sign of membership in, a cultural elite. The ability and desire to abstract from extraneous circumstances, and not relate, for example, that which is seen in a picture to one's own life world, is a product of what Bourdieu calls one's cultural or educational capital (Bourdieu 1984; see also Novitz 1992).

Any activity, from cooking to deodocaphonic music, can be appreciated in a variety of ways, "from the simple actual sensation to scholarly appreciation." The refined appreciation of a work of art, particularly of a nonrepresentational work of art, requires the mastery of the, at the time, appropriate instruments (Bourdieu 1993, 220–21). They require, for example, knowledge of the history of art, of different styles, of individual artists, of art theory, classifications into historical and stylistic categories (Renaissance, Impressionism, etc.) and knowledge about acceptable ways of interpreting works of art. The higher the degree of subtlety one can achieve, the better one masters the code, and the higher is one's cultural capital. If I am able, for example, not only to identify a painting as belonging in the Italian Renaissance, but to locate it as belonging to a particular school (Sienese, Venetian), or as being created in a particular workshop, I have a higher degree of cultural capital.

In general, the ability and inclination to approach a work of art in a "disinterested" or "aesthetic" manner which does not relate the work to practical, moral, or political questions is directly related to one's educational capital, which simply refers to the duration of one's schooling (Bourdieu 1984, 18). The higher one's educational (or academic) capital, the better, generally speaking, one's ability to approach a work of art in the manner presupposed in much aesthetic theory and art history. Differences between people with equal amounts of educational capital are explicable in terms of their social origin (determined on the basis of their fathers' education). But education alone is not decisive, since success in academic pursuits, or even access to education, is also determined by social background (23). People with little formal education do not typically observe a work of art in a detached manner, but relate it to the world in which they live. According to Bourdieu,

> nothing more rigorously distinguishes the different [social] classes than the disposition objectively demanded by the legitimate consumption of legitimate works, the aptitude for taking a specifically aesthetic point of view on objects already constituted aesthetically . . . and the even rarer capacity to constitute aesthetically objects that are ordinary or even "common" . . . or to apply the principles of "pure" aesthetic in the most everyday choices of everyday life, in cooking, dress or decoration, for example. (Bourdieu 1984, 40)

But the ability to view a work of art or any other object independently of its context is not just a matter of having the right education, and hence the right conceptual apparatus to do so. It requires in addition, Bourdieu observes, "withdrawal from economic necessity" (54). These requirements restrict the ability to approach art in the manner presupposed in some forms of aesthetic theory and art history to socially privileged groups.

The assumed difference between high art and low or popular art is, as mentioned by Stolnitz and as implied by Bourdieu, in part a consequence of the disinterested approach. Advocates of the disinterested approach assume that through it the intrinsic features of works of art will be revealed and justify such a distinction. With the demise of the disinterested approach, there are, however, good reasons to assume that this distinction too must be abandoned.

The High and the Low

In *The Boundaries of Art*, David Novitz examines different attempts to distinguish between high and popular art on the basis of the intrinsic features of the objects belonging to the two different categories (Novitz 1992). Normally, the distinction

between the two types of art is understood in terms similar to the ones we encountered in Stolnitz's account above. High art is thought to be not merely entertaining or pleasing, but to satisfy a more refined taste, a difference which, it is then assumed, is based on a formal difference between the high and the low (Novitz 1992, 23). Novitz examines possible answers to the question wherein this formal difference may consist: does high art have a higher "formal complexity"? Or does it arouse or embody different ("nobler") feelings than popular art? Is it produced in a different manner? On closer inspection, none of the suggested features allow us to draw a clear distinction between high and low or popular art. Some forms of popular art, for example film, are highly complex, while some forms of high art (for example minimalist paintings, or medieval Madonnas) cannot be said to be complex. Similarly with the other suggested distinctions: regardless of the suggested feature, it is always possible to find a work of popular art with the same feature, and vice versa.

Richard Shusterman reaches a similar conclusion when he examines the reasons given for the supposed inferiority of the popular arts, and finds that underlying most arguments, even ostensibly political and social arguments against popular art, there is actually the charge that the popular arts are aesthetically worthless or inferior to the high arts (Shusterman 1992, chap. 7). Shusterman does not wish to promote the popular arts at the cost of the high arts, but argues that the popular arts have some of the same aesthetic qualities (particularly the ability to provide rewarding aesthetic experiences) as those usually credited exclusively to the high arts. Not all popular art is good art, interesting or rewarding, but then the same can be said about the high arts. Much of what we now consider high art (Greek drama, Shakespeare, many classical novels and poems) began life as popular art, and many creators of so called high art (Shusterman mentions T. S. Eliot as an example) certainly hoped for a wide audience, and did not want to create works exclusively for a small elite. Shusterman also points out that the rejection of, for example, rock music is often due to the simple fact that the critics do not devote the same degree of prolonged attention to the creations of rock music as they do to the canonical works of high art, but reject it in advance (Shusterman 1992, 188).

In his examination, Novitz draws the conclusion that, since works of art are socially produced, the demarcation is actually a socially created distinction. The reasons for the distinction between high art and popular art "are to be found in certain social relations, and not in the physical features, origins, or causal properties of the works" (Novitz 1992, 28). Among the causes of the origin of the emergence of the distinction between high and popular art, Novitz points to factors similar to those discussed above: the dominance of profitability and market relations in society, the development of mass-produced literature, a new emphasis on the freedom of the individual, and the consequent gradual isolation of the artist from the mainstream of society. According to Novitz, the distinction between high and popular art becomes particularly evident from the beginning of this century, when modernist art becomes increasingly esoteric and difficult to

understand. High art becomes an epithet for art created without any obvious concern for or in direct opposition to commercially successful art.

Novitz's contention that the distinction between high and popular art only becomes a subject of theoretical and historical reflection in the twentieth century is, I believe, mistaken. As my discussion shows, already Addison and Shaftesbury found it necessary to distinguish the high from the popular arts, though they did not do so in these terms. The distinction was, we have seen, clearly present and a matter of some concern for Moritz, Kant, and Schiller towards the end of the eighteenth century. Kant and Schiller rejected the popular arts for much the same reason that they are frequently rejected today: they are mere entertainment, and do not contribute to enlightenment or moral edification, and they appeal to the sensuous rather than the rational part of man.

Novitz's analysis of the social function of the distinction between high and popular art is, however, in line with the one suggested in this work. Since high art was only accessible to those with a minimum of education, its appreciation became a sign of belonging to a cultural elite. Consequently, "the distinction between high and popular art does not merely distinguish different types of art, but, much more than this, it actually accentuates and reinforces traditional class divisions within capitalist society" (Novitz 1992, 36).

To rely on the conception of art as autonomous is, therefore, to treat as privileged one particular discourse, among many possible and competing discourses. The superiority of the high arts cannot be assumed without argumentation. To do so is to become an advocate of one specific culture or group at the expense of others.

Much of the connection between the disinterested approach to art and the distinction between high an low can be understood in historical and sociological terms. Levine's examination of the emergence of cultural hierarchy in America is very instructive in this connection.

The detached manner in which we are expected to listen to a piece of music, or the quiet solemnity we observe in a theater are not products of nature. Shakespeare did not write his plays for an audience that was expected to receive it with the quiet attentiveness we now customarily observe in the theater. Throughout America in the nineteenth century, Shakespeare was considered a component of popular culture. Shakespeare's plays were well known in the United States in the eighteenth and nineteenth centuries and the subject of many travesties, burlesques, and parodies. His plays were performed frequently to considerable audiences all over America. The performances have similarities with the theater in England in the late seventeenth, early eighteenth centuries, where the performance of the play was combined with other forms of entertainment, for example joggling, acrobatics, gymnastics, popular songs and dances (Levine 1988, 21).

Towards the end of the nineteenth century and during the twentieth, Shakespeare's plays gradually change their status: Shakespeare becomes "an elite, classic dramatist, to whose plays the bulk of the populace cannot relate" (ibid., 34). Professors

were needed for the explanation and elucidation of Shakespeare's prose, notes and introductions to his plays were necessary, or even "translations" (72). What is now considered "legitimate theater" (76) becomes increasingly exclusive, and expensive, whereas the movies provide cheaper entertainment for the working class (77). A similar development affected the reception of music in America in the nineteenth century.

Musicians previously divided their time between (say) work for larger orchestras playing larger works, and the performance of popular music, such as dance music. Often a musical programme would contain a mix of both. With the establishment of permanent orchestras this changed. In Boston, the musicians of the Boston Symphony Orchestra were explicitly forbidden to play for dances (124). If the orchestras still performed "lighter" music this would be done in special performances separate from the regular programming which was meant for "those who preferred to have their culture unsullied by compromise" (131). All the symphony orchestras needed wealthy financial supporters because they were not financially viable. The lack of financial viability becomes a sign of distinction in high culture: it is distinct from the commercially successful.

This claim has recently been made by Barbara Amiel (1995), the former newspaper editor turned London socialite and right-wing ideologue, who is married to the newspaper magnate Conrad Black. She argues in favor of public support for the fine arts and the opera in particular. Opera is elitist in the sense that it is "enjoyed by a narrow band of people," but it is here that we find the difference between fine art and pop culture. As a fine art, opera addresses sensibilities which cross all social differences. "[I]n the same way that physical beauty, agility or power have a narrower distribution among all classes of human beings, so the love of the fine arts is guided by a narrower development in the human brain."

We saw the beginning of this conception in the writings of Moritz, Kant, and Schiller. Through the process described by Levine, music ("art music") comes to be seen as sacred. Popular music and songs, which were previously interspersed into a symphonic program, now appear low, vulgar, something not to be indulged. "The urge to deprecate popular musical genres was an important element in the process of sacralization" (Levine 1988, 136). The work of the composers (as opposed to the work of the performers) obtain a sacred character, not to be tampered with, but to be reproduced as faithfully as possible.

For the listener to classical music, the development Levine describes leads to the demand than one has large amounts of time to study the intricacies of musical performance, the lives of the different composers, the history of music, and so on, insight which can only be obtained through vast expenditures of time, only available to few. Competence in these matters became a form of conspicuous leisure in Veblen's sense of that term. The cultural elite in America felt threatened by industrialization, capitalism, commercialism, and the many new immigrants. The attempt at a cultural unification were partly a reaction to these phenomena.

Today's standard behavior in a concert hall or a theater—passivity, attention, quiet, motionlessness—is the result of a systematic effort to discipline and "culture"

the audience. The enforcement of rules and prejudices against audible and visible expressions of approval or disapproval of a performance results in the enforcement of a cultural monopoly on the choice of repertoire (189). The enjoyment of music becomes something spiritually elevated rather then mere entertainment. The illusion is created that this manner of appreciating art is the one for which the works of art were originally intended, "that the aesthetic products of high culture were originally created to be appreciated in precisely the manner late nineteenth-century Americans were taught to observe: with reverent, informed, disciplined seriousness" (229).

Part of the distinction between high and low art is found in the ceremonial behavior surrounding high art. Classical music is performed by people wearing suits or formal dress, whereas rock or jazz can be performed in jeans and T-shirt. Sitting quietly in one's seat while listening to a piece of music or a play is the behavioral equivalent of the imposed disinterested approach to artworks. It is the opposite of the loud, unruly, participatory stance assumed by audiences in England in the seventeenth and eighteenth centuries, in America in the early nineteenth century, or at a contemporary rock concert. To attend a symphony one has to master behavioral conventions, such as not clapping between the movements or at the end of a solo, and not getting up to dance if one should feel so inclined. The disinterested approach is enforced by social sanctions which differ from those operational in rock or jazz (which naturally have their own behavioral conventions). This is a point of considerable philosophical significance: the autonomous, disinterested approach to art is not the obvious or "natural" one, but one that emerges as a result of a historical process and individual socialization.

The disinterested approach to a work of art described by Stolnitz (1986) *is* sophisticated. As mentioned in the discussion of Danto in chapter 3, something *is* required to see things as art. It requires the cultivation of a *habitus* in Bourdieu's sense of that term. Beliefs are present as a "state of the body." Values given body can "instil a whole cosmology" (Bourdieu 1990, 68–69). Levine's work on cultural hierarchy suggests that this is very much the case for the things we consider "high art." The solemn silence of the museum, the concert hall, and the theater and of our reading reinforces the belief that we enter another world, secluded from the rest of our lives and that we are in the presence of the sacred.

Philosophy of Art and Social Distinction: Art and Ideology

Through its reliance on the conception of the autonomy of art contemporary philosophy of art has a function analogous to that of its historical predecessors. The conception of the autonomy of art connects to the reinforcement of

social distinctions. The ostensible disinterestedness of much contemporary phi-
losophy of art connects to social interests: it reinforces distinctions between those
to whom "high art" is accessible and those to whom it is not.

There are, we are led to believe, inherent features of some types of art which
make them more conducive to the disinterested approach than others, a feature or
features which distinguish them from, say, folk art or popular entertainment. The
difference is a simple one of quality. The differentiating feature between that
which becomes canonical and that which does not, is presented as a fact, as a
simple matter of what is great art and what is not, as a question of features of
objects and not a matter of the rules guiding a cultural practice, or the way in
which a historically, socially, and politically contingent discourse has been con-
structed. The representation of the normative as the merely factual is a feature of all
ideology. In the words of Wartofsky: "When norms present themselves as descrip-
tions of fact, we have ideology" (Wartofsky 1980, 241).

The concept of ideology is frequently seen as problematic because it seems to
depend on an conception of privileged access to the truth. If I consider a set of
beliefs "false consciousness," I seem to imply that I have escaped this false con-
sciousness and I am therefore able to pronounce with certainty on the truth or fal-
sity of other beliefs. Such a point of view would resemble the deservedly discredited
epistemological foundationalism. I use "ideology" in a more limited sense, however,
in which it embodies the insight that our views of the world are perspectival,
shaped by historical and social contingencies. It is when a perspectival view is ele-
vated to an eternal truth and when it embodies social interests or norms that are
not recognized as such that a view becomes ideological. The elevation of a socially
and culturally contingent, historically limited condition of the existence and appre-
ciation of art to an essential fact about the true nature of art as such turns the
reliance on this conception into an ideology (see Eagleton 1991 for an instructive
discussion of the many senses of "ideology"). This is equally the case for traditional
aesthetics as for the alternative, descriptive approach. Essentialism mistakes the
products of historical and social contingencies for natural or purely formal features
of objects; descriptivism uncritically elevates the prevailing order, which forms
the basis for its descriptions, to a matter of fact, and in this way gives to the pre-
vailing state of the arts the appearance of being eternal and natural.

The ideological function appears as well when the conception of the auton-
omy of art is taken (as it almost always is) as an indication that the social function
of art can be ignored in a philosophical analysis. The conception of the autonomy
of art becomes equated with the idea that art is independent of society. Peter
Bürger has aptly summarized how the autonomy of art can be taken for the view
that art is therefore independent of social constraints. The category of autonomy
permits, Bürger says,

> the description of art's detachment from the context of practi-
> cal life as a historical development—that among the members

of those classes which, at least at times, are free from the pressures of the need for survival, a sensuousness could evolve that was not part of any means-ends relationships. Here we find the moment of truth in the talk about the autonomous work of art. What this category cannot lay hold of is that this detachment of art from practical contexts is a *historical process*, i.e., that it is socially conditioned. (Bürger 1984, 46)

If the autonomy of art is not viewed as the product of a historical process but as the essential, timeless truth of art, the conception of the autonomy of art becomes, Bürger says, ideological. In this reified form,

[t]he category "autonomy" does not permit the understanding of its referent as one that has developed historically. The relative dissociation of the work of art from the praxis of life in bourgeois society thus becomes transformed into the (erroneous) idea that the work of art is totally independent of society. (Ibid.)

Some forms of art do, no doubt, in some measure have a life of their own in our society. The relative isolation of high art is a result of specific historical circumstances; to the extent that art is autonomous, the autonomy is a result of historical contingencies, and not a natural fact about art as such. Similarly with the disinterested approach to art. To the extent that such an approach is possible or desirable, it is a product of socialization, and not the exercise of a natural faculty some humans have to a higher degree than others. Through the uncritical assumption of the conception of the autonomy of art, philosophy of art elevates a historically contingent, social, political, and cultural norm to the status of a fact of nature, or a purely conceptual truth.

Some of the points I have made have also been made by, for example sociologists of art, advocates of new forms of art history, and postmodernists investigating forms of popular culture in the contemporary world. But the historicist approach taken in this work makes it possible to draw conclusions which have not been drawn by either: the distinction between high and low is not something which has emerged as a result of a recent cultural disintegration, but has been slowly built into our conception of art and culture since the later eighteenth century. The distinction was present in the eighteenth century differentiation between polite and vulgar forms of art, and even earlier in the distinction between mechanical and liberal arts. From its very first formulations in the works of Addison, Shaftesbury, Hutcheson, and Hume, the fine arts were an alternative to and were developed on the ruins of traditional forms of popular culture. The modern conception of art has always had built into it cultural differentiations, though these became more pronounced with the dissipation of the hope of creating a homogenous public sphere. In Shaftesbury

and Hume we still find the hope that a universal culture can be created, but this proves, in the course of the eighteenth century, increasingly difficult. Consequently, the idea of art connects to the creation of differences, a development which becomes particularly evident throughout the nineteenth century where possession of culture becomes opposed to the mob (cf. Williams 1961).

The historicist approach allows us to glimpse an answer to the question why areas such as the philosophy and history of art have proven peculiarly resistant to theoretical changes. The historical account given in this work has shown that the emergent conception of art became a part of a new expressive order. This conception of art became part of a view most educated people form of themselves, a part of a personal narrative, as, for example, Fry had occasion to observe in the early part of this century. Because the modern conception of art is ingrained in the expressive order it is particularly resistant to change. To change, it requires change in more than a theoretical conception: a deeply held view many of us have of ourselves must change. With the formation of this view of the self is also formed a view of that which it is not: the appreciator of art, as opposed to the non-appreciator, the polite as opposed to the vulgar, culture as opposed to barbarism.

The modern conception of art emerged as part of complex cultural, social, and political transformations in the seventeenth and eighteenth centuries. There was no longer any central authority by which political power and claims to truth could be validated. Everything, Shaftesbury and others claimed, should be open to critical scrutiny within the public sphere. This critical scrutiny also encompassed previously accepted forms of morality and behavior, and notions of what it is to be a respectable human being. New behavioral criteria take the place of birth. Among these, the possession of taste and politeness were of particular importance. In the redrawing of the boundaries of human activity, certain activities relating to the possession of taste obtain special significance: knowledge of painting, an interest in sculpture and gardening, acquaintance with certain forms of literature, familiarity with music and architecture—all of which come to be known as the polite, or later the fine arts. Addison, Shaftesbury, Hutcheson, and Hume assured their readers that by surrounding themselves with art they would set themselves off to an advantage, and indicate their moral superiority. The grouping together of what came to be known as the fine arts and the idea that they should be approached in a disinterested manner, disregarding the sweat of the laborers expended in the erection of buildings or creation of gardens, became an important part of the self-consciousness of the emerging middle class. Because they alone were able to approach art in this manner, this approach to art became part of the way they justified their social position to themselves and others. The doctrine of the autonomy of art, and the idea that art must be approached disinterestedly, or in a specifically aesthetic manner, provide their advocates with a personal narrative through which they can see themselves as more worthy than others.

With its science, industry, and technology, and with its requirement of constant change the modern age reveals possibilities which previously could hardly be

imagined. But at the same time it destroys: people are torn from their traditional contexts; what used to be indisputably good and beautiful can no longer find a place. Again and again the modern age has been considered spiritless and a destroyer of spiritual values. In this situation the arts and the aesthetic became a refuge for spiritual values. In particular, this has been the case for those movements which deplored the utilitarian aspects of modern capitalism and declared that art has its value in and of itself. As an intellectual refuge, art would then represent an alternative to inhuman conditions in the real world. But if it is claimed that art should be appreciated for its own sake in isolation from the struggles of everyday existence, it becomes such an alternative only by equipping itself with a halo. But art and our conceptions of the arts are not isolated from the broader realities of our everyday lives. I hope that the present work has made it apparent that our concept of the arts is deeply ingrained in historical processes of a social, political, and cultural nature and that it represents people's attempt to understand aspects of their present and their past.

NOTES

6. *Art and Science*

1. Whenever I use expressions that are now considered sexist (such as "man," "men," "mankind," or "gentleman"), this reflects eighteenth-century useage and not my preference.

7. *New Discursive Practices*

1. "The *idea* of a supreme Being, infinite in power, goodness, and wisdom, whose workmanship we are and on whom we depend, and the *idea* of ourselves as understanding rational beings, being such as are clear in us, would, I suppose, if duly considered and pursued, afford such foundations of our duty and rules of action as might place *morality amongst the sciences capable of demonstration:* wherein I doubt not but from self-evident propositions, by necessary consequences as incontestable as those in mathematics, the measures of right and wrong might be made out to anyone that will apply himself with the same indifference and attention to the one as he does to the other of these sciences" (*Essay*, 4.3.18).

2. "[V]olumes writ of navigation and voyages, theories and stories of zones and tides multiplied and disputed, nay, ships built and fleets set out would never have taught us the way beyond the line; and the antipodes would be still as much unknown as when it was declared heresy to hold there were any" (*Essay*, 4.3.30). For a remark about "mechanics," see also *Essay*, 3.10.9.

9. Standards of Taste

1. The decline of birth as a criterion is also evidence of the growing influence of middle-class values: "[W]ith the rise of the middle classes following the Civil War and with the decay of the nobility and gentry through debauchery and prodigality of living, men were disillusioned; and as they recalled the glory of English nobility of preceding generations, they could have little short of contempt for the atheistic and riotous debauchees of the Restoration and later, who had nothing except the title" (Heltzel 1925, 13). Whether the nobility was so much worse in the late seventeenth century than it had previously been is perhaps an open question, but no doubt the middle class saw the development in the terms used by Heltzel.

2. "In brief, the gentleman, according to Chesterfield, should have a smattering in the criticism of painting, sculpture, and architecture to fit him for conversation upon these subjects, but he must not descend into the details of any of them nor concern himself with any of those low and mechanical parts which are beneath the gentleman" (Heltzel 1925, 211).

10. Shaftesbury and the Morality of Art Appreciation

1. Shaftesbury "sets into motion the idea which, more than any other, marks off modern from traditional aesthetics and around which a great deal of the dialectic of modern thought has revolved, viz., the concept of 'aesthetic disinterestedness'" (Stolnitz 1961c, 98). Aesthetic disinterestedness "describes a certain mode of perceiving" peculiar to a certain kind of experience: aesthetic experience. When perceiving anything in this manner any other concerns, such as practical, moral, political or religious are suspended (ibid., 98–99). To consider anything, typically a work of art, in a disinterested manner is to value it or perceive it "for its own sake."

2. The view that Shaftesbury rejected his teacher's philosophy is only true with modifications. Shaftesbury accepted much of Locke's philosophy, though not his ethical views and his view of human nature. See Fowler 1882, 44–45. In a letter to Michael Ainsworth dated June 3rd, 1709, Shaftesbury says that he admires Locke for his writings on government, policy, trade, coin, education, toleration, etc., but he cannot accept Locke's view of human nature, which he sees as essentially the same as Hobbes'. "'Twas Mr. Locke that struck at all fundamentals, threw all order and virtue out of the world, and made the very idea of these . . . *unnatural* and without foundations in our minds." Shaftesbury correctly thought Locke a much greater danger in this respect than Hobbes, because Locke generally was so much more highly estimated than Hobbes. Shaftesbury was also greatly disturbed by Locke's "moral relativism," and thought it derived, probably again correctly, from too much reading of "Indian barbarian stories of wild nations" (Shaftesbury 1900, 403–4). Perhaps the fear of moral relativism is the reason why Shaftesbury was so vehemently opposed to the reading of travel-books, a very popular genre in the early eighteenth century (see Shaftesbury [1711] 1963, 1:221–23). For Locke's view on the purpose of the education of the mind, see Locke [1693] 1963, sec. 33 (p. 27) and sec. 45 (p. 36).

3. See *The Confession of Faith agreed upon by the Assembly of Divines at Westminster*, e.g., chaps. 6 and 9, and *The Book of Common Prayer*, Articles of Religion, 9, 10, and 18. In 1738 Hutcheson was tried for heresy for being in contravention of this principle. See Scott 1900, 83; MacIntyre 1988, 245.

4. Jeremy Collier expresses this view in his *Essays Upon Several Moral Subjects:* "A good Man is contented with hard Usage at present, that he may take his *Pleasure* in the other World" (Collier 1698, pt. 2, 191). See also Locke, *Essay* 1.3.12, 13, where he argues that moral principles require rewards and punishments.

5. "This passage [about the disinterested love of God] brings us close to the aesthetically relevant meaning of 'disinterestedness.' Perception cannot be disinterested unless the spectator forsakes all self-concern and therefore trains attention upon the object for its own sake." Stolnitz applies the term "aesthetic" in the modern sense, where it refers to something which is independent of, for example, morality and religion. "Aesthetic perception looks to no consequences ulterior to itself." In developing the notion of aesthetic disinterestedness, later writers unpack "what is already implicit in his [Shaftesbury's] account" (Stolnitz 1961c, 107–8).

6. A passage by Addison reminds one of this (and other) places in the *Characteristics:* "A man of a Polite Imagination is let into a great many Pleasures, that the Vulgar are not capable of receiving. He can converse with a Picture, and find an agreeable Companion in a Statue. He meets with a secret Refreshment in a Description, and *often feels a greater Satisfaction in the Prospect of Fields and Meadows, than another does in the Possession. It gives him, indeed, a kind of Property in every thing he sees,* and makes the most rude uncultivated Parts of Nature administer to his Pleasures: So that he looks upon the World, as it were, in another Light, and discovers in it a Multitude of Charms, that conceal themselves from the generality of Mankind" (*Spectator* 411 [21 June 1712], my italics; Bond 1965, 3:538).

7. See also 1:91: "The admirers of beauty in the fair sex would laugh, perhaps, to hear of a moral part in their amours." Compare 1:324.

8. Shaftesbury gives a related example in connection with mathematics: when doing mathematics it is possible to experience "a pleasure and delight superior to that of sense" (1:296), but this pleasure has no connection to any advantage we ourselves may derive from it. See also the previously quoted passage by Addison (note 6 above).

9. See also 2:267–68. Shaftesbury derived from his reading of Plato and Plotinus a view of the universe as one harmonious whole, and he was in this question, as in many others, influenced by the Cambridge Platonists. See Cassirer 1951b. My concern is with the contemporary context of Shaftesbury's writings. It is therefore beyond the scope of this work to go into details about Shaftesbury's theoretical sources.

10. This is another area in which there is agreement between Shaftesbury's position and the view of the Cambridge Platonists. Shaftesbury's first published work was a preface to a collection of sermons by the Cambridge Platonist Benjamin Whichcote (Whichcote 1698). See, for example, the attack on Hobbes in the preface, xxv f. Many elements in Shaftesbury's conception of human nature and of his moral philosophy can be found in Whichcote's sermons, but, as J. A. Bernstein points out in his introduction to the 1977 facsimile reprint of the work, we "cannot judge the degree to which the reading of these sermons actually influenced the young Shaftesbury, or were merely consonant with views he had already formed" (vii).

11. *The Reformation of Manners*

1. "Manners and morals were regulated, because it is through the *minutiae* of conduct that the enemy of mankind finds his way to the soul; the traitors of the Kingdom might be revealed by pointed shoes or golden ear-rings" (Tawney 1984, 124).

2. "Bartholomew Fair was held at Smithfield on 25 August, the feast of St Bartholomew. There, in the seventeenth century, you could see plays, puppet-shows, clowns, rope-dancers and waxworks, introduced by showmen dressed as fools or as wild men of the woods, while your ears were assaulted by drums and penny trumpets" (Burke 1978, 112).

3. Regarding festivals in early-eighteenth-century England, see Malcolmson 1973, chap. 2. On the participation of the upper classes in popular recreations, see Malcolmson, chap. 4: "[D]uring the first half of the eighteenth century in particular, many gentlemen were not entirely disengaged from the culture of the common people. They frequently occupied something of a half-way house between the robust, unpolished culture of provincial England and the cosmopolitan, sophisticated culture which was based in London" (Malcolmson 1973, 68).

4. "In both England and New England in the seventeenth and eighteenth centuries puritanism is transformed from a critique of the established order in the name of King Jesus to an endorsement of the new economic activities of the middle classes. At the end of this process economic man emerges fully fledged; throughout, human nature appears as given, and human need or what is useful to supply it as a single, uncomplicated standard for action. Utility and advantage are treated as clear and perspicuous notions which stand in no further need of justification" (MacIntyre 1966, 150).

5. That a reformation of manners "would confirm the present establishment, both in Church and State" was stated directly by John Dennis, *The Person of Quality's Answer to Mr. Collier's Letter*, 29; quoted from Bahlman 1957, 43.

6. Richard Baxter, *A Christian Directory*, 2d ed. (London, 1678), bk. 1, 390; quoted from Malcolmson 1973, 7.

7. It is instructive to compare to Chesterfield's attitude to laughter. He writes to his son that "[f]requent and loud laughter is the characteristic of folly and ill manners; it is the manner in which the mob express their silly joy at silly things; and they call it being merry. In my mind there is nothing so illiberal, and so ill bred, as audible laughter" (*Letters to his Son*, CXLIV, 9 March 1748; quoted in Heltzel 1925, 429–30).

8. "Another thing that much afflicted him, was to see the very designs of the *Revolution* daily perverted, and the noble effects, that ought naturally to stream from it, like to be frustrated: not by the opposers and sworn enemies of it, from whom less cou'd not be expected; but by many of those who were the most active in it, and who suck'd in the Principles of it with their first milk. These, finding the sweet of Places and Pensions, were resolv'd to hold or procure them at any rate" (Toland in Shaftesbury 1721, viii). Shaftesbury began "to be prejudic'd not a little against all Courtiers" (ibid, xv). It is possible, of course, that Toland exaggerated Shaftesbury's aversion to the court to serve his own political (republican) purposes, but judging from Shaftesbury's published writings there is probably a good deal of truth in Toland's remarks.

9. The chapter of Shaftesbury's life relating to his, perhaps partly underground, political activities still remains to be written. From a letter written to Benjamin Furley from Naples it appears that Shaftesbury feared that the correspondence between him and Furley was being intercepted. Furley had received a letter without Shaftesbury's seal, though Shaftesbury says he always makes sure to seal his letters (9 August 1712; Shaftesbury 1900, 510–11). A letter from later the same year warns Furley against an unnamed traitor, and urges him to burn the letter after having read it (Shaftesbury 1900, 519–20).

10. Judging from *Tatler* 3 (16 April 1709), Richard Steele was himself actually a member of a Society for Reformation of Manners, though obviously a relatively moderate member.

11. For evidence of views similar to Boyer's (the author of *The English Theoprastus*), see Klein 1984; regarding Shaftesbury's possible knowledge of the work, see ibid., 198–99. The work was in any case not original but a compilation of views and statements from other works.

12. The *Sociable Enthusiast* is now published in Anthony Ashley Cooper, Third Earl of Shaftesbury, *Standard Edition: Complete Works, Selected Letters and posthumous Writings* (Shaftesbury [1703] 1987).

12. *Politeness*

1. Already Hume pointed out that this connection between liberty and growth in arts and sciences hardly holds up to a closer historical scrutiny. In reference to Addison and Shaftesbury Hume says: "But what would these writers have said, to the instances of modern ROME and of FLORENCE? Of which the former carried to perfection all the finer arts of sculpture, painting, and music, as well as poetry, though it groaned under tyranny, and under the tyranny of priests: While the latter made its chief progress in the arts and sciences, after it began to lose its liberty to the usurpation of the family of MEDICI,"; "Of Civil Liberty" [1741], Hume [1777] 1987, 90.

2. "[T]he figure we are like to make abroad, and the increase of knowledge, industry and sense at home, will render united Britain the principal seat of arts . . . When the free spirit of a nation turns itself this way [to the improvement of art and science], judgments are formed; critics arise; the public eye and ear improve; a right taste prevails, and in a manner forces its way. Nothing is so improving, nothing so natural, so congenial to the liberal arts, as that reigning liberty and high spirit of a people, which from the habit of judging in the highest matters for themselves, makes them freely judge of other subjects, and enter thoroughly into the characters as well of men and manners, as of the products or works of men, in art and science" (Shaftesbury 1969, 20–23). According to Steele, "the present grandeur of the British nation might make us expect, that we should rise in our public diversions, and manner of enjoying life, in proportion to our advancement in glory and power" (*Tatler* 12, [7 May 1709]).

3. Forrester's little book enjoyed considerable popularity. The *British Library Catalogue* lists eight different printings between 1734 and 1773. Johnson defined politeness in

similar terms. It is "the observance of those little civilities and ceremonious delicacies, which inconsiderable as they may appear to the man of science, and difficult as they may prove to be detailed with dignity, yet contribute to the regulation of the world, by facilitating the intercourse between one man and another" (*Rambler* 98 [23 February 1751]; quoted from Heltzel 1925, 445).

4. *The Whole Duty of Man* was first published in 1658. Addison calls it "one of the best Books in the World" in *Spectator* 568.

5. Cf. also the following remark: "There are few so affectedly clownish as absolutely to disown good breeding, and renounce the notion of beauty in outward manners and deportment" (2:266).

6. Cf. also the following passage: "Should a writer upon music, addressing himself to the students and lovers of the art, declare to them 'that the measure or rule of harmony was caprice or will, humour or fashion,' 'tis not very likely he should be heard with great attention or treated with real gravity. For harmony is harmony by nature, let men judge ever so ridiculously of music. So is symmetry and proportion founded still in nature, let men's fancy prove ever so barbarous, or their fashions ever so Gothic in their architecture, sculpture, or whatever other designing art. 'Tis the same case where life and manners are concerned. Virtue has the same fixed standard. The same numbers, harmony, and proportion will have place in morals, and are discoverable in the characters and affections of mankind; in which are laid the just foundations of an art and science superior to every other of human practice and comprehension" (1:227–28).

7. "Before *The Tatler* and *Spectator*, if the writers for the theatre are excepted, England had no masters of common life. No writers had yet undertaken to reform either the savageness of neglect or the impertinence of civility" (Johnson 1905, 93).

13. *Hutcheson and the Problem of Conspicuous Consumption*

1. Hutcheson's inquiries were published four times during his lifetime, each time with alterations: in 1725, 1726, 1729, and in 1738. A modern edition of the first treatise, edited with an introduction and notes by Peter Kivy, was published in 1973. I refer to it in the following by giving the year 1973. I refer to Garland Publishing's facsimile of the second edition (New York, 1971) for Treatise II by the year 1726.

2. For a partial, but nevertheless very long, list of works discussing *The Fable of the Bees*, see Kaye's edition, 2:419f. The reactions to and influence of Mandeville is discussed extensively in Hundert 1994.

3. "*The Grumbling Hive* relies upon the ideology of public and private virtue in order to make its point; if luxury, vice and corruption are connected with wealth and power and so with prosperity, then the converse is also true: virtue is accompanied by simplicity, poverty and primitive conditions" (Goldsmith 1985, 34–35).

4. Hundert documents that Mandeville's attack was directed against those claiming to be well-bred and polite (1994, 117–26, 141–44). Mandeville made it clear in his preface to volume 2, first published in 1729: "In the very Politeness of Conversation, the Complacency, with which fashionable People are continually soothing each other's Frailties, and in almost every part of a Gentleman's Behaviour," Cleomenes (who Mandeville declares to speak for him in the dialogues which make up the second volume) found that "there was a Disagreement between the outward Appearances, and what is felt within, that was clashing with Uprightness and Sincerity" (2:17). See also the third dialogue in vol. 2. In particular, Mandeville disliked Steele and Shaftesbury. See Goldsmith 1985, 42.

5. In the fourth edition Hutcheson says that "Approbation and Condemnation are probably simple Ideas, which cannot be farther explained" (introduction to Treatise II). Cf. Locke, *Essay*, 2.20.1: Pain and pleasure "like other simple *ideas*, cannot be described, nor their names defined; the way of knowing them is, as one of the simple *ideas* of the senses, only by experience." A simple idea is uncompounded and "contains in it nothing but *one uniform appearance* or conception in the mind, and is not distinguishable into different *ideas*" (*Essay*, 2.2.1).

6. The importance of the intention with which an act is carried out is clear from a passage in Hutcheson's essay in the *London Journal*. Even when someone does something which is justly blameable "[t]heir intention . . . is scarce ever malicious, unless upon some sudden transitory passion, which is frequently innocent, but most commonly honourable or kind, however imperfectly they judge of the means to execute it" (Hutcheson [1724] 1994, 102).

14. *From the Morality to the Autonomy of Art*

1. "Sagt der Künstler: aber wenn mein Werk gefällt oder Vergnügen erweckt, so habe ich doch meinen Zweck erreicht; so antworte ich: umgekehrt! Weil du deinen Zweck erreicht hast, so gefällt dein Werk, oder daß dein Werk gefällt, *kann vielleicht ein Zeichen* sein, daß du deinen Zweck in dem Werke selbst erreicht hast. War aber der eigentliche Zweck bei deinem Werke mehr das Vergnügen, das du dadurch bewürken wolltest, als die Vollkommenheit des Werks in sich selber; so wird mir eben dadurch der Beifall schon sehr verdächtig, den dein Werk bei diesem oder jenem erhaltet hat" (Moritz [1785] 1962, 7).

2. I give, first, the sections in *The Critique of Judgement*, and second, page numbers. Page references are to Meredith's translation, which I generally follow, but have modified in many places.

3. Meredith misleadingly translates "Lohnkunst" as "industrial art." This obscures the point that it is an activity done for money, and that this is what makes it problematic for Kant.

4. See the definition of honorarium and how it differs from wages in Zedler's *Universal-Lexicon* from 1735, cited in Woodmansee 1994, 42. See Mattick 1993b for a discussion of the problematic relationship between art and money in the eighteenth century.

5. "Pietism proper was in its origins an introverted, emotional modification of Lutheranism, seeking the realization of the Kingdom of God on earth by the mystical transformation of the individual soul, and was a movement rooted in the lover middle classes. Besides encouraging devotion to feeling . . . Pietism simultaneously imposed a severe, puritanical discipline upon its adherents. The Pietists met together in conventicles, did not go to church, and like the English Non-Conformists were often persecuted by the authorities" (Boulby 1979, 6).

REFERENCES

Allen, B. G. 1982. Seeing Art. *Canadian Journal of Philosophy* 12.

———. 1994. The Historical Discourse of Philosophy. *Canadian Journal of Philosophy* supp. vol. 19:127–58.

Allestree, Richard. 1684. *The Works of the Learned and Pious Author of the Whole Duty of Man.* London.

Amiel, Barbara. 1995. In Defence of Elitism: Benfits for Everyone. *Macleans.* 31 July. Toronto.

Anderson-Reece, Erik. 1993. Who's Afraid of Corporate Culture: The Barnett Newman Controversy. *The Journal of Aesthetics and Art Criticism* 51:49–57.

Arnstein, W. L., and W. B. Willcox. 1983. *The Age of Aristocracy: 1688 to 1830.* 4th ed. Toronto.

Astell, Mary. 1709. *Bart'lemy Fair: Or, An Enquiry after Wit; In Which due Respect is had to a Letter Concerning Enthusiasm, to my Lord . . . By Mr Wotton.* London.

Bacon, Francis. [1620] 1939. The Great Instauration. In E. A. Burtt, *The English Philosophers: From Bacon to Mill.* New York.

Bahlman, D. W. R. 1957. *The Moral Revolution of 1688.* N.p.

Bakhtin, Mikhail. 1984. *Rabelais and His World.* Bloomington, Ind.

Barasch, M. 1985. *Theories of Art: From Plato to Winckelmann.* New York.

———. 1990. *Modern Theories of Art.* Vol. 1: *From Winckelmann to Baudelaire.* New York.

Barnouw, Jeffrey 1993. The Beginnings of "Aesthetics" and the Leibnizian Conception of Sensation. In Mattick 1993a:52–95.

Baxandall, Michael 1972. *Painting and Experience in Fifteenth Century Italy.* Oxford.

Beardsley, M. C., and W. K. Wimsatt. 1987. The Intentional Fallacy. In Margolis 1987:367–380.

————. 1966. *Aesthetics—From Classical Greece to the Present.* New York.

————. 1987. The Aesthetic Point of View. In Margolis 1987:10–28.

Becker, Howard S. 1982. *Art Worlds.* Berkeley.

Bell, Clive. 1927. *Art.* London, 1927.

Berger, Peter. 1983. On the Obsolescence of the Concept of Honor. In Stanley Hauerwas and Alaisdair MacIntyre, eds., *Changing Perspectives in Moral Philosophy.* Notre Dame, Ind.

Berman, Marshall. 1988. *All That is Solid Melts Into Air: The Experience of Modernity.* New York.

Bernstein, R. J. 1985. *Beyond Objectivism and Relativism: Science, Hermeneutics, and Praxis.* Philadelphia.

Berry, C. J. 1994. *The Idea of Luxury: A Conceptual and Historical Investigation.* Cambridge.

Bolton, Richard, ed. 1992. *Culture Wars: Documents from the Recent Controversies in the Arts.* New York.

Bond, Donald F., ed. 1965. *The Spectator.* 5 vols. Oxford.

Boulby, Mark. 1979. *Karl Philipp Moritz: At the Fringe of Genius.* Toronto.

Bourdieu, Pierre. 1984. *Distinction: A Social Critique of the Judgement of Taste.* Cambridge, Mass.

————. 1990. *The Logic of Practice.* Trans. Richard Nice. Stanford, Calif.

————. 1993. *The Field of Cultural Production: Essays on Art and Literature.* Ed. Randal Johnson. New York.

Boyer, Abel. 1706. *The English Theophrastus: or, the Manners of the Age. Being the Modern Characters of the Court, the Town and the City.* 2d ed. London.

Bramston, James. [1733] 1972. *The Man of Taste.* London. 1733. Reprint in Gilmore 1972:87–102.

Brand, Peggy Z. 1994 Evaluating Art: A Feminist Case for Dickie's Matrix System. In R. J. Yanal, ed., *Institutions of Art: Reconsiderations of George Dickie's Philosophy.* University Park, Pa.

Brett, R. L. 1951. *The Third Earl of Shaftesbury: A Study in Eighteenth Century Literary Theory.* London.

Brownings, A., ed. 1966. *English Historical Documents: 1660–1714.* London. Vol. 8 of D. C. Douglas, general editor, *English Historical Documents.*

Brubaker, Rogers. 1993. Social Theory as Habitus. In Craig Calhoun, Edward LiPuma, and Moishe Postone, eds., *Bourdieu: Critical Perspectives.* Chicago.

Bryson, Norman. 1983. *Vision and Painting.* New Haven.

Bürger, Christa. 1980. Literarischer Markt und Öffentlichkeit am Ausgang des 18. Jahrhunderts in Deutschland. In C. Bürger, P. Bürger, and J. Schulte-Sasse, eds., *Aufklärung und Literarischer Öffentlichkeit.* Frankfurt am Main.

Bürger, Peter. 1984. *Theory of the Avant-Garde.* Minneapolis.

Bürger, Peter and Christa Bürger. 1992. *The Institutions of Art.* Trans. Lorenz-Krüger. Lincoln, Neb.

Burke, Peter. 1978. *Popular Culture in Early Modern Europe.* London.

Burney, Fanny. [1782] 1986. *Cecilia, or Memoirs of an Heiress.* London.

Calhoun, Craig. 1993. Habitus, Field, and Capital: The Question of Historical Spcificity. In Craig Calhoun, Edward LiPuma, and Moishe Postone, eds., *Bourdieu: Critical Perspectives.* Chicago.

Carroll, Noël. 1988. Art, Practice, and Narrative. *The Monist* 71:140–56.

———. 1994. Identifying Art. In R. J. Yanal, ed., *Institutions of Art: Reconsiderations of George Dickie's Philosophy.* University Park, Pa.

Cassirer, Ernst. 1951a. *The Philosophy of the Enlightenment.* Princeton.

———. 1951b. *The Platonic Renaissance in England.* Austin, Tex.

Castronovo, David. 1987. *The English Gentleman: Images and Ideals in Literature and Society.* New York.

Cohen, Ted. 1994. Partial Enchantments of the *Quixote* Story in Hume's Essay on Taste. In R. J. Yanal, ed., *Institutions of Art: Reconsiderations of George Dickie's Philosophy.* University Park, Pa.

Collier, Jeremy. 1698. *Essays Upon Several Moral Subjects 1698–1709. Part I and Part II.* London. Reprint of third ed., Hildesheim, 1969.

Crow, Thomas E. 1985. *Painters and Public Life in Eighteenth-Century Paris.* New Haven.

Danto, A. C. 1981. *The Transfiguration of the Commonplace: A Philosophy of Art.* Cambridge, Mass.

———. 1986. *The Philosophical Disenfranchisement of Art.* New York.

Davies, Stephen. 1991. *Definitions of Art.* Ithaca, N.Y..

Defoe, Daniel. [1729], 1972. *The Compleat English Gentleman.* Karl D. Bülbring, ed., 1890. Reprint Folcroft Library Editions.

Descartes, René. [1649] 1975. *The Passions of the Soul,* in *The Philosophical Works of Descartes,* vol. 1. Trans. E. S. Haldane and G. R. T. Ross. Cambridge.

Dickie, George. 1974. *Art and the Aesthetic: An Institutional Analysis.* Ithaca, N.Y.

———. 1984. Stolnitz's Attitude: Taste and Perception. *Journal of Aesthetics and Art Criticism* 43:195–203.

Dreyfus, H. L., and S. E. Dreyfus. 1987. From Socrates to Expert Systems: The Limits of Calculative Rationality. In Rabinow and Sullivan 1987:327–50.

Dunlop, Ian. 1972. *The Shock of the New: Seven Historical Exhibitions of Modern Art.* London.

Dunn, John. 1984. *Locke.* Oxford.

Eagleton, Terry. 1990. *The Ideology of the Aesthetic.* Oxford.

———. 1991. *Ideology: An Introduction.* London.

Earle, Peter. 1989. *The Making of the English Middle Class.* Berkeley.

Elias, Norbert. 1983. *The Court Society.* Trans. E. Jepchott. Oxford.

Erneling, Christina E. 1993. *Understanding Language Acquisition: The Framework of Learning.* Albany, N.Y.

Falkenheim, J. V. 1980. *Roger Fry and the Beginnings of Formalist Art Criticism.* Ann Arbor, Mich.

Feyerabend, P. 1988. *Against Method.* Revised edition. London.

Fielding, Henry. [1742] 1985. *Joseph Andrews.* Harmondsworth.

Fish, Stanley. 1989. *Doing What Comes Naturally: Change, Rhetoric, and the Practice of Theory in Literary and Legal Studies.* Durham, N.C.

Forrester, James. 1745. *The Polite Philosopher.* 3d. ed. London.

Foss, M. 1972. *The Age of Patronage: The Arts in England 1660–1750.* Ithaca, N.Y.

Fowler, Thomas. 1882. *Shaftesbury and Hutcheson.* London.

Frankena, William K. 1983. MacIntyre and Modern Morality. *Ethics* 93 (April 1983).

Fry, Roger 1910a. The Grafton Gallery-I. *The Nation* 8 (19 November).

———. 1910b. A Postscript on Post-Impressionism. *The Nation* 8 (24 December):536–37.

———. 1929. *Vision and Design.* London.

———. 1926. *Transformations.* London.

Gadamer, Hans-Georg 1975. *Wahrheit und Methode.* 4th. ed. Tübingen.

———. 1987. The Problem of Historical Consciousness. In Rabinow and Sullivan 1987:82–140.

Gasset, J. Ortega y. 1956. *The Dehumanization of Art.* New York.

Gibson-Wood, C. 1984. Jonathan Richardson and the Rationalization of Connoisseurship. *Art History* 7:38–56.

Gildon, Charles. 1714. *A New Rehearsal, or Bays the Younger etc. To which is prefixed a Preface in Vindication of Criticism in General, by the late Earl of Shaftesbury.* London.

Gilmore, T. B., ed. 1972. *Early 18th Century Essays on Taste.* New York.

Goldsmith, M. M. 1985. *Private Vices, Public Benefit: Bernard Mandeville's Social and Political Thought.* Cambridge.

Gombrich, E. H. 1980. *Art and Illusion: A Study in the Psychology of Pictorial Representation.* 5th ed. London.

———. 1979a. In Search of Cultural History. In *Ideal and Idols: Essays on Values in History and Art*. Oxford.

———. 1979b. The Logic of Vanity Fair: Alternatives to Historicism in the Study of Fashions, Style and Taste. In *Ideal and Idols: Essays on Values in History and Art*. Oxford.

Goodman, Nelson. 1968. *Languages of Art: An Approach to a Theory of Symbols*. New York.

———. 1978. *Ways of Worldmaking*. Indianapolis, Ind.

———. 1984. *Of Mind and Other Matters*. Cambridge, Mass.

Göricke, Walter. 1921. Das Bildungsideal Bei Addison und Steele. *Bonner Studien zur Englischen Philologie* 14. Bonn.

Guilbaut, Serge. 1983. *How New York Stole the Idea of Modern Art: Abstract Expressionism, Freedom and the Cold War*. Chicago.

Gumbrecht, H. U. 1978. Modern, Modernität, Moderne. In O. Brunner, W. Conze, and R. Koselleck, eds., *Geschichtliche Grundbegriffe*, 4:93–131. Stuttgart.

Habermas, Jürgen. 1989. *The Structural Transformation of the Public Sphere*. Cambridge, Mass.

———. 1987. *The Philosophical Discourse of Modernity*. Cambridge, Mass.

Hacking, Ian. 1990. Two Kinds of New Historicism for Philosophers. *New Literary History* 21:343–64.

Hampshire, S. 1959. Logic and Appreciation. In W. Elton, ed., *Aesthetics and Language*. Oxford.

———. 1982. *Thought and Action*. New edition. Notre Dame.

Hanson, N. R. 1958. *Patterns of Discovery: An Inquiry into the Conceptual Foundations of Science*. Cambridge.

Harré, R. 1979. *Social Being: A Theory for Social Psychology*. Oxford.

Harris, John. 1704. *Lexicon Technicum, or an Universal Dictionary of the Arts and Sciences*. London, 1704. Reprinted 1708, 2nd expanded edition in 2 vols. 1710. 5th and last ed. 1736.

Hauser, Arnold. 1951. *The Social History of Art*. New York, 4 vols.

Hegel, G. W. F. [1820] 1942. *Philosophy of Right*. Trans. T. M. Knox. Oxford.

Heltzel, V. B. 1925. "Chesterfield and the Tradition of the Ideal Gentleman." Ph.D. thesis, University of Chicago.

Hill, Christopher. 1958. *Puritanism and Revolution*. London.

———. 1969. *Reformation to Industrial Revolution*. Harmondsworth, 1969.

———. 1974. *Change and Continuity in Seventeenth-Century England*. London.

———. 1980. *Some Intellectual Consequences of the English Revolution*. London.

———. 1988. *A Turbulent, Seditious, and Factious People: John Bunyan and his Church 1628–1688*. Oxford.

Hirschman, Albert O. 1977. *The Passions and the Interests: Political Arguments for Capitalism before Its Triumph*. Princeton.

Hobbes, Thomas. [1651] 1968. *Leviathan*. Ed. C. B. Macpherson. Harmondsworth.

Hume, David. [1777] 1987. *Essays, Moral, Political, and Literary*. Ed. E. F. Miller. Indianapolis.

Hundert, E. G. 1994. *The Enlightenment's "Fable": Bernard Mandeville and the Discovery of Society*. Cambridge.

Hutcheson, Francis. 1726. *An Inquiry into the original of our Ideas of Beauty and Virtue*. 2d ed. London.

———. 1750. *Reflections Upon Laughter, and remarks upon the Fable of the Bees*. Glasgow 1750. Originally published in *The Dublin Journal* in 1725. Reprint New York, 1971.

———. 1973. *An Inquiry concerning Beauty, Order, Harmony, Design*. Ed. with an introduction by P. Kivy. The Hague. The first of the two treatises in Hutcheson 1726.

———. [1724] 1994. Reflection on the Common Systems of Morality. In T. Mautner, ed., *Two Texts on Human Nature*, by Francis Hutcheson. Cambridge. First published in the *London Journal*, nos. 277 and 278, 1724.

Ingarden, R. 1961. Aesthetic Experience and Aesthetic Object. *Philosophy and Phenomenological Research* 21.3.

Isenberg, Arnold. 1987. Analytical Philosophy and the Study of Art. *Journal of Aesthetics and Art Criticism* 46, special issue: 125–36.

Jack, Malcolm. 1989. *Corruption and Progress: The Eighteenth-Century Debate*. New York.

Jacob, M. C. 1981. *The Radical Enlightenment: Pantheists, Freemasons and Republicans*. London.

Jacoby, Russell. 1984. *The Last Intellectuals: American Culture in the Age of Academe*. New York.

———. 1994. *Dogmatic Wisdom: How the Culture Wars Divert Education and Distract America*. New York.

Jensen, U. J. 1981. Repräsentation und Tradition. In Dieter Henrich, ed., *Kant oder Hegel? Über Formen der Begründung in der Philosophie*. Stuttgarter Hegel-Kongreß 1981.

———. J. 1983. Udvikler videnskaben sig? In Erik Schroll-Fleischer, ed., *Evolution, Kultur og Samfund*. Herning, Denmark.

Johnson, Samuel. 1905. *Lives of the English Poets*. Vol. 2. Oxford.

Kames, Henry Home, Lord. 1785. *Elements of Criticism. The Sixth Edition*. Edinburgh. 2 vols. Reprint New York, 1972.

Kant, Immanuel. [1784] 1963. What is Enlightenment? Trans. L. W. Beck, in L. W. Beck, ed., *Kant on History*. New York.

———. [1790] 1952. *The Critique of Judgement*. Trans. J. C. Meredith. Oxford.

Kennick, W. E. 1958. Does Traditional Aesthetics Rest on a Mistake? *Mind* 67 (1958):317–34.

Kivy, Peter. 1976. *The Seventh Sense: A Study of Francis Hutcheson's Aesthetics and its Influence in Eighteenth-Century Britain*. New York.

Klein, Hannelore. 1967. *"There is no Disputing About Taste." Untersuchungen zur Englischen Geschmachsbegriff im 18. Jahrhundert.* Münster.

Klein, L. E. 1984. The Third Earl of Shaftesbury and the Progress of Politeness. *Eighteenth-Century Studies* 18:186–214.

Koselleck, Reinhart. 1988. *Critique and Crisis: Enlightenment and the Pathogenesis of Modern Society.* Oxford.

Kosuth, Joseph. 1969. Art after Philosophy. *Studio International* 178.

Kristeller, P. O. 1951–52. The Modern System of the Arts: A Study in the History of Aesthetics I–II. *Journal of the History of Ideas,* 12:496–527 and 13:17–46.

Kuhn, T. 1970. *The Structure of Scientific Revolutions.* Second edition, enlarged. Chicago.

———. 1974. Second Thoughts on Paradigms. In F. Suppe, ed., *The Structure of Scientific Theories.* Chicago.

Lash, Scott. 1993. Pierre Bourdieu: Cultural Economy and Social Change. In Craig Calhoun, Edward LiPuma, and Moishe Postone, eds., *Bourdieu: Critical Perspectives.* Chicago.

LeGrand, Antoine. 1694. *An Entire Body of Philosophy According to the Principles of the Famous Renate Des Cartes.* Reprint with intro. by R. A. Watson. New York, 1972.

Levine, Lawrence W. 1988. *Highbrow/Lowbrow: The Emergence of Cultural Hierarchy in America.* Cambridge, Mass.

Levinson, Jerrold. 1979. Defining Art Historically. *British Journal of Aesthetics* 19:232–50.

———. 1989. Refining Art Historically. *Journal of Aesthetics and Art Criticism* 47:21–33.

———. 1993. Extending Art Historically. *Journal of Aesthetics and Art Criticism* 51:411–24.

Locke, John. [1669] 1876. De Arte Medica. In H. R. Fox Bourne, *The Life of John Locke.* 1:222–227. London.

———. [1689] 1960. *Two Treatises of Government.* Ed. P. Laslett. New York.

———. [1693] 1963. Some Thoughts Concerning Education. *The Works of John Locke,* vol. 9. London, 1823. Reprinted by Scientia Verlag, Aalen, Germany.

———. [1690] 1974. *An Essay Concerning Human Understanding.* London. Everyman's Library, two vols. based on fifth ed. 1706.

Lovejoy, Arthur O. 1964. *The Great Chain of Being: A Study of the History of an Idea,* Cambridge, Mass.

Löwenthal, Leo 1961. *Literature, Popular Culture and Society.* Palo Alto.

MacIntyre, A. 1966. *A Short History of Ethics.* New York.

———. 1984. *After Virtue.* 2nd ed. Notre Dame, Ind.

———. 1988. *Whose Justice? Which Rationality?.* Notre Dame, Ind.

Malcolmson, R. W. 1973. *Popular Recreations in English Society, 1700–1850.* Cambridge.

Mandelbaum, M. 1976. On the Historiography of Philosophy. *Philosophy Research Archives* 2:708–44.

Mandeville, Bernard. [1714] 1924. *The Fable of the Bees*, Ed. F. B. Kaye. 2 vols. Oxford.

Margolis, Joseph, ed. 1987. *Philosophy Looks at the Arts.* Third ed. Philadelphia.

Marshall, Gordon. 1980. *Presbyteries and Profits: Calvinism and the Development of Capitalism in Scotland, 1560–1707.* Oxford.

Mash, Roy. 1987. How Important for Philosophers is the History of Philosophy? *History and Theory* 26:287–299.

Mason, J. E. 1971. *Gentlefolk in the Making: Studies in the History of English Courtesy Literature and Related Topics from 1531 to 1774.* New York.

Mattick, Paul, Jr., ed. 1993a. *Eighteenth-Century Aesthetics and the Reconstruction of Art.* Cambridge.

———. 1993b. Art and Money. In Mattick ed. 1993a:152–77.

———. 1993c. Introduction to Mattick, 1993a.

Mautner, Thomas. 1994. Introduction to *Two Texts on Human Nature*, by Francis Hutcheson. Cambridge.

Mayr, E. 1982. *The Growth of Biological Thought.* Cambridge, Mass.

———. 1990. When is Historiography Whiggish? *Journal of the History of Ideas* 51:301–9.

———. 1988. *Towards a New Philosophy of Biology.* Cambridge.

McKendrick, N., ed. 1982. *The Birth of a Consumer Society: The Commercialization of Eighteenth Century England.* London.

———. 1982a. The Consumer Revolution of Eighteenth-Century England. In McKendrick 1982:9–33.

———. 1982b. The Commercialization of Fashion. In McKendrick 1982:34–99.

Miller, James. [1738] 1972. *Of Politeness.* London. Reprinted in Gilmore 1972:206–24.

Moore, James. 1990. The Two Systems of Francis Hutcheson: On the Origins of the Scottish Enlightenment. In Stewart 1990:37–59.

Moritz, Karl Philip. [1785] 1962. Versuch einer Vereinigung aller schönen Künste und Wissenschaften unter dem Begriff des in sich selbst Vollendeten. In Moritz, *Schriften zur Ästhetik und Poetik.* Kritische Ausgabe. Ed. H. J. Schrimpf. Tübingen.

Nef, J. U. 1957. Coal Mining and Utilization. In C. Singer, E. J. Holmyard, A. R. Hall, and T. I. Williams, eds., *A History of Technology.* Vol. 3: *From the Renaissance to the Industrial Revolution, c. 1500 – c. 1750.* New York.

Newman, Peter C. 1985. *The Company of Adventurers.* New York.

Noble, Richard. 1990. Resisting the Censor: Art, Morality, and the public Good. *Canadian Dimension* 24:6–8.

Novitz, David. 1992. *The Boundaries of Art.* Philadelphia.

Osborne, Harold. 1981. What is a Work of Art? *British Journal of Aesthetics* 21:3–11.

Pears, Iain. 1988. *The Discovery of Painting: The Growth of Interest in the Arts in England 1680–1768*. New Haven.

Pelzer, John, and Linda Pelzer. 1982. The Coffee Houses of Augustan London. *History Today* 32:40–47.

Perry, Ruth. 1986. *The Celebrated Mary Astell*. London.

Plump, J. H. 1982a. The Commercialization of Leisure. In McKendrick 1982:265–86.

———. 1982b. The Acceptance of Modernity. In McKendrick 1982:316–34.

Pollitt, J. J. 1974. *The Ancient View of Greek Art*. New Haven.

Pollock, Griselda. 1988. *Vision and Difference: Femininity, Feminism and the Histories of Art*. London.

Pope, Alexander. [1733] 1951. An Essay on Man. In Alexander Pope, *Selected Poetry and Prose*, ed. W. K. Wimsatt, Jr. New York.

Porter, Roy. 1982. *English Society in the Eighteenth Century The Pelican Social History of Britain*. Harmondsworth.

Putnam, H. 1975. The Corroboration of Theories. In *Mathematics, Matter and Method: Philosophical Papers, vol. 1*. Cambridge.

———. 1981. *Reason, Truth and History*. Cambridge.

———. 1983a. *Realism and Reason: Philosophical Papers, vol. 3*. Cambridge.

———. 1983b. Beyond Historicism. In Putnam 1983a.

———. 1990. The Craving for Objectivity. Chap. 8 in *Realism with a Human Face*. Cambridge, Mass.

Rabinow, P., and W. M. Sullivan, eds. 1987. *Interpretive Social Science: A Second Look*. Berkeley.

Reichenbach, Hans. 1951. *The Rise of Scientific Philosophy*. Berkeley.

Richardson, Jonathan. 1719. *Two Discourses: 1. An Essay on the Whole Art of Criticism as it Relates to Painting. 2. An Argument in Behalf of the Science of a Connoisseur*. Reprint 1972. Menston, Yorkshire.

Ritter, Joachim. 1971. Ästhetik, Ästhetisch. *Historisches Wörterbuch der Philosophie*, vol. 1. Basel.

———. 1978. *Landschaft—zur Funktion des Ästhetischen in der Modernen Gesellschaft*. Münster. Also in *Subjektivität. Sechs Aufsätze*, Frankfurt am Main, 1974.

Rorty, R. 1979. *Philosophy and the Mirror of Nature*. Princeton.

———. 1982. *Consequences of Pragmatism. Essays: 1972–1980*. Minneapolis.

———. 1984. The Historiography of Philosophy: Four Genres. In Rorty, Schneewind and Skinner 1984:49–75.

———. 1989. *Contingency, Irony, and Solidarity*. Cambridge.

Rorty, R., J. B. Schneewind, and Q. Skinner, eds. 1984. *Philosophy in History: Essays in the Historiography of Philosophy*. Cambridge.

Russell, Bertrand. 1952. *Our Knowledge of the External World as a Field for Scientific Method in Philosophy*. London.

———. 1946. *History of Western Philosophy*. London.

Ryle, Gilbert. 1960. *The Concept of Mind*. New York.

Saisselin, R. G. 1992. *The Enlightenment Against the Baroque: Economics and Aesthetics in the Eighteenth Century*. Berkeley.

Schiller, Friedrich. [1793] 1967. *On the Aesthetic Education of Man In a Series of Letters*. Trans. E. M. Wilkinson and L. A. Willoughby. Oxford.

———. 1975. *Über Kunst und Wirklichkeit. Schriften und Briefe zur Ästhetik*. Leipzig.

Schulte-Sasse, J. 1980. Das Konzept bürgerlich-literarischer Öffentlichkeit und die historischen Gründe seiner Zerfalls. In Schulte-Sasse 1980:83–115.

Scott, Rebecca. 1992. "Inevitable Relations": Aesthetic Revelations from Cézanne to Woolf. In Stephen Regan, ed., *The Politics of Pleasure*. Philadelphia.

Scott, W. R. 1900. *Francis Hutcheson, his life, teaching and position in the history of philosophy*. Cambridge, 1900. Reprint: New York, 1966.

Scruton, Roger. 1983. *The Aesthetic Understanding: Essays in the Philosophy of Art and Culture*. Manchester.

Sekora, John. 1977. *Luxury: The Concept in Western Thought, Eden to Smolett*. Baltimore.

Shaftesbury. [1701] 1981. *The Adept Ladies or the Angelic Sect. Being the Matters of Fact of Certain Adventures Spiritual, Philosophical, Political, and Gallant*. In a Letter to a Brother, 1701–2. In Anthony Ashley Cooper, Third Earl of Shaftesbury, *Standard Edition. Complete Works, Selected Letters and posthumous Writings*, vol. I, 1. Stuttgart-Bad Cannstatt.

———. [1703] 1987. *The Sociable Enthusiast*, in Anthony Ashley Cooper, Third Earl of Shaftesbury, *Standard Edition. Complete Works, Selected Letters and posthumous Writings*, vol. II, 1. Stuttgart-Bad Cannstatt.

———. [1711] 1963. *Characteristics of Men, Manners, Opinions, Times etc.*. 2 vols. Ed. John M. Robertson. Glouchester, Mass. This ed. first published 1900.

———. 1721. *Letters from the right hounorable the late Earl of Shaftesbury, to Robert Molesworth, esq; now the Lord Viscount of that name*. Edited by J. Toland. London.

———. 1900. *The Life, Unpublished Letters and Philosophical Regimen of Anthony, Earl of Shaftesbury, Author of the Characteristics*. Ed. by B. Rand. London.

———. 1969. *Second Characters, or the Language of Forms*. Ed. B. Rand. New York. First published Cambridge 1914.

Shapin, S., and S. Schaffer. 1985. *Leviathan and the Air Pump: Hobbes, Boyle and the Experimental Life*. Princeton.

Sheehan, James J. 1989. *German History 1770–1866*. Oxford.

Sher, Richard B. 1990. Professors of Virtue: The Social History of the Edinburgh Moral Philosophy Chair in the Eighteenth Century. In Stewart 1990:89–126.

Shusterman, Richard. 1989. Introduction: Analysing Analytic Aesthetics. In R. Shusterman, ed., *Analytic Aesthetic*. Oxford.

———. 1992. *Pragmatist Aesthetics: Living Beauty, Rethinking Art*. Oxford.

———. 1993. On the Scandal of Taste: Social Privilege as Nature in the Aesthetic Theories of Hume and Kant. In Mattick 1993a:96–119.

Sibley, F. 1987. Aesthetic Concepts. In Margolis 1987:29–52.

Silvers, Anita. 1993. Pure Historicism and the Heritage of Heroines: Who Grows in Phyllis Wheatlye's Garden? *Journal of Aesthetics and Art Criticism* 53:475–82.

Skinner, Q. 1984. The Idea of Negative Liberty: Philosophical and Historical Perspectives. In Rorty, Schneedwind, and Skinner 1984:193–221.

———. 1988a. A Reply to my Critics. In J. Tully, ed., *Meaning and Context: Quentin Skinner and his Critics*. Princeton.

———. 1988b. Some problems in the analysis of political thought and action. In J. Tully, ed., *Meaning and Context: Quentin Skinner and his Critics*. Princeton.

Smith, Adam. [1759] 1976. *The Theory of Moral Sentiments*. Ed. D. D. Raphael and A. L. Macfie. Oxford.

Smith, Barbara Herrnstein. 1988. *Contingencies of Value: Alternative Perspectives for Critical Theory*. Cambridge.

Spingarn, J. E., ed. 1908. *Critical Essays of the Seventeenth Century*. 3 vols. Oxford.

Sprat, Thomas. [1667] 1958. *The History of the Royal Society of London, for the Improving of Natural Knowledge*. London. Ed. with critical apparatus by J. I. Cope and H. W. Jones. St. Louis, Mo., and London.

Stewart, M. A., ed. 1990. *Studies in the Philosophy of the Scottish Enlightenment*. Oxford.

Stolnitz, Jerome. 1961a. On the Origin of Aesthetic Disinterestedness. *Journal of Aesthetics and Art Criticism* 20:131–44.

———. 1961b. Beauty: Some Stages in the History of an Idea. *Journal of the History of Ideas* 22: 185–204.

———. 1961c. On the Significance of Lord Shaftesbury in Modern Aesthetic Theory. *Philosophical Quarterly* 11:97–113.

———. 1978. The Aesthetic Attitude in the Rise of Modern Aesthetics. *Journal of Aesthetics and Art Criticism* 36:409–22,

———. 1984. The Aesthetic Attitude in the Rise of Modern Aesthetics—Again. *Journal of Aesthetics and Art Criticism* 43:205–8.

———. 1986. The Actualities of Non-Aesthetic Experience. In M. H. Mitias, ed., *Possibility of the Aesthetic Experience*, Dordrecht/Boston.

Summers, David. 1993. Why Did Kant Call Taste a "Common Sense"? In Mattick 1993a: 120–51.

Tatarkiewicz, Wladyslaw. 1970–74. *History of Aesthetics.* 3 vols. The Hague, Paris and Warsaw.

———. 1980. *A History of Six Ideas: An Essay in Aesthetics.* London and Warsaw.

Tawney, R. H. 1984. *Religion and the Rise of Capitalism.* Harmondsworth.

Taylor, Charles. 1971. Interpretation and the Sciences of Man. In Rabinow and Sullivan 1987:33–81.

———. 1984. Philosophy and Its History. In Rorty, Schneedwind, and Skinner 1984:17–30.

———. 1989. *Sources of the Self: The Making of the Modern Identity.* Cambridge, Mass.

Thomas, Keith. 1991. *Religion and the Decline of Magic: Studies in Popular Beliefs in Sixteenth- and Seventeenth-Century England.* Harmondsworth.

Tilghman, B. J. 1984. *But is it Art? The Value of Art and the Temptation of Theory.* Oxford.

Toulmin, S. 1972. *Human Understanding: The Collective Use and Evolution of Concepts.* Princeton.

———. 1983. The Construal of Reality: Criticism in Modern and Postmodern Science. In W. J. Mitchell, ed., *The Politics of Interpretation.* Chicago.

Townsend, Dabney. 1982. Shaftesbury's Aesthetic Theory. *Journal of Aesthetics and Art Criticism* 41.

Tully, James, ed. 1988. *Meaning and Context: Quentin Skinner and his Critics.* Princeton.

———. 1993. *An Approach to Political Philosophy: Locke in contexts.* Cambridge.

Veblen, Thorstein. 1931. *The Theory of the Leisure Class.* New York.

Volosinov, V. N. 1973. *Marxism and the Philosophy of Language.* New York.

Walmsley, Peter. 1993. Dispute and Conversation: Probability and the Rhetoric of Natural Philosophy in Locke's *Essay. Journal of the History of Ideas* 54:381–94.

Warnke, Martin. 1993. *The Court Artist: On the Ancestry of the Modern Artist.* Cambridge.

Wartofsky, Marx W. 1979. *Models: Representation and the Scientific Understanding.* Dordrecht, London. *Boston Studies in the Philosophy of Science* 48.

———. 1980. Art, Artworlds, and Ideology. *Journal of Aesthetics and Art Criticism* 38:239–47.

Watt, Ian. 1967. *The Rise of the Novel: Studies in Defoe, Richardson and Fielding.* Berkeley and Los Angeles.

Weber, Max. 1958. *The Protestant Ethic and the Spirit of Capitalism.* Trans. Talcott Parsons. New York.

Whichcote, Benjamin. 1698. *Select Sermons of Benjamin Whichcote.* A Facsimile reproduction with an introduction by J. A. Bernstein. New York, 1977. With an introduction by Shaftesbury.

Williams, Raymond. 1961. *Culture and Society 1780–1950.* Harmondsworth, 1961.

Wittgenstein, Ludwig. 1953. *Philosophical Investigations.* Oxford.

———. 1969. *On Certainty.* Trans. D. Paul and G. E. M. Anscombe. New York.

Wood, Neal. 1983. *The Politics of Locke's Philosophy: A Social Study of "An Essay Concerning Human Understanding."* Berkeley.

Woodmansee, M. 1994. *The Author, Art, and the Market: Rereading the History of Aesthetics.* New York.

Woodward, J. 1699. *An Account of the Societies for Reformation of Manners, in London and Westminster, and other Parts of the Kingdom. With a Persuasive to Persons of all Ranks to be Zealous and Diligent in Promoting the Execution of the Laws Against Prophaneness and Debauchery, For the Affecting a National Reformation.* London.

Woodward, J. 1704. *An Account of the Progress of the Reformation of Manners, in England, Scotland, and Ireland, and Other Parts of Europe and America. The twelfth ed. with considerable additions.* London.

Woolf, Leonard. 1975. *Sowing: An Autobiography of the Years 1880–1904.* In S. P. Rosenbaum, ed., *The Bloomsbury Group: A Collection of Memoirs, Commentary and Criticism.* Toronto and Buffalo.

Wotton, William. 1705. *Reflections upon Ancient and Modern Learning.* 3rd ed. London.

Zolberg, Vera L. 1990. *Constructing a Sociology of the Arts.* Cambridge.

INDEX